French Salon Paintings
from Southern Collections

EXHIBITION SCHEDULE

The High Museum of Art, Atlanta, January 21 - March 3, 1983
The Chrysler Museum, Norfolk, April 4 - May 15, 1983
The North Carolina Museum of Art, Raleigh, June 25 - August 21, 1983
The John and Mable Ringling Museum of Art, Sarasota, September 15 - October 23, 1983

This exhibition and catalogue have been made possible in part by grants
from the National Endowment for the Arts, a Federal agency, and Equifax
Inc. of Atlanta. The exhibition is presented under the patronage of the
Cultural Services of the French Embassy.

Edited by Kelly Morris.
Designed by Jim Zambounis.
Typeset by Preston Rose Company, Atlanta.
Printed by Balding + Mansell, Wisbech, England.

Library of Congress Catalogue No. 82-82944

ISBN 0-939802-15-5

French
Salon Paintings
from
Southern Collections

ERIC M. ZAFRAN

Introductory Essay by GERALD M. ACKERMAN

THE HIGH MUSEUM OF ART
ATLANTA, GEORGIA

LENDERS TO THE EXHIBITION

The Ackland Art Museum, University of North Carolina, Chapel Hill
The Chrysler Museum, Norfolk
Columbus Museum of Arts and Sciences, Columbus, Georgia
The Corcoran Gallery of Art, Washington, D.C.
Cummer Gallery of Art, Jacksonville
Dallas Museum of Fine Arts
The Dimock Gallery, George Washington University, Washington, D.C.
The Dixon Gallery and Gardens, Memphis
The Henry Morrison Flagler Museum, Palm Beach
The High Museum of Art, Atlanta
Kimbell Art Museum, Fort Worth
The Lowe Art Museum, Coral Gables
John E. Mortensen, Jr., Norfolk
Museo de Arte de Ponce, Puerto Rico (Luis A. Ferré Foundation)
Museum of Fine Arts, Houston
Museum of Fine Arts, St. Petersburg
National Gallery of Art, Washington, D.C.
National Museum of American Art, Smithsonian Institution, Washington, D.C.
National Portrait Gallery, Smithsonian Institution, Washington, D.C.
New Orleans Museum of Art
The North Carolina Museum of Art, Raleigh
Norton Gallery of Art, West Palm Beach
The Phillips Collection, Washington, D.C.
Stuart Pivar Collection, Courtesy The University of Virginia Art Museum, Charlottesville
The John and Mable Ringling Museum of Art, Sarasota
Sheila and David Saul, Atlanta
Kurt E. Schon, Ltd., New Orleans
The J. B. Speed Art Museum, Louisville
The University of Kentucky, Carnahan House Conference Center, Lexington
The University of North Carolina at Wilmington
The Walters Art Gallery, Baltimore
Mr. and Mrs. James E. Wenneker, Lexington

ACKNOWLEDGEMENTS

Many people have helped to make this exhibition possible. To all the lenders, both public and private, we extend our heartfelt thanks for their willingness to share their treasures. The tour of the exhibition to three other Southern museums is due to the interest and support of the directors of those institutions: David Steadman, Director, The Chrysler Museum, Norfolk; Edgar Peters Bowron, Director, The North Carolina Museum of Art, Raleigh; and Richard Carroll, Director, The John and Mable Ringling Museum of Art, Sarasota. At the High Museum, the project had from the first the enthusiastic endorsement of Director Gudmund Vigtel.

In locating and arranging the loans of the works in the exhibition, the following individuals have provided assistance and courtesies for which I am most grateful: William Wilson, Curator of Collections, The John and Mable Ringling Museum of Art, Sarasota; Dr. Rene Taylor, Director, Museo de Arte de Ponce; William A. Fagaly, Assistant Director for Art, New Orleans Museum of Art; Robert Schlageter, Director, and L. Vance Shrum, Assistant to the Director, Cummer Gallery of Art, Jacksonville; Michael Milkovich, Director, Museum of Fine Arts of St. Petersburg; Steven Nash, Assistant Director and Chief Curator, Dallas Museum of Fine Arts; David B. Lawal, Director, University of Virginia Art Museum, Charlottesville; Fred C. Fussell, Curator, Columbus Museum of Arts and Sciences, Columbus, Georgia; Harry Lowe, Acting Director, and Birute Vileisis, Assistant to the Director, National Museum of American Art, Washington, D.C.; Addison Franklin Page, Director, and Mary Carver, Registrar, The J. B. Speed Art Museum, Louisville; J. Carter Brown, Director, National Gallery of Art; Laughlin Phillips, Director, The Phillips Collection; Ira Licht, Director, and John Haletsky, Curator, Lowe Art Museum, Coral Gables; Pinkney Near, Curator, Virginia Museum of Fine Arts, Richmond; Bruce Weber, Curator of Collections, Norton Gallery of Art, West Palm Beach; Mitchell Kahan, Curator, North Carolina Museum of Art; Chancellor William H. Wagoner, University of North Carolina at Wilmington; Charles Simmons, Executive Director, and Phyllis Kathryn Guy, Curator, The Henry Morrison Flagler Museum, Palm Beach; Evan Turner, Director, Innis H. Shoemaker, Assistant Director, and Katharine C. Lee, Curator, Ackland Art Museum, Chapel Hill; Robert Figg, Director, Carnahan House, University of Kentucky Conference Center; Harriet W. Fowler, Curator, University of Kentucky Museum, Lexington; Edward Nygren, Curator, and Judith Riley, Registrar, The Corcoran Gallery of Art, Washington, D.C.; Lenore D. Miller, Curator of Art, Dimock Gallery, George Washington University, Washington, D.C.; David Robb, Chief Curator, and Michael Mezzatesta, Curator, Kimbell Art Museum, Fort Worth; Dr. Thomas L. Zamparelli, Director of Research, Kurt E. Schon, Ltd., New Orleans; Edward Mayo, Registrar, Museum of Fine Arts, Houston; Marion L. Grayson, formerly curator, Museum of Fine Arts, St. Petersburg; Monroe Fabian, Curator, National Portrait Gallery; Thomas Sokolowski, Curator of European Painting and Sculpture, and Catherine Jordan, Registrar, Chrysler Museum, Norfolk.

Michael McKelvey made most of the copy photographs; Jay E. Cantor kindly supplied the photo of the Stewart home; and at the Musée d'Orsay, Martine Pouget assisted in obtaining photographs of the Salons.

For the sponsorship of the French Embassy, we would like to thank André-Jean Libourel,

Cultural Counselor of the French Embassy in New York and Jack Batho, French Cultural Attache in New Orleans.

A number of experts kindly gave opinions and advice. I would like to thank Mark Gerstein, Gabriel Weisberg, Bob Cashey, Joseph Rishel, John Wisdom, Stuart Pivar, and Geneviève Lacambre. Several individuals who had already carried out research on some of the works included in the exhibition were kind enough to share their findings with me. Professor Gerald Ackerman, to whom we owe the splendid introductory essay on the Salon, also graciously supplied the relevant text from his forthcoming monograph and catalogue raisonée of Jean-Léon Gérôme. Likewise, Mark Walker sent the information he has accumulated on the various Bouguereaus in the exhibition. For those works lent by the Walters Art Gallery, Baltimore, William Johnston furnished material from his forthcoming catalogue of that collection; and David Rust contributed information on the Corot lent by the National Gallery.

For assistance with the research, I am indebted to Elizabeth Lane, Paula Hancock, and Alice Howard in Atlanta and to Neil Blumstein in Paris. The staffs of the following libraries have provided gracious assistance: Frick Art Reference Library (New York), Metropolitan Museum of Art (New York), New York University Institute of Fine Arts, The Witt Library (London), and Bibliothèque nationale (Paris).

The details of transporting the paintings and organizing the tour were handled with great efficiency by the High Museum's registrars, first by Shelby White Cave and then by her successor Marjorie Harvey. My assistant, Rhetta Kilpatrick, gave of her time and energy far beyond the call of duty. The High Museum's splendid team of editor Kelly Morris and designer Jim Zambounis contributed all their wonted talents and skills to making the catalogue look and read as well as possible. Katherine Albright of Preston Rose Company, Atlanta, carried out the typesetting with remarkable ability and patience, and Guy Dawson of Balding + Mansell oversaw the printing of the catalogue with notable sensitivity.

Finally, we must acknowledge the generosity of those sponsors who have made it possible for the exhibition to progress from concept to reality. These are the National Endowment for the Arts, a Federal agency, and Equifax Inc. of Atlanta. We hope this combination of corporate and federal support will set a positive example for future endeavors.

Eric M. Zafran
Curator of European Art
The High Museum of Art

PREFACE

Over the last decade, art historians have challenged and re-evaluated a great deal of established dogma. Among other effects, this has led to revived interest in schools and styles of art which had been discredited over many years of preoccupation with modern attitudes. Until recently, major portions of nineteenth century art—unless they were seen as harbingers of Impressionism or the stirrings of modern art—were given short shrift.

It is to be expected, perhaps, that those depictions of moralizing sentiment, of allegory and elaborate illusion which make up so much of French Salon painting—the "official" art of most of the nineteenth century—never really lost favor with the public. But that this art, which had been seen as the very antithesis of the modern movement, is now taken seriously by art historians shows the extent to which critical opinion has been revised.

One reward of such revisionism is the reappearance of forgotten material, some of which should never have been put out of sight in the first place. There is no question that the best of Salon painting can offer much enjoyment and even surprise, and the public is definitely the winner when exhibitions of the rediscoveries are put on view.

In the case of our exhibition of Salon paintings from Southern collections, the pleasant surprise is enhanced by the obscurity in which so many of these pictures had languished. Fashion had so discredited these works that many were literally out of sight for years. That they can now be enjoyed again without embarrassment is a credit to those art historians who refused to be intimidated by the dogmas of taste.

Much work has gone into this exhibition, both in terms of research and in the search for good works of art which had been hidden from view. Our curator of European art, Eric Zafran, pursued this material with the excited determination of an explorer. His efforts have produced an exhibition of great appeal; it sheds light on a little known phase of art history and American collecting.

I join Dr. Zafran in his expressions of appreciation to the many individuals and institutions who made this exhibition possible, most especially to the lenders listed on page 4, and to our colleagues in Norfolk, Raleigh, and Sarasota, who will present this show in their institutions. We are greatly indebted to the National Endowment of the Arts and Equifax Inc. of Atlanta for their enlightened financial support.

Gudmund Vigtel
Director
The High Museum of Art

THE GLORY AND DECLINE OF A GREAT INSTITUTION

Gerald M. Ackerman

The Salon—a large, almost annual exhibition of contemporary painting in Paris—lasted as an institution from the mid-eighteenth into the twentieth century. Through most of this period, the Salon played a dominant role not just in Parisian and French artistic circles but in the artistic life of the whole western world.

The selections in this exhibition come from a fifty-year period (from 1848 to 1898) during which the Salon was at the peak of its importance in popularity, influence and magnitude. By the end of this period, it had declined to relative unimportance. During these fifty years, the French government changed its form five times, but the Salon continued, suffering interruptions in its schedule only from wars and revolutions. The Salon was a symbol of the French government's support of the arts.

The Salons themselves escape our powers of imagination. They were vast: thousands of pictures covered the walls of high exhibition halls, whole populations of sculpture stood on stands and tables (fig. 1). The *livrets* or catalogues published for each Salon contain thousands of names we no longer know, and the titles of thousands of pictures which have disappeared.

Each year the Salon brought thousands of visitors to Paris: tourists, art lovers and collectors, critics and dealers from all over the continent and from as far away as Russia and America. Nowhere else could they see such a large survey of contemporary art. We must remember the love of the citizens of the nineteenth century for artistic events of mammoth proportions: we have only to think of the concerts with double orchestras and choruses of a thousand that were so popular all over the continent, and of the panoramas—paintings which surrounded the viewer. And of course we must not forget the popular world's fairs or *expositions universelles* held in Paris in the years 1855, 1867, 1878, 1886, and 1900. The art exhibitions of these fairs were usually on an ambitious scale. Sometimes the Salon for that year was included among the exhibits; at other times there were retrospectives of famous French artists. Committees of artists from other countries were invited to put together surveys of contemporary art from their homelands.

The Salon was praised by foreign visitors and critics. An English critic, P. G. Hamerton, thought that the Salon of 1863 was "almost a perfect ideal of all that an exhibition should be," and he described with cold humor the immensity of the exhibition:

The reader has probably visited the *Palais de l'Industrie*. He who has, will remember well the arched entrance that looks to the drive in the Champs-Elysées. Entering there the visitors find themselves at the foot of a magnificent staircase of white stone, on ascending which they arrive at the exhibition of pictures, which is on the upper floor, and extends the whole length of the building in an uninterrupted line of rooms with tent-like ceilings of white canvas to subdue the glare from the glass roof. There are three large halls, one in the middle and one at each end of the building, with a double line of lower rooms between. The halls at the two ends open upon two other magnificent stone staircases, where the wearied spectator may refresh himself with brioches and babas, and Malaga and Xeres to his liking. A plan much to be recommended is to eat a baba and drink a glass of Malaga at one end, then to march steadily to the other, and repeat the dose. You then descend, at the eastern end of the building, into the garden which occupies the whole of the immense nave, and there, under the broad glass roof, you see a great

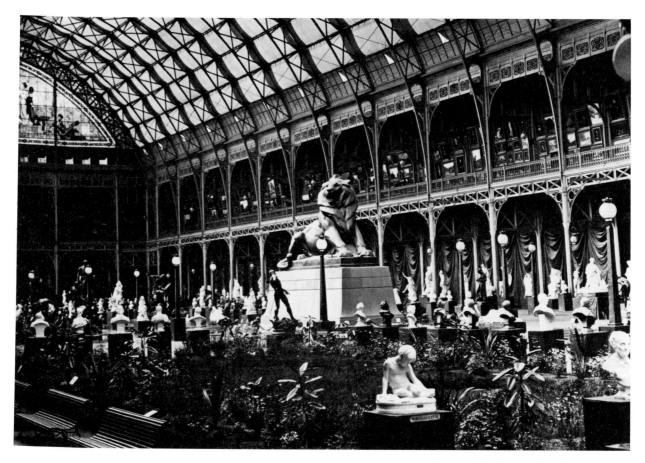

Fig. 1. The Salon of 1880.
Photo courtesy Musée d'Orsay, Paris.

number of statues, each sufficiently isolated from the rest to admit of perfect examination. After looking at the statues, the majority of spectators stop at the restaurant there established, and eat galantine and drink wine and even hot coffee, and the gentlemen buy cigars and so refresh themselves.[1]

He forgets to mention that there were thirty rooms of paintings.

The crowds of visitors were large, too; 50,000 would show up on some mid-century Sunday afternoons, and overall attendance of half a million was not extraordinary. But we should not think that all of Paris was mad for contemporary art; Theodore Zelder notes that the art exhibition of the World's Fair of 1878, which was in a separate building, was entered by only a quarter of the visitors.[2]

Descriptions like Hamerton's, statistics of the number of works and numbers of visitors, and old photographs of the exhibition rooms (fig. 2) still leave the Salons beyond our imaginations. We can never reconstruct that experience, of 30 large rooms with four rows of new paintings hung one above the other.

Nonetheless, we all have opinions about the Salon. Most of us think of it as a pompous, reactionary, official institution pledged to the protection of mediocre, insincere artists and bad art, an institution that egged artists into painting patriotic machines and rejected the works of good or sincere artists. We have heard more about the pictures and artists excluded from various Salons than of those included. This is what Bruno Foucart describes as the "negative history" of the Salons.

9

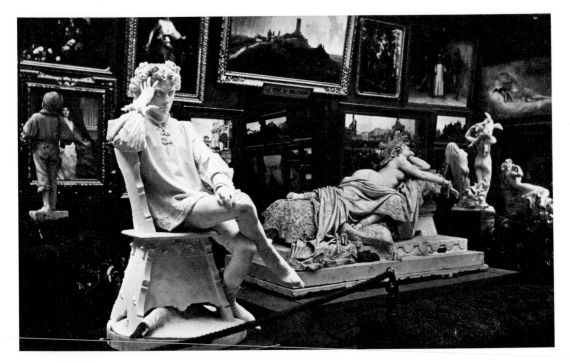

Fig. 2. Exposition Universelle of 1878.

THE EXCITEMENT OF THE SALON

"The painting exhibit," a French critic wrote in 1844, "is the main event of the year. It is talked about for two months in advance, two months of feverish impatience. . . ."[3]

The rules for each Salon were published in advance of the date for submission of pictures; artists hurried to finish the works they wished to show while they cursed or approved of the new rules. The election or selection of the jury and the hanging committee were also talked about; as the jury made its decisions, leaks filled the city with rumors. The conduct of the jury was commented upon by everyone in the know: its severity or laxity, who was the real power, who was weak and made concessions, who missed the most sessions, and so on.

Once the Salon opened and one could see what works had been accepted, new discussions started. The reviews of the critics began to appear in the daily papers, and continued from issue to issue, describing and criticizing different works each day, keeping up the curiosity of the public. People returned to the Salon to see works they had missed which certain critics had praised. Poorly hung pictures were rehung

under pressure. Letters of complaint were written to the Ministry, to the papers. The artists returned day after day, to look at their works on the wall, to hear the comments of the crowds, and to visit and mix with other artists (fig. 3). And when it was all over, the prize ceremony was another event to be marveled at. During the Second Empire, the Emperor Napoleon III himself handed out the awards in the *Grand Salon* of the Louvre.

HOW IT CAME TO BE

The first Salon in 1699 was an exhibition of works by artists who were members of the Royal Academy, a group of painters who admitted each other to the society according to certain rules of qualification. There was not a second one until 1725, held in the *Grand Salon* (now called the *Salon Carée*) of the Louvre. The room gave its name to the exhibitions, which were held, thereafter, almost every year.

The exhibitions continued to be exclusively for academicians throughout the eighteenth century, until they were opened by the Revolution to all artists, French and foreign. The first Salon of the Revolution, in 1791, was

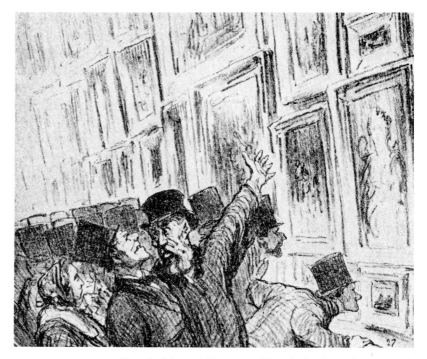

Fig. 3. Honoré Daumier, *"Just look where they've stuck my picture!"*, lithograph from *Le Charivari*, 1859.

without awards or jury. It was consequently very large and so uneven in quality that it was thought best to form a jury for the next Salon, in 1793. That same year the Academy was disbanded. Soon after, the Institute of France was formed, a large institution comprising in several divisions what had been the Academies of music, philosophy, literature, fine arts, and the sciences. The Fine Arts section was the Fourth Division. This division had new rules for the academicians, who were now appointed to a limited number of chairs by the government, instead of being elected into an unlimited group by the members of the group. The control of the Salon and of the Ecole des Beaux-Arts was retained by the artists in the Fourth Division.

With modifications, the arrangement remained the same for over half a century; the fine arts section eventually came to be called the Academy of Fine Arts. The academicians were often professors at the Ecole des Beaux-Arts as well as members of the Institute.

Throughout this time almost all successful artists exhibited at the Salon. The most successful received prizes and distinctions that eventually led to their becoming members of the Academy.

NINETEENTH CENTURY REFORMS

In the period of our exhibition (1848 to 1898), there were two major reforms of the art establishment, each designed to separate the Ecole des Beaux-Arts and the Salon from the control of the academicians. In 1863, the Ecole and the Salon were put under the administration of the Ministry of Public Education, with the intention of isolating the exhibition from the Institute and the Ecole. This separation was only theoretical, for despite the constant changing of the rules for the selection of the jury it was still formed for the most part of members of the two institutions.

Under the Third Republic, in 1880, an even greater separation was made: the administration of the Salon was taken away from the Ministry of Public Education and the Director of Fine Arts and given to a specially-formed society which elected its own juries. Even though many of the favorite painters of the old guard were still elected as jurors, the jury was fairly representative of most of the schools of

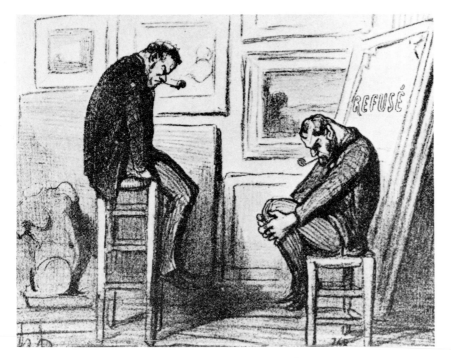

Fig. 4. Honoré Daumier, *Artist's studio several days after the opening of the exhibition,* from *Le Charivari,* 1855.

painting active in France at the time. Generations overlapped in the Salon and on the jury: Neo-classicists, fossils from the beginning of the century; Romantics from the thirties and forties; Realists, in many varieties, from the fifties and sixties; and finally, in the eighties, Symbolists or Aesthetes. As a result, the Neoclassicist Charles Gleyre lived long enough to vote against the paintings of the Symbolist Gustave Moreau.

WHY IT WAS IMPORTANT TO ARTISTS

Most artists did not dream of prizes; they simply wanted to have their works in the Salon. There were thousands of painters—portrait painters, landscapists, decorators, painters of still lifes—who worked on the periphery of "high art." Their only exposure to the public (and it was an enormous public) was at the Salon. Their addresses were listed along with their names in the catalogues, so prospective customers who liked their work could seek them out. The public trusted painters who had had works accepted by the Salon, and disdained those who had been rejected. (An oft-repeated story demonstrates the attitude of the public:

the landscapist Jongkind had sold a painting just before the jury rejected it, and the buyer asked for a refund.) Rejected works were for a long time stamped on the stretcher with a large disheartening *refusé* or an *R* (fig. 4) which made them hard to sell unless the stamped stretcher bar were replaced.

There was another reward besides an official medal: the State often purchased works from the Salons; under Napoleon the III the money from the entry fees—which were started in 1851—was used for this purpose. Works thought to be important were kept for the Luxembourg Museum (fig. 5), others were dispersed throughout provincial museums and governmental offices.

HOW THE SALON FUNCTIONED

One of the most interesting things about the Salon as an institution was that it was so poorly defined in many aspects. First, it did not have a real home. At the beginning of the century, the Salon was regularly held in the Louvre, but repairs and redecorating often moved it to the Tuileries. At other times it was in the courtyard of the Palais Royale, and once in the set

republican Undersecretary of Fine Arts Turquet tried to dominate a jury which he thought smacked too much of the old regime. He fought the jury, harangued it, and circumvented its decisions by hanging rejected pictures, usually on political themes. In 1880 the jury revolted and no prizes were awarded.[5]

Artists with strong personalities could also manipulate the jury; for, as in any such *ad hoc* organization, power lies waiting for the enterprising to use. From 1835 to 1848 the landscapist Théodore Rousseau had his works kept out of the Salon by one member of the jury, a respected Neo-classical landscape painter Joseph-Xavier Bidault, who was for a time the president of the Academy. The opposition of Bidault was an open scandal, and was rectified in the Salon of 1849. Delacroix, too, had an active enemy on the jury, another painter who had received many commissions for decorative paintings from the State, Joseph Blondel.

The year 1869 was a rough one for avantgarde painters. A group of young Realists, followers of Manet who would later be known as the Impressionists, had had most of their pictures rejected by a very severe jury. Even their hero, the already-recognized Manet, had had one of his entries rejected, and Renoir, Sisley, Cézanne and Monet saw every one of their paintings turned down. Frédéric Bazille, who got one picture through the jury, wrote to his father that the rejections were all due to one person:

> The fault lies entirely with M. Gérôme, who treated us like a band of mad men saying that it was his duty to do all he can to stop our works from appearing.[6]

Gérôme's animosity was either short-lived or rendered ineffective by his colleagues, for after this one setback, Bazille and his friends (except Renoir) had works accepted to the next Salon.

Or perhaps Gérôme just skipped his jury duty the next year. Absenteeism was a big problem:

not everyone elected or appointed to the jury attended the sessions. In 1861, twelve of the thirty-four members of the Fourth Division of the Institute did not show up for jury duty. Six of the absentees were painters of note: Vernet, Ingres, Pujol, Schnetz, Delacroix, and Coudre, so that the selection was made by a jury in which eight painters were outnumbered by seven sculptors, three engravers and seven amateurs. The Neo-classicist Picot was the bully on this jury, and he talked through most of the works he liked.[7] As noted before, this was the jury that rejected so many works that it engendered another reform.

The reluctance of artists to work on the jury was well-known. Chennevières, Director of Fine Arts through most of the Second Empire and for most of the first decade of the Third Republic, discussed the problem in his memoirs:

> Some of the most considerable artists by resigning get out of an honor which, coming back each year for two months, has become for them an unsupportable and ruinous forced duty. And those who accept the tasks do so not without complaints (which would have some justification) of the strain which—seeing the extra honor of being trusted by their colleagues—is difficult to turn down.[8]

When important and powerful people stayed away, it left the ambitious jurors who were present great room for political maneuvering. And many jury members did come to the sessions wishing to protect their students, or to champion certain artists or schools. Very like our congressmen, they would coax the votes of their fellow members, extract and make promises, and trade votes. The vote-trading became so complicated that the jurors had to keep notes.

Out of the developed etiquette of the jury, an extraordinary custom evolved: a single juror could get one rejected work in on his own vote,

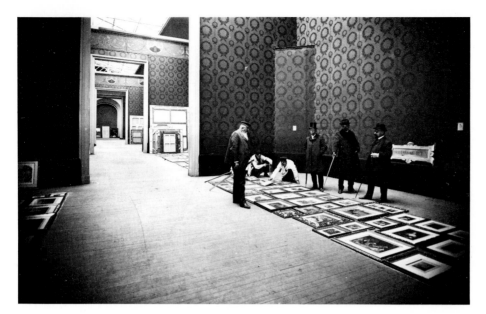

Fig. 6. Judging at the Salon of 1903.

pleading *charité*.[9] All that happened in the jury was supposed to be confidential. Artists were not supposed to know if their works had been accepted or not until the first day of the Salon, but as we know from the comments of Bazille and others, leaks were common and often very specific.

JUDGING THE ENTRIES

Two months before the opening of the Salon, the jurors met in the exhibition halls. Through the efforts of a large staff of guards, the pictures were set out by sizes so that they could easily be seen. Medium-sized works were arranged on the floor (fig. 6), and the jury would crowd around as the president pointed out one picture after another. They were held back by a portable line supported by two guards. The president carried a little bell which he would ring for the vote. In response, arms and umbrellas would go up or down (fig. 7). The guards would quickly sort out the pictures, moving the rejected works out of the hall. Smaller pictures were shown one by one on an easel; the jurors could sit through this process as the guards changed the works. Larger paintings would be leaned against the walls, and the jury would move through the rooms to inspect and vote on them. One can read an apparently well-informed and exciting account of the process by Zola.[10]

The jurors worked their way quickly through the thousands of entries. Sometimes they found that in their haste they had turned down works by well-known colleagues—even ones exempt from being juried—whose signatures were illegible or hard to find. Mistakes of this sort were redressed quietly. If the jury had been too severe and had not accepted enough works, they would go through the process a second time, selecting more works from those previously rejected. It was then that the *charité* vote was usually exercised. The selection process took weeks and no one was ever satisfied with all the results. One jury would be lenient, and get criticized for the large size and the low quality of the exhibition. The next jury would in reaction be strict, and get criticized for its severity.

THE PRIZES AND AWARDS

The jury chose the prize winners too, after it had selected the works for exhibition. Normally there were first, second, and third class medals. Later these were augmented by the Medal of Honor and later still the Grand Medal of Honor. From 1864 to 1872 the classes were abolished, and only one kind of medal was given. The jury might also make recommendations to the administrators for appointments or advancements in the Legion of Honor. Beginning in 1874, the jury also chose

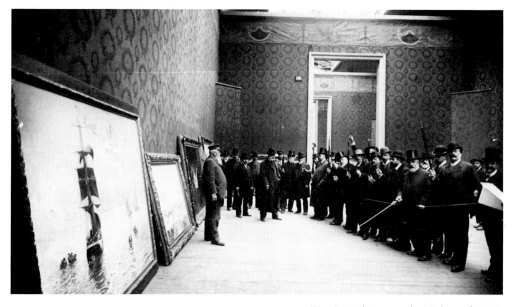

Fig. 7. Judging at the Salon of 1903.

the winner of the Prix du Salon, which, like the Prix de Rome awarded by the Ecole des Beaux-Arts, gave the winner a three-year scholarship at the French Academy in Rome. During most of the nineteenth century, the number of medals and awards varied from 21 to 40—not very many considering that almost two thousand artists competed. After 1880, the number was upped to 85, still not generous.

Again we can imagine vote-trading of a very political nature taking place while the winners were selected, as well as bullying from the administrators on the staff. In 1865 the final decision for the Grand Medal of Honor had to be made between a landscape by Corot and a portrait of the Emperor by Cabanel. The pressure on the jurors must have been tremendous. The portrait of the Emperor won after the twenty-sixth walk-through.

THE SALON DES REFUSES

One of the most famous results of the Salons was the *Salon des Refusés,* the Salon of Rejected Works. It was an intermittant phenomenon; the best known was that of 1863. The jury that year had been extremely severe. The Emperor himself, hearing the rumors, visited the exhibition rooms while the accepted pictures were being hung. According to Chennevières, who was on the hanging committee, the Emperor asked to be shown the rejected works.

Taken to the storage, he fanned through a stack that was leaning against a wall, catching the frames against his knee. Seeing that they were not much different from the accepted works, he ordered that they be shown in a *Salon des Refusés* appended to the official Salon. Extra rooms in the Palace of Industry were opened and decorated; and all the artists of the rejected paintings were invited to show their paintings there. Many of them did not want to participate in an unjuried show, and over a hundred works were withdrawn. The exhibition had its own catalogue, and was set up with the same dignity as the official Salon. It was in this *Salon des Refusés* that Manet's famous *Déjeuner sur l'Herbe* and Whistler's *The White Girl* were shown.[11] The *Salon des Refusés* continued for several years, but died out from lack of interest. It was revived a couple of times afterwards, when juries were thought to have been too severe.

THE HANGING COMMITTEE

How the pictures were hung was of utmost importance. The hanging was done by an appointed committee under the Director of Fine Arts. Throughout most of the Second Empire and the beginning of the Third Republic, the Director was the Comte de Chennevières. In his memoirs he decribes the long sessions, which lasted from early in the morning until

late at night, as he and his comrades (painters and administrators) decided where and how the pictures were to be hung. Each night they went home, exhausted, headachy, and cranky. During the afternoon the committee took a half-hour break for refreshments; Chennevières, however, would have to leave his colleagues to listen to the importunings of artists and friends of artists who wanted certain pictures to be given favored positions.[12]

Many problems of placement were obviated by the 1861 decision to arrange the works alphabetically. Before, the pictures had been divided into various groups, sometimes by genre; at other times, non-juried and juried works had been hung separately. The best position was "on the line"—that is, at the bottom, just above the dados—but pictures were hung all the way up under the glare of the skylights (fig. 8). Small pictures could simply not be seen if they were hung high.

Once the Salon had opened, the Comte de Chennevières had more problems: artists dissatisfied with the hangings would harass him in person and by letter. At the Salon of 1857, a painter from Strasbourg, Théophile Schuler, not liking the lighting and location of his history painting, wrote requesting that his picture be rehung lower and in better light. His letter was followed by others from Delacroix and Gavarni, seconding the request. "Do you think," Chennevières asks helplessly, "that it was easy for a poor Curator of Exhibitions to resist petitions like that?"[13]

OPEN TO THE PUBLIC

In the early days of the Salon, artists had come into the exhibition the day before it opened to touch up and varnish their paintings; they often brought friends with them; and soon critics and notables managed to be there too. To this day an opening in France is called a *vernissage* after the word for "varnish," *vernisse*.

The actual varnishing of the pictures just before the opening became a lost tradition very

early, but a visit to the Salon the day before the doors were open to the general public remained a privileged social event. It was more-or-less exclusive, depending upon the democratic inclinations of the administration at the time. Even so, there were always great crowds for the *vernissage*. (See Tissot, no. 63, p. 163.) After the Salon opened for the public, admission prices varied: certain hours cost five francs, others one franc, and there was usually one free day a week.

THE CRITICS

The critics, or *salonniers* as they came to be known, were a great part of the Salon tradition. As many as 30 or 40 would write reviews (which came to be called "salons") that were serialized in magazines, in the newspapers, (*en feuilleton,* at the bottom of the page). The newspaper articles of the more influential newspaper critics were gathered as quickly as possible in books to be sold as guides while the Salon was still on. Other critics wrote books especially for the Salon visitors. Most of the reviewers simply supported the accepted attitudes towards the paintings, giving the longest passages to the larger history paintings or allegories in each Salon. Genre, portraits, nudes and landscapes not only dominated the Salons, but increased in proportion from year to year. Smart critics noted this trend early.

Théophile Gautier was the most redoubtable of the critics. For more than thirty years he provided reliable commentary based upon enthusiastic observation of the art life of Paris. He visited artists' studios ahead of time to see what was going to be entered, and discussed the entries with them; he returned after the opening to look at works turned down. Toward the end of his long career (he wrote Salon reviews from 1832 to 1870), he became a bit sloppy; members of his family visited the Salons for him and provided descriptions which he rewrote. However, the breadth of his taste, the warmth of his enthusiasm, his sympathy for the intentions of

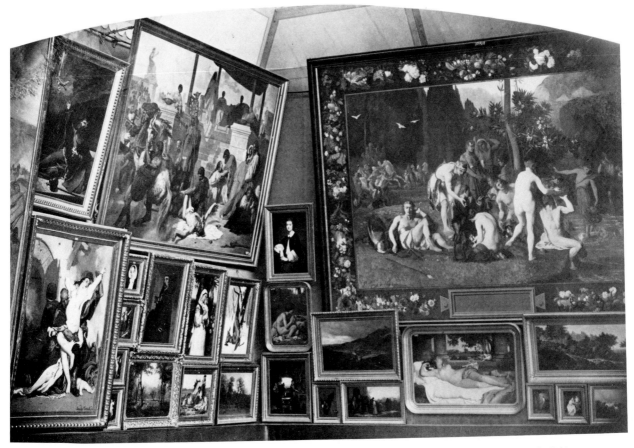

Fig. 8. The Salon of 1861.
Photo courtesy Musée d'Orsay, Paris.

the artists, and his extraordinary literary skill—like John Ruskin, he could describe anything—made his work popular, and thus influential. These qualities make his salons a pleasure to read to this day. His principle weakness was a vague theoretical foundation.

On the other hand, the Salon reviews of the next great critic, Charles Baudelaire, had a brilliant theoretical basis. Baudelaire was more exclusive in his appreciation of artists, less broad in the range of schools appreciated, and more biased in judgement. His salons are collections of little essays on various topics suggested by the exhibitions.[14]

After Gautier and Baudelaire, the best guide to the Salons is Emile Zola, the novelist, who wrote salons off and on throughout his life, some for Parisian papers, and some for a Russian journal.[15] Zola came into criticism with some old-fashioned ideas; he wanted to defend

Realists with a Romantic theory developed in his youth: art was based on the character of the artist, not on objectivity. From this point of view he championed a small, daring group of artists, Manet and his followers, the Impressionists. He attacked the older established painters with wit and energy, portraying them not simply as old-fashioned, but as bad, insincere artists, enemies of all originality—a characterization which has stuck. His reviews, like Baudelaire's, include short essays on aesthetic topics. He also editorialized about the administration of the Salons, and often suggested reasonable reforms.

Besides this gifted trio, there were so many other critics that they formed a union in 1899. Some were professional critics who reviewed the Salons year after year, and some were fly-by-night free-lancers who wrote an occasional Salon for quick money, or for some political

19

reason. They were not all hacks, but most of them were, and reading them can be dreary. Their salons are foils to the criticism of Gautier, Baudelaire, and Zola.

WHAT WENT WRONG?

Gradually, throughout the nineteenth century, the Salon outgrew the intentions of its founders. It could no longer serve the needs of either the government, or the artists, or the public. Attempts to modify and update the system sometimes backfired. Reforms that were supposed to weaken the power of the academicians on the jury often had the opposite effect. Most of the changes were made in good faith, in hope of improvements: better rules for better juries, better juries for better shows. Indeed, toward the end of the century, even the old Salon-fighter Zola was congratulating the administration for its hard, unappreciated work.[16]

The underlying and unsuspected problem was a change in the market for art.[17] During the fifteenth and sixteenth centuries, under the guild system, artists had kept shops with street displays where they sold their own works. Some former artists had gradually turned into full-time dealers. Under the Academy statutes of 1848, academicians could only sell their works under contract from their own studios; they were not to keep shops or have public displays of their stocks. The academicians of the seventeenth and eighteenth centuries were a small group with a limited patronage. They had to sell their works to the crown or the aristocracy. The first Salons were designed to show their skills to precisely these patrons.

But by the mid-eighteenth century, the Salons had already become a popular event. Among the new regulars at the Salons were members of the ever-increasing, ever-richer bourgeoisie. They bought pictures too, some of them were sincere lovers of art, collectors seeking the prestige of ownership, and investors.

The number of painters grew with the number of buyers. By the middle of the nineteenth century there were at least 4000 painters in France.[18] They produced so many pictures that the state alone could not absorb them; only the middle class could. The new middle class art patrons were seldom interested in grandiose theories of art or works produced to demonstrate them. They preferred genre pictures to histories; and if they bought histories, the subjects were anecdotes about the famous, rather than depictions of heroic deeds. The other "house pictures" they bought included still lifes, landscapes, animal pictures, and, of course, portraits. These types of paintings dominated the Salon from the 1840s on. Later on in the century, as the bourgeoise taste became more sophisticated, the nude, an academic specialty, became acceptable and popular, too. These nudes were usually more or less erotic, with little in the way of literary or historical allusion.

The artists of these "lower" genres wanted yearly Salons without a limit on the number of entries. Every time the administration tried to limit the number of Salons or the number of works shown, the mass of artists protested through the press, through petitions, and through personal pressure on government officials. As the "lower genres" increased their number from year to year, the Salon was slowly transformed from an institution glorifying art in the service of God and the ruler into a market place displaying wares for sale.

Academic art theory, formulated during the Italian Renaissance, had justified painting as an art that instilled piety and inspired patriotism. The academic curriculum, developed to implement the goals established by the Renaissance theorists, had trained artists for the production of history paintings, thought the most suitable for glorifying church and state. The ideals of academic art theory and the artistic needs of the state coincided perfectly, and that is why the state supported the academic system, and the Salons, for so long. The academic training in figure drawing, in archaeological accuracy, perspective backgrounds, as

well as the study of classical and biblical literature, had all aimed at the eventual production of history paintings.

The first academicians, when initiating their colleagues into the Academy, had respected this hierarchy by reserving the official title of History Painter for only the greatest talents among their ranks. The lesser titles—Genre Painter, Portraitist, Landscapist, etc.—were given to artists of limited abilities.

As the public began to favor the lower genres of painting, the art world seemed schizophrenic: lip-service was paid to the grander genres, prizes and awards were given to them, but the public bought the lesser genres. It was not uncommon for an important painter to die with his prize-winning canvases still in his studio, unsold.

The old guilds, which had included all artists, had been able to control the whole market. The guild could actually guarantee careers for those it protected by simply keeping competition out of the local market. The Academy, because it did not admit commercial painters (portraitists, decorators, and hacks) could not control them. In the nineteenth century these groups grew tremendously, and their demand to be exhibited in the Salons changed its nature. The system of awards and honors could protect the careers of only a few favored painters, those whose production fit the needs of the government.

The prestige and importance of the Salon kept sinking. By 1896 its reputation was so low that a special edition of the Parisian *Grand journal* suggested it be abolished. The issue was entitled "Down with the Salons." It included long interviews with important artists. The institution was staunchly defended by the old guard, but treated with indifference or contempt by younger artists.[19]

PUTTING THE ARTISTS IN CHARGE

The administration of the Salons was always on the defensive. Its complicated goal was to have the exhibition run by the artists without changing its theoretical background and yet, at the same time, to keep the selection of paintings representative of contemporary French schools. The official administration alternated between giving recognized artists control of the jury, and restricting that control. While wanting to influence the policy of the Salons, the administration also wanted to have the responsibility for the decisions of the jury taken off its back.

In 1880, after a decade of turbulent republican control, the government finally got rid of all responsibility for the Salon by turning the administration over to an independent society of artists formed for the purpose of running the Salons, the *Société des artistes françaises*, open to all participants of earlier Salons. So the state got rid of a hot potato, or maybe it was a cold potato. Ironically, it was precisely at this time that the Salon began to lose its prestige. It had been argued that government interference had been ruining the Salons. Now it seemed that it might have been the governmental control that had given the Salon its format and style. Despite the attraction of the idea of a Salon run by independent artists, the official status of the earlier Salon had been its distinguishing feature.

The pressures of the market had changed the situation. Artists needed steady sales, not yearly awards or commissions. Painters who could not win state commissions, and who could not expect them—the mass of portrait painters, landscapists and genre painters—needed another system of art distribution. From the mid-nineteenth century on we can see the development of art dealers and independent exhibitions.

DEALERS

A few dealers had always existed in Paris, but they were akin to antique dealers. However, in 1835 Louis Martinet established galleries on the *Rue des Italiens* and began to show contemporary works. In 1860, a year when there was no Salon, he gave an Ingres retrospective. The

pictures in his galleries changed steadily, so that it was said that one had to visit it at least once a month to keep up. His gallery closed in 1866, but a few other dealers had shared the market with him, Susse on the *Place de la Bourse* since 1835, and galleries in some of the large department stores. By 1847 the print-making firm of *Goupil et Cie* was selling contemporary paintings which it displayed in its shops. Usually they were works by the same popular artists which the firm reproduced in prints.

By the time of the last Impressionist Exhibition in 1884, there were several independent dealers willing to show artists of the group. Indeed, it was probably the development of the dealer system which made further group shows unnecessary. Dealers could offer many advantages. They could give one-man shows with exclusive publicity; and they could make an artist famous, as the Belgian dealer Gambart had done with Rosa Bonheur. Some dealers would even support an artist when his sales were low.

By emphasizing the artist, the dealer changed the habits of art collectors: they no longer bought a Salon piece or an award-winner, they bought a Meissonier or a Monet. The 1880s and the 1890s produced the great dealers whose names we all know: Vollard, Durand-Ruel, and Georges Petit.

ALTERNATIVE EXHIBITIONS

In France the government long maintained a tradition of dominating exhibitions, but in less-centralized countries, societies of artists ran even the largest exhibitions. The *Società promotice dei belli arti* in Italy and the many *Künstlerverein* in Germany were such groups. There were so many independently sponsored exhibitions in London that some critics as early as 1850 questioned the necessity of the annual Royal Academy Exhibition.[20] Similar societies started in France, becoming quite numerous by the end of the nineteenth century. They held exhibitions too, of various sizes, as did some charity organizations. The Union of French Artists, the Society of Young Artists, The Society of Women Painters and Sculptors (founded in 1881), *Le Cercle de l'Union artistique* (commonly called *Les Mirlitons*), and the Society of Orientalists were all groups whose small exhibitions competed with the Salons.

These were supplemented in the last quarter of the century by exhibitions organized by small groups of artists to show their works together. The most famous are those of the Impressionists, which started in 1874 and lasted into the 1880s. They were followed by group exhibitions of the Synthesists and the Rosicrucians. The independent group exhibitions were good starting places for young artists; in smaller shows, their works were more likely to attract the attention of the public and the critics. Furthermore, the works of various artists of a group helped to explain each other, and each artist got to show many more works than he would have at the Salon, without submitting them to a jury. However, it was hard to keep group identity as artists matured and changed; the groups were often short-lived.

Mary Stranahan reported 64 exhibitions in Paris in 1887. She explained, "An exhibition is the popular method of reducing the wrong done to an artist in the Salon, of commemorating his death, of supplying funds for the victim of an innundation, of establishing a hospital or of raising a statue to a hero."[21]

Towards the end of the century, two new salons challenged the traditional Salon. In 1884 the City of Paris organized the first *Salon des Artistes Indépendants*, without jury or awards. The exhibition had over a thousand works, so it was a true rival in size. The debuts of most new movements—the Symbolists, and the Cubists, for instance—took place in the Independent Salons after this.

The traditional Salon suffered even more in prestige when a temperamental storm among its own members ended in the secession of a large group of artists who set up a rival society with a rival exhibition of its own. The first *Salon de la Société nationale des Beaux-Arts* was in 1889. The members and exhibitors included

Meissonier (the president), Puvis de Chavannes, Besnard, Carrière, Roll, Rodin, Stevens, Sargent, Boldini, and Bracquemond. Despite the prestige of the founders, this rival Salon did not become very important, perhaps because it was so conservative and not very different from the regular Salon. The younger artists of the avant-garde separated themselves from both groups; they showed separately in many small groups shows.

By the end of the century, the Salon had simply become lost among the many exhibitions in Paris. By losing its connection to the state, by dropping its commitment to the grand manner of painting, and by catering to the bourgeoise market of the late nineteenth century, the Salon had lost the intellectual interest and excitement that had belonged to it as an official exhibition, where styles and schools had overlapped, co-existed and competed with one another. The tension and the sense of continuity, which had characterized the Salon for centuries, were lost.

[1] P. G. Hamerton, "Painting in France. The Salon of 1863," *The Fine Arts*, 1863, pp. 232f. We should temper the enthusiasm of this review with the less appreciative description of the same Salon in chapter 10 of Emile Zola's novel, *L'Oeuvre*, (The Masterpiece), 1886.
[2] Theodore Zelder, *France, 1848-1950*, vol. 2, New York, 1978, p. 445.
[3] Jules Janin, *L'Eté à Paris*, 1844, p. 148.
[4] Emile Zola, *Salons*, Paris, 1959, pp. 50-51.
[5] Phillipe de Chennevières, *Souvenirs d'un Directeur des Beaux-Arts*, Paris, IV, pp. 98-106.
[6] Art Institute, *Frédéric Bazille and Early Impressionism*, Chicago, 1978, p. 179.
[7] Henri Fouquier, *L'Art officiel et la Liberté*, Paris, 1861, cited by Tabarant, p. 276.
[8] Chennevières, IV, p. 93.
[9] Cézanne, who submitted works regularly, was admitted to only one Salon, in 1882, by the *charité* vote of his friend Guillemet.
[10] Zola, *The Masterpiece*, chapter 10.
[11] For a good if partisan description of this *Salon des Refusés* see chapter five of Zola's *The Masterpiece*.
[12] Chennevières, I, p. 37.
[13] Ibid., I, p. 38.
[14] *Art in Paris, 1845-1862*, London, 1965.
[15] Zola, *Salons*, Paris, 1859.
[16] Ibid., pp. 233ff.
[17] Harrison C. White and Cynthia A. White, *Canvases and Careers*, New York, 1961, *passim*.
[18] Ibid., pp. 44-54.
[19] See the excerpts (interviews with Gérôme, B. Constant, Rafaelli, and Renoir) in *Equivoques*, Musée des Arts Décoratifs, Paris, 1973, pp. 21-22.
[20] See Holt, 1981, p. 31. Although the Royal Academy was an independent institution, its annual exhibitions were very prestigious and equivalent—on a smaller scale—to the French Salon.
[21] Stranahan, *History of French Painting*, New York, 1888, p. 474.

SELECTED BIBLIOGRAPHY

Akademie der Künste. *Le Salon Imaginaire.* Berlin: 1968.

Art Institute of Chicago. *Frédéric Bazille and Early Impressionism.* Chicago: 1978.

Crespelle, J. P. *La belle Epoque.* Paris: 1966.

de Chennevières, Phillipe. *Souvenirs d'un Directeur des Beaux-Arts.* Paris: 1979.

Foucart, Bruno. "Salons." *Encyclopedia universalis*, vol. 14. Paris: 1975, pp. 640-642.

Hauser, Arnold. *The Social History of Art.* London: 1951.

Holt, Elizabeth. *Triumph of Art for the Public.* Garden City, New Jersey: 1979.

Holt, Elizabeth. *The Art of All Nations.* Garden City, New Jersey: 1981.

Letheve, Jacques. *La vie quotidienne des artistes françaises dans le 19ieme siècle.* Paris: 1968.

Musée des Arts Décoratifs. *Equivoques.* Paris: 1973.

Philadelphia Museum of Art. *The Second Empire: Art in France under Napoleon III.* Philadelphia: 1978.

Sloan, J. C. *French Art between the Past and the Present.* Princeton, New Jersey: 1950.

Stranahan, Mary. *The History of French Painting.* New York: 1888.

Tabarant, A. *La vie artistique au temps de Baudelaire.* Paris: 1942, 1963.

White, H. C., and White, A. *Canvases and Careers.* New York; 1965.

Zelder, Theodore. *France 1848-1945.* New York: 1978.

FRENCH SALON PAINTINGS
FROM SOUTHERN COLLECTIONS

Eric M. Zafran

When Edward Strahan published his monumental three-volume *Art Treasures in American Collections* in 1881, he mentioned only three cities in the southern part of the United States: Baltimore, Washington, and Louisville. Today, as this exhibition demonstrates, the situation is completely different. In the course of the intervening century, there has been a shift in the pattern of American collecting.

Most of the "treasures" that Strahan recorded were nineteenth century French academic works—Salon paintings of impressive size and dramatic content. These works, with their elaborate frames, demanded placement in luxurious settings. They appealed to affluent Americans, the tycoons who were constructing huge mansions with art galleries to be filled with the best that money could buy. Strahan's book is largely a record of this grandiose taste and this exhibition includes works that belonged to some of the major late nineteenth century collectors—Vanderbilt (fig. 9), Astor, Mills, Johnston, Stewart, and Belmont.

That paintings from famous Northeast collections are now in the South is the result of a dramatic change in taste. The rapid and near-total ascendency of the French Impressionist and Post-Impressionist school of paintings, combined perhaps with the development of photography as an art form, led to the devaluation of official or Salon painting, which was regarded as bombastic, banal, sentimental, religiose, or simply old-fashioned. A few American millionaires such as John Ringling and William Randolph Hearst continued to buy these works, but many of the more prominent collections, such as the Astor (fig. 10), were dispersed at public auction for prices that would have astonished Strahan. The nadir for

this type of art was probably reached in 1956, when the Metropolitan Museum in New York, which like most museums at that time kept these works in storage, sold a large group of paintings from what had been one of the most important nineteenth century American collections of French paintings, that of Catharine Lorillard Wolfe, bequeathed to the Metropolitan in 1887.

Several of the paintings from the Wolfe collection, including Chaplin's *Haïdée* (no. 18) were purchased by Walter P. Chrysler, Jr. While working as chief curator at the Chrysler Museum in Norfolk, I became aware of these unremarked riches of official nineteenth century French painting. In addition to the Chaplin, Norfolk is now the home of paintings such as Gleyre's *Le Bain* (no. 40) and Laurens's *Le Bas Empire: Honorius* (no. 47), which had been very famous in their time—even accorded illustrations in Strahan's book—but which over the years had lost their identity.

When I came to the High Museum, I found works by other notable nineteenth century French painters who had exhibited at the Salon—Fromentin, Decamps, and Merson. This gave rise to the idea for this exhibition: to discover, document, and publish examples in Southern collections which were—in their amazing variety of subjects and styles—characteristic of the Paris Salon in the second half of the nineteenth century. This body of work demanded to be treated with the same seriousness afforded other historical schools.

While wide-spread and self-conscious collecting of nineteenth century Salon paintings in the Southern region is a relatively recent phenomenon, there were personal collections established in the nineteenth century which

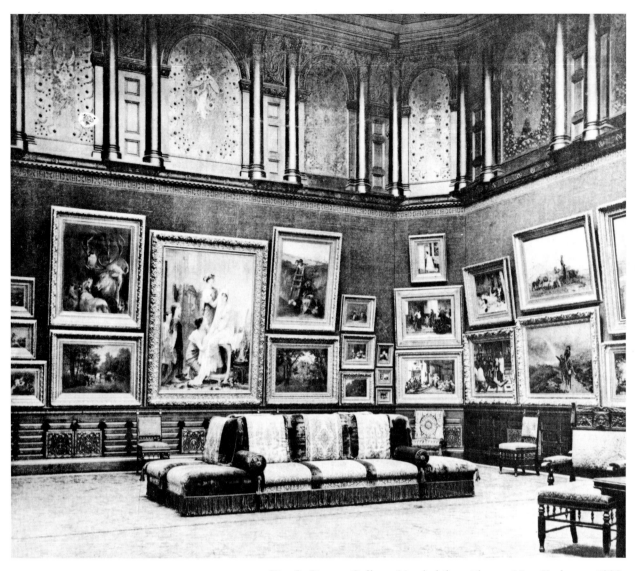

Fig. 9. Picture Gallery, Vanderbilt residence, New York, ca. 1880.

have remained intact. The most important was formed by William T. Walters, who settled in Baltimore in 1841 and developed both his business and his collection there. According to an 1892 article in the *Magazine of American History*, Walters "visited Europe frequently . . . met eminent English and continental artists, sculptors, and art critics . . . [and] aimed to inspire living artists into the production of matchless masterpieces." The collector purchased important paintings by Delaroche and de Neuville and commissioned specific works from artists such as Alma Tadema and Gérôme. After Walter's death in 1894, the collecting was continued by his son Henry and the gallery was opened to the public. In an early view of the French nineteenth century room (fig. 11), we can see that the Gérôme commissioned by Mr. Walters, *The Christian Martyrs' Last Prayer* (no. 36), is given a prominent place.

At the same time that the Walters collection was being established in Baltimore, a significant group of nineteenth century European

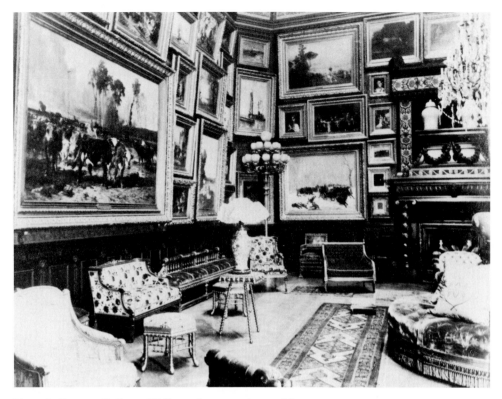

Fig. 10. Picture Gallery, William Astor residence, New York, ca. 1881. Detaille's *En retraite* (no. 24) is on back wall.

works was also being assembled in Washington by the wealthy merchant and banker William Wilson Corcoran. A special gallery was designed by the architect James Renwick, Jr. in 1859, but completion was delayed by the Civil War until 1874. In the Main Picture Gallery, one hundred and fifteen paintings were installed in the manner of that time—in several tightly-packed tiers according to no artistic classification. In 1897 the collection was moved to the present Corcoran Gallery. The original building was used by the United States Court of Claims until 1964, when it was taken over by the Smithsonian Institution and (renamed as the Renwick Gallery) once again became a gallery of art. The main gallery, now known as the Grand Salon, was reinstalled in nineteenth century fashion with works lent from the Corcoran Gallery and the European collection of the National Museum of American Art (which had comprised the original National Gallery). From this excellent recreation of a period gallery (fig. 12) we are fortunate to be able to present two characteristic

examples of French Salon taste—Adrien Moreau's *Le Bac* (no. 55, Salon of 1884) and Zamacois's *Refectory of the Trinitarians* (no. 70, Salon of 1868).

The Corcoran collection has been augmented by other donations. The most significant was the 1925 bequest of the collection of Montana Senator William A. Clark, which added a great many French nineteenth century works, especially by Corot and Cazin. (The terms of this bequest prohibit loans.) Other donations to the Corcoran include Fantin-Latour's 1896 Salon piece *La Toilette* (no. 30), which was purchased by Mrs. Edward Walker from the artist the day before he died.

While in Washington we should also mention Mrs. J. B. Henderson, who collected the works of contemporary French artists, having studied with Charles Chaplin before settling in Washington with her husband, Senator Henderson. Her portrait by Constant (no. 19) and one of her husband are now in the National Portrait Gallery, a branch of the Smithsonian Institution which has many portraits of notable

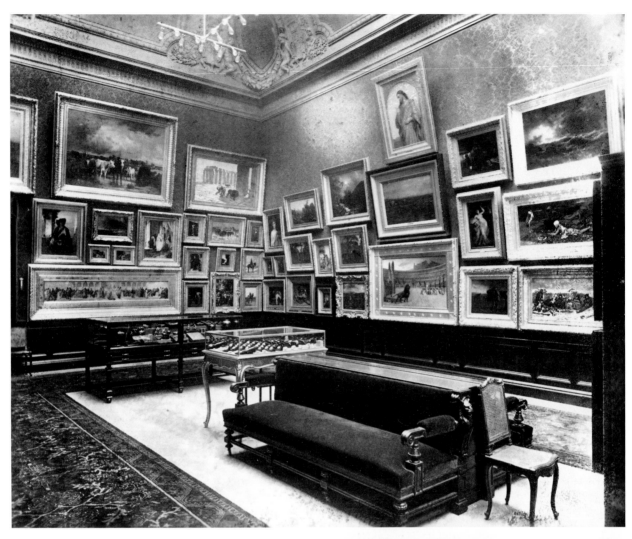

Fig. 11. The Walters Art Gallery, Baltimore, ca. 1902. At right, Gérôme's *The Christian Martyrs' Last Prayer* (no. 36). Photo courtesy The Walters Art Gallery.

Fig. 12. The Grand Salon, Renwick Gallery, Washington, D.C., ca. 1980. Photo courtesy The National Museum of American Art, Washington.

Figs. 13, 14. Emile Munier, *Portraits of Mr. and Mrs. Chapman H. Hyams*, 1889.
Photos courtesy The New Orleans Museum of Art.

Americans by other fashionable nineteenth century French artists such as Bonnat and Blanche.

In New Orleans in the later part of the nineteenth century, Mr. and Mrs. Chapman Hyams formed a small collection of contemporary French works which was donated in 1915 to the Isaac Delgado Museum (now the New Orleans Museum of Art), where it is still maintained in a special gallery. The Hyamses travelled to Europe to meet the artists whose paintings they collected, and in 1889 their portraits were painted by a Bouguereau follower, Emile Munier (figs. 13, 14). We have borrowed works by Henner (no. 43) and Gérôme (no. 37) from the Hyams Collection, but in the beautifully appointed gallery that houses their collection there remain Bouguereau's *Whisperings of Love* (1889) (fig. 15) and two of Vibert's most amusing cardinal

paintings, as well as an impressive *Charge of Arabs* by Schreyer.

Following on the destruction wrought by the Civil War, the Deep South had few major collectors of art of any sort. In an attempt to bring culture to the region, large scale expositions were organized in emulation of the great world's fairs or *expositions universelles* of London and Paris. The most notable of these was the Cotton States and International Exposition held in Atlanta in 1895. In addition to elaborate pavillions for Women, industries, and various states, there was a Fine Arts building (fig. 16) designed by W. T. Downing. In the official history of the event, Walter G. Cooper described the building as "a classical design of extraordinary beauty, conceived in the Italian Renaissance, of the Florentine school." The exhibitions of the fine arts (fig. 17) included a selection of European works, mainly from

Fig. 15. W. Bouguereau, *Whisperings of Love,* 1889, oil on canvas, 80 x 54 inches, The New Orleans Museum of Art. Gift of Mrs. Chapman Hyams. Photo courtesy The New Orleans Museum of Art.

Fig. 16. The Fine Arts Pavillion, The Cotton States and International Exposition, Atlanta, 1895.

Fig. 17. Exhibition gallery, Fine Arts Pavillion, The Cotton States and International Exposition, Atlanta, 1895.

France. Merson's *"Je vous salue, Marie"* (no. 53) won a gold medal, remained in Atlanta, and ultimately came into the collection of the High Museum. Thus we are able to include an example by an artist whose work is relatively rare in America.

In the early part of the twentieth century, the area of the South that witnessed the greatest influx of nineteenth century French art was the state of Florida, which became the retreat of Northern millionaires. One of these was Henry Morrison Flagler, a Cleveland businessman who had become a partner with John D. Rockefeller in the formation of Standard Oil in 1867. As a wedding present for his third wife he built the mansion Whitehall at Palm Beach in 1901. It was designed by the firm of Carrère and Hastings, and featured—at Mr. Flagler's insistence—a Louis XIV music room (with a large pipe organ) that also served as an art gallery (fig. 18). His collection, which contained works of various European schools of the late nineteenth century, was partly dispersed following his death in 1913 and his wife's in 1917. In 1959, under the guidance of Flagler's

granddaughter, Jean Flagler Matthews, Whitehall was restored and opened as a museum. Many of the works from the original collection were reassembled, and others have been donated or lent, so that the music room/art gallery again has a convincing period appearance. From it we have borrowed characteristic paintings by three diverse masters popular in nineteenth century France: Diaz (no. 25), Jacque (no. 46), and Schreyer (no. 61).

A later settler in Florida, the circus magnate John Ringling began collecting European art in 1925 and built a museum in Sarasota to house his collection. For the nearby residence Ca'd'Zan, built for his wife Mable, he purchased nineteenth century French works which complemented the sumptuousness of the house and formed a fitting background to their grandiose lifestyle. In a photograph of the Ringling's breakfast room (fig. 19), we can see both the replica of Rosa Bonheur's famous *Labourage nivernais* (no. 4) and Detaille's *En Retraite* (no. 24). In the ballroom (fig. 20), Alfred Stevens's *Parisian Celebrities* shows an array of famous individuals, including Sarah Bernhardt.

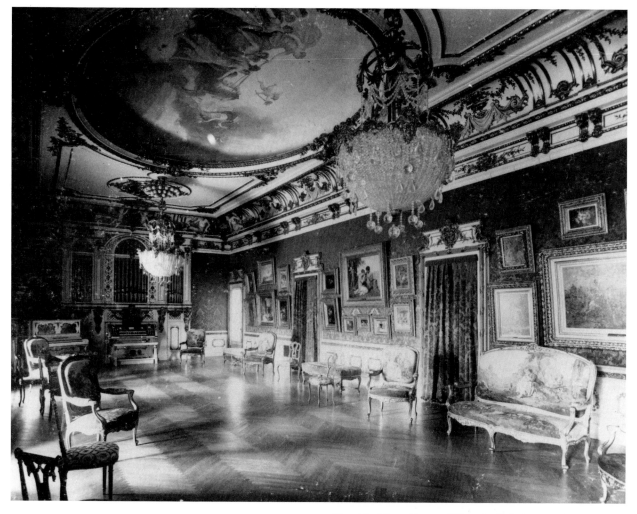

Fig. 18. Music Room, Whitehall, Palm Beach, ca. 1902. Photo courtesy The Henry Morrison Flagler Museum, Palm Beach.

Fig. 19. Breakfast Room, Ca'd'Zan, Ringling residence Sarasota.

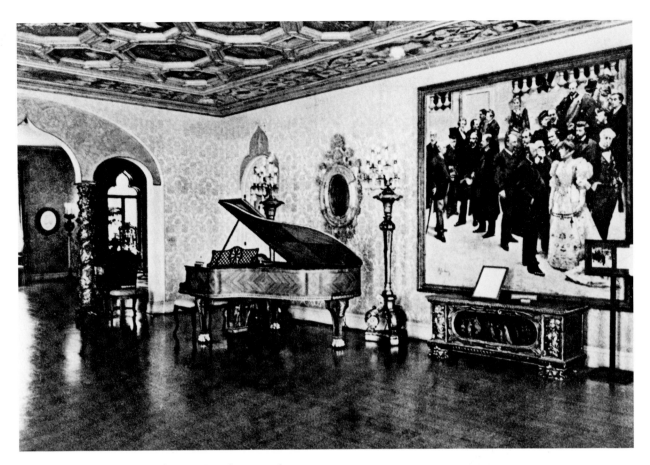

Fig. 20. Ball room, Ca'd'Zan, Ringling residence, Sarasota.

The 1950s saw the formation of several collections that were to have significant holdings in nineteenth century Salon painting. Walter P. Chrysler, Jr., who has already been mentioned, collected everything from Italian Baroque painting to Art Deco jewelry. Making purchases in both Paris and America, he was able to acquire important Salon paintings. In addition to the examples by Gérôme (no. 34), Bouguereau (no. 6), and Breton (no. 13) included here, the collection also boasts major Salon pieces by Charles Jacque, Guillaumet, Rousseau, and Harpignies. In 1971, this outstanding collection was moved from Provincetown to Norfolk. The Chrysler Museum continues to supplement the collection; a notable addition is the splendid Tissot that is included in this exhibition (no. 63).

In Puerto Rico, the governor Louis Ferré formed a collection of paintings similar to the Chrysler collection in its emphasis on the Italian Baroque and French nineteenth century. We have borrowed the Gérôme (no. 33), Bonvin (no. 5), and Firmin Girard (no. 39) from the Ferré Foundation, housed at the Museum in Ponce.

A less well-known small collection, but one of great refinement, was begun in 1955 by Mrs. Blakemore Wheeler in Louisville, Kentucky. Mrs. Wheeler had an appreciation not only for Old Masters but also for nineteenth century realist and genre painters such as Tissot (fig. 21). Unfortunately, by the terms of her bequest these works cannot be lent, but the Speed Museum, under the leadership of its director Addison Page, has shown its appreciation for these

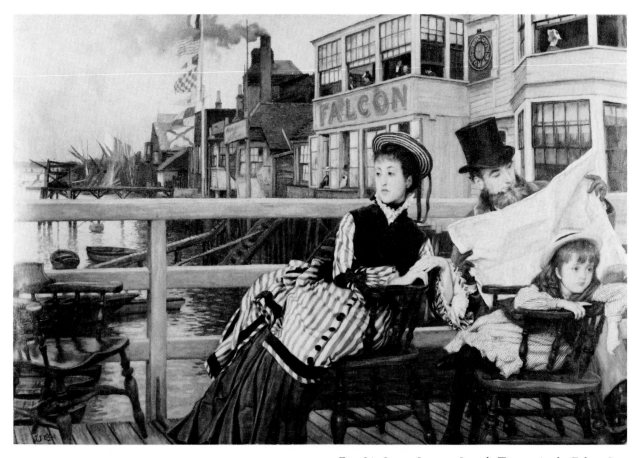

Fig. 21. James Jacques Joseph Tissot, *At the Falcon Inn*, The J. B. Speed Art Museum, Louisville. Gift of Mrs. Blakemore Wheeler, 1963.

works by adding others that complement them. Thus we are able to include an outstanding early Salon work by Cabanel (no. 14).

Another Southern museum that has shown initiative in collecting Salon paintings is the Cummer Gallery in Jacksonville, which in 1963 purchased the Bouguereau (no. 7) originally commissioned by Mr. Stewart (fig. 22). According to the Stewart sale catalogue, the artist considered this his greatest work.

The South, of course, has not had a monopoly on collecting these once unfashionable works and ushering them back to prominence. One of the outstanding collectors and an indefatigable proselytizer for Salon paintings has been Stuart Pivar of New York. He organized the important Pompier exhibition at Hofstra University in 1974. In the past few years, Mr.

Pivar has placed a number of his finest works on loan to The University of Virginia Art Museum at Charlottesville and we have thus considered them within our geographical territory and fair game. Anyone looking at the outrageous depiction of Cleopatra by Cabanel (no. 15) or the luscious Cupid and Psyche by Bouguereau (no. 12) will be thankful for the collector's generosity.

Several other universities have provided refuge for Salon works. The Bouguereau (no. 8), long sequestered at the University of North Carolina in Wilmington, and the Dupré (no. 27) at the University of Kentucky are in public buildings where they serve as decor. The Southern university museums that have seriously pursued the collecting and exhibition of Salon paintings are the Ackland Art Gallery at

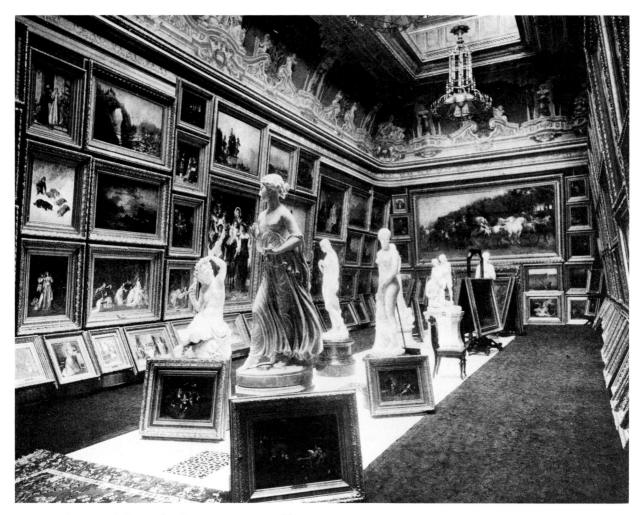

Fig. 22. Picture Gallery, the Stewart mansion, New York, ca. 1883. Bouguereau's *Promenade à âne* (no. 7) is at center of left wall.

the University of North Carolina in Chapel Hill, from which we borrowed the Barrias (no. 2) and a Vollon (no. 67), and the Lowe Art Gallery of the University of Florida in Coral Gables, which lent the Ernst (no. 28).

In recent years, still more Southern museums and collectors have shown interest in nineteenth century French academic art. The Dallas Museum acquired Meissonier's gem-like *Information* (no. 51); the Houston Museum of Fine Arts bought Gustave Doré's *House of Caiaphas* (no. 26); in Tuskaloosa, the businessman-collector Jack Warner has purchased major canvases by Rosa Bonheur; and in Lexington, Mr. and Mrs. James Wennecker

have formed a collection of works by a group of nineteenth century French artists led by Vibert (no. 66; see also fig. 23).

Even given these varied resources of the region, it has not been possible to illustrate every significant aspect or all important artists who showed at the Paris Salon in the second half of the nineteenth century. Some, like Gustave Moreau, whose work always aroused considerable interest at the Salon, are not represented in Southern collections. Major works by the Impressionists—who sought and gained limited acceptance at the Salon, both before and after they organized their own exhibitions—have become impractical to borrow for an extended

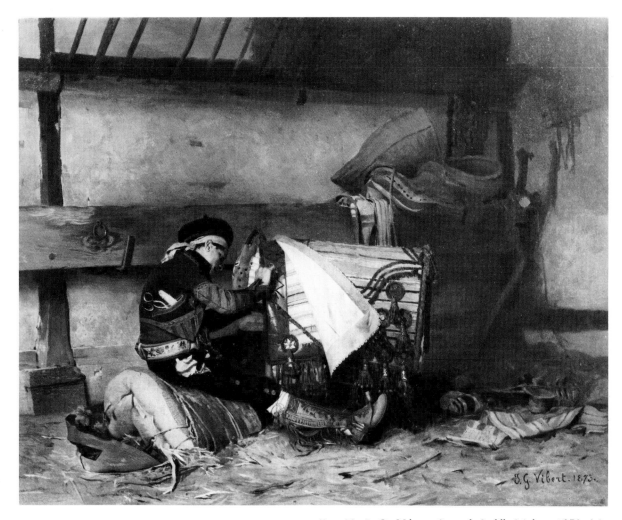

Fig. 23. J. G. Vibert, *Spanish Saddle Maker*, 1873. Mr. and Mrs. James Wennecker Collection, Lexington.

period. The Impressionists, however, are well known, while the focus of this exhibition is on the typical Salon artists who are not.

Of the seventy paintings which make up the exhibition, twenty-two actually were shown in Salons. Another five—those by Bonheur, Cabanel, Lecomte-Vernet, Corot, and Dupré—are replicas of successful Salon paintings. In the case of the Humbert, we have the preliminary study for a painting which was purchased by the State from the Salon of 1874 (fig. 24). Others of these works—Meissonier's *Information* (no. 51) and Decamps's *Cour de ferme* (no. 22)—were shown publicly in Paris at the Exposition Universelle. Several of the

other paintings, however, were never exhibited in Paris, for they were specifically commissioned by wealthy American collectors. Most notable of these are Bouguereau's *Promenade à âne* painted for Mr. Stewart (fig. 22), Gérôme's *Christian Martyrs' Last Prayer* for Mr. Walters (fig. 11), and Gleyre's *Le Bain* (no. 40) for Mr. Johnston.

The Salon served as the showplace for an artist's talents, and through the late nineteenth century, certain artists could be counted on to display their finest and most elaborate creations. Painters such as Cabanel, Bouguereau, and Gérôme appeared year after year, and became the very models of official Salon painters.

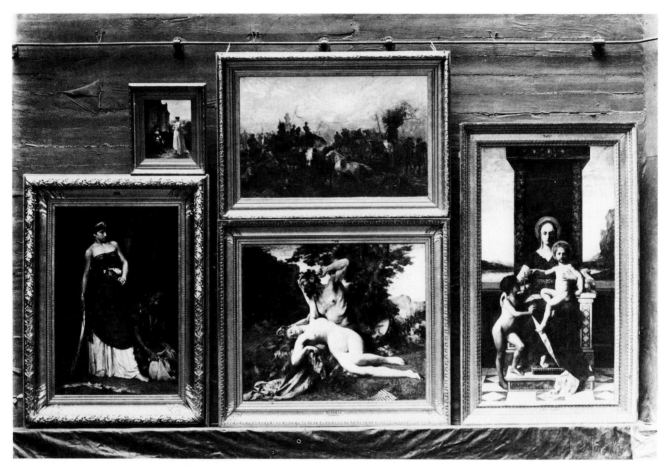

Fig. 24. State purchases from the Salon of 1874, including Humbert's *The Virgin and Child with Saint John the Baptist* (see no. 40).
Photo courtesy Musée d'Orsay, Paris.

They are well represented in this exhibition. They painted a variety of subjects, but in general they carried on the academic tradition of giving pride of place to historical, mythological, and religious subjects. Literature and drama frequently served as sources of inspiration (see Cabanel's use of Shakespeare and Plutarch, nos. 14, 15). Bouguereau drew from myth and classical drama for his representations of Orestes and Cupid (nos. 6, 12) and Gérôme relied on Herodotus and Gautier for his *King Candaules* (no. 33). Other traditional painters of history and allegory were Baudry and Laurens. The former's oil study (no. 3) anticipates his decoration of the Opéra and Laurens's *Honorius* (no. 47), a famous work in the Salon of 1880, is representative of his many recreations of historical personages.

Reflecting the Christian revival of the late nineteenth century, the Salon during this period contained many religious works. In the present exhibition are such traditional subjects as *The Annunciation* by Bouguereau (no. 9) and the *Virgin and Child with Saint John the Baptist* by Humbert (no. 44), while less common religious subjects are treated by such diverse artists as Corot, Doré, and Merson. In addition, we have (from the Walters collection) works by Delaroche (no. 23) and Gérôme (no. 36) which are two of the nineteenth century's best-known images of Christian martyrdom.

Two famous works on military themes are in the exhibition: Meissonier's painting of an incident from the Napoleonic campaigns (*Information*, no. 51), for which Mr. Vanderbilt paid an unprecedented sum, and *En Retraite* (no. 24) by his chief follower Detaille, which caused a sensation at the Salon of 1873 for its graphic depiction of carnage during the Franco-Prussian War. Another of the leading military painters was Yvon, who was also a skilled portraitist; we have his portrait of one of the chief personalities of the era, the Emperor Napoleon III (no. 69). In addition, the exhibition includes stylish portraits by Benjamin Constant (no. 19) and Carolus-Duran (no. 16) and depictions of the fashionable society of the Belle Epoch by Stevens (no. 62) and Tissot (no. 63).

As in seventeenth century Holland, painters specialized in specific categories. In addition to portraiture there were the genres of low-life, humble interiors, and still lifes. Bail (no. 1), Ribot (no. 57), Bonvin (no. 5), and Vollon (nos. 67, 68) all supplied realistic works to satisfy this bourgeoise taste. The specialists in animal subjects, *animaliers*, are represented by the replica of Rosa Bonheur's acclaimed *Labourage nivernais* (no. 4) and one of Charles Jacque's many depictions of sheep (no. 46).

Painter-and-playwright J. G. Vibert contributed self-conscious humor and a keen sense of satire to the Salon. We have two examples (nos. 65, 66) that reveal the wit and theatricality of his immensely popular anecdotal paintings.

Another group of painters, the Orientalists, specialized in Eastern *exotica*. Inspired by the examples of Delacroix, they travelled to the Near East, Egypt, and North Africa, and recorded the land and peoples. Eugène Fromentin's *Tribu nomade* (no. 31) is an outstanding example of this sort of work; other Orientalist painters represented here are Lecomte-Vernet (no. 48), Schreyer (no. 61), and Gérôme (nos. 34, 37). While French painters were travelling to the Near East to find subjects, the art of the Far East flooded Paris. Japanese prints and *objets d'art* gave rise to *japonisme*, a taste that influenced a wide variety of artists. Of Salon painters who succumbed to it, we can offer

notable examples in Firmin Girard's *Toilette japonaise* (no. 39) and paintings by Lefebvre (no. 49) and Stevens (no. 62), who were also specialists in the painting of women.

The nude was one of the most popular categories in every Salon. Included in this exhibition are two paintings (nos. 8, 12) which attest to Bouguereau's mastery in this realm. There is also one of Henner's characteristic nymphs (no. 43). Charles Chaplin was another specialist in this subject, and if his *Häidée* (no. 18) is not nude she certainly has the sexual allure which contributed to the popularity of so many Salon works. Young women were also frequently featured in peasant or farm scenes. We have two works which show the size to which artists inflated such humble subjects: Breton's *Festival of Saint John* (no. 13) and Dupré's *In the Pasture* (no. 27). Millet (no. 54) was one of the very few artists whose work had a serious social content.

Lastly there was a group of independent artists, men such as Puvis de Chavannes (no. 56), Fantin-Latour (no. 30), and Carrière (no. 17), who developed their own idiosyncratic styles to represent fantastic images or imaginary scenes.

Lucy Hooper, reviewing the Salon of 1875 in *The Art Journal*, wrote:

> The first few days which are devoted to the examination of the *Salon* are usually productive of intense weariness and bewilderment of mind. That vast exhibition, where so many thousand objects are presented to the view of the spectator (the paintings alone number two thousand and nineteen), the difficulty of finding the work or works of any favourite artist, the multiplicity of subjects and of styles, all combine to perplex the strongest brain.

This exhibition's mixture of styles and themes, its solemnity and sentimentality, its great jumble of images, may produce this effect. It is hoped that it will also provide the excitement and pleasure of the French Salon when it was at its peak.

CATALOGUE
OF THE
EXHIBITION

ARTISTS IN THE EXHIBITION

Joseph Bail: 1
Félix-Joseph Barrias: 2
Paul-Jaques-Aimé Baudry: 3
Rosa Bonheur: 4
François Bonvin: 5
William Adolphe Bouguereau: 6, 7, 8, 9, 10, 11, 12
Jules Breton: 13
Alexandre Cabanel: 14, 15
Carolus-Duran: 16
Eugène Carrière: 17
Charles Chaplin: 18
Benjamin Constant: 19
Jean-Baptiste-Camille Corot: 20
Thomas Couture: 21
Alexandre-Gabriel Decamps: 22
Paul Delaroche and Charles-François Jalabert: 23
Jean-Baptiste-Edouard Detaille: 24
Virgile Narcisse Diaz de la Peña: 25
Gustave Doré: 26
Julien Dupré: 27
Rudolf Ernst: 28
Henri Fantin-Latour: 29, 30
Eugène Fromentin: 31
Jean-Léon Gérôme: 32, 33, 34, 35, 36, 37, 38
Marie-François-Firmin Girard: 39
Marc-Gabriel-Charles Gleyre: 40
Jean-Louis Hamon: 41
Ferdinand Heilbuth: 42
Jean-Jacques Henner: 43
Jacques-Fernand Humbert: 44
Louis-Gabriel-Eugène Isabey: 45
Charles-Emil Jacque: 46
Jean-Paul Laurens: 47
Charles Emile Hippolyte Lecomte-Vernet: 48
Jules-Joseph Lefebvre: 49
Jean-Louis-Ernest Meissonier: 50, 51
Hugues Merle: 52
Luc-Olivier Merson: 53
Jean François Millet: 54
Adrien Moreau: 55
Pierre Puvis de Chavannes: 56
Théodule Augustin Ribot: 57
Ferdinand Roybet: 58, 59
Adolf Schreyer: 60, 61
Alfred Stevens: 62
James Jacques Joseph Tissot: 63
Jehan-Georges Vibert: 64, 65, 66
Antoine Vollon: 67, 68
Adolphe Yvon: 69
Eduardo Zamacois: 70

BIBLIOGRAPHICAL ABBREVIATIONS

Apollo, 1978	M. Amaya, "Contrasts and Comparisons in French Nineteenth-Century Paintings," *Apollo,* April 1978, pp. 16-25.
Baschet, 1885	Ludovic Baschet, ed., *Catalogue illustré des oeuvres du W. Bouguereau* in the series *Artistes modernes,* Paris, 1885.
Bellier and Auvray, 1882-87	Emile Bellier de la Chavignerie and Louis Auvray, *Dictionnaire Général des artistes de l'école française,* 3 vols., Paris, 1882-87.
Bénézit, 1948-54	E. Bénézit, *Dictionnaire critique et documentaire des peintres . . .,* 8 vols., Paris, 1948-54.
Castagnary, 1892	J. A. Castagnary, *Salons 1857-70,* 2 vols., Paris, 1892.
Champlin and Perkins, 1888	John D. Champlin, Jr., and Charles C. Perkins, *Cyclopedia of Painters and Painting,* New York, 1888.
Claretie, *L'Art,* 1876	Jules Claretie, *L'Art et les artistes français contemporains,* Paris, 1876.
Claretie, *Peintres,* 1884	Jules Claretie, *Peintres et sculpteurs contemporains,* 2 vols., Paris, 1884.
Clement and Hutton, 1884	Clara E. Clement and Laurence Hutton, *Artists of the Nineteenth Century and Their Works, A Handbook,* 2 vols., Boston, 1884 (reprint St. Louis, 1969).
Cook, 1888	Clarence Cook, *Art and Artists of Our Time,* 3 vols., New York, 1888.
Dayton, 1960	Dayton Art Institute, *French Paintings 1789-1929: From the Collection of Walter P. Chrysler, Jr.,* exhibition catalogue, March 25 - May 22, 1960.
Dayton, *Gérôme,* 1972	Dayton Art Institute, *Jean-Léon Gérôme (1824-1904),* exhibition catalogue, 1972.
Doucet, 1905	Gérome Doucet, *Les Peintres français,* Paris, 1905.
Equivoques, 1973	*Equivoques, Peintures françaises du XIXe siècle,* exhibition catalogue, Musée des Arts Décoratifs, Paris, March 9 - May 14, 1973.
GBA	*Gazette des Beaux-Arts,* Paris.
Haller, 1899	Gustave Haller, *Nos Grands Peintres,* Paris, 1899.
Held, 1965	Julius S. Held, *Catalogue: Paintings of the European and American Schools, Museo de Arte de Ponce,* Ponce, Puerto Rico, 1965.
Hering, 1892	F. F. Hering, *The Life and Works of Jean-Léon Gérôme,* New York, 1892.
Hofstra, 1974	The Emily Lowe Gallery, Hofstra University, Hempstead, Long Island, *Art Pompier: Anti-Impressionism,* exhibition catalogue, October 22 - December 15, 1974.

Montrosier
Eugène Montrosier, *Les Artistes modernes,* 4 vols., Paris, 1882.

Nashville, 1977
Tennessee Fine Arts Center at Cheekwood, Nashville, *Treasures from the Chrysler Museum at Norfolk and Walter P. Chrysler, Jr.,* exhibition catalogue, June 12 - September 5, 1977.

Randall, 1979
Lilian M. C. Randall, ed., *The Diary of George A. Lucas,* 2 vols., Princeton, 1979.

Saunier
Charles Saunier, *La Peinture au XIX siècle, Anthologie d'art français,* Paris, n.d.

Second Empire, 1978
The Second Empire 1852-1870, Art in France under Napoleon III, exhibition catalogue, Philadelphia Museum of Art, Detroit Institute of Arts, Grand Palais, Paris, 1978-79.

Shepherd Gallery, 1975
Ingres and Delacroix through Degas and Puvis de Chavannes: The Figure in French Art, 1800-1870, exhibition catalogue, Shepherd Gallery, New York, Spring 1975.

Strahan, *Treasures,* 1881
E. Strahan (E. Shinn), *The Art Treasures of America,* 3 vols., Philadelphia, 1881.

Stranahan, *History,* 1917
C. H. Stranahan, *A History of French Painting from its Earliest to its Latest Practice,* New York, 1917.

Suida, 1949
William E. Suida, *A Catalogue of Paintings in the John and Mable Ringling Museum of Art,* Sarasota, 1949.

Tabarant, 1942
A. Tabarant, *La Vie artistique au temps de Baudelaire,* Paris, 1942 (reprint edition 1963).

Thieme and Becker, 1907-50
U. Thieme and F. Becker, *Allgemeines Lexikon der Bildenden Künstler von der Antike bis zur Gegenwart,* 37 vols., Leipzig, 1907-50.

Vachon, 1900
Marius Vachon, *W. Bouguereau,* Paris, 1900.

Vento, 1888
Claude Vento, *Les Peintres de la femme,* Paris, 1888.

Weisberg, *Realist Tradition,* 1980
Gabriel P. Weisberg, *The Realist Tradition, French Painting and Drawing: 1830-1900,* exhibition catalogue, organized by The Cleveland Museum of Art, 1980-81.

Wildenstein, 1978
Wildenstein and Co., *Veronese to Franz Kline: Masterworks from the Chrysler Museum at Norfolk,* exhibition catalogue, New York, April 13 - May 13, 1978.

JOSEPH BAIL, 1862-1921

1. *Les Bulles de Savon (Soap Bubbles)*, 1895
Oil on canvas, 51½ x 77 inches (138.4 x 195.6 cm.)
Signed at lower left: *Bail Joseph*

Kurt E. Schon, Ltd., New Orleans.

Provenance: M. Ochs; Sale, Paris, May 8, 1940.

Exhibitions: Salon, Paris, 1895, no. 82; Exposition
Universelle, Paris, 1900.

Bibliography: *Salon de 1895, Catalogue illustré*, Paris, 1895,
detail ill., p. 135; Thiébault-Sisson, *Salon de 1895*, Paris,
1895, p. 38; J. Uzanne, "Joseph Bail," *Figures Contem-
poraines* from *l'Album Mariani*, Paris, 1896-1908, VIII,
n.p.; L. Baschet, ed., *Exposition Universelle, 1900*, Paris,
1900, n.p., ill; J. Valmy-Baysse, "Joseph Bail," *Peintres
d'aujourd'hui*, 1910; Saunier, II, n.d., p. 241; Bénézit, I,
p. 343.

Bail came from a family of painters in Lyon.[1] His father
Jean-Antoine practiced in the realistic tradition of genre
subjects and young Bail received his first training from
him, before spending time in the studios of Gérôme and
Carolus-Duran. His own characteristic work reflects less
the influence of these academic masters than a study of
Chardin's paintings, which he would have seen in the
Louvre, and the works by contemporary realists such as
Vollon and Ribot.

Bail began exhibiting at the Salon in 1878, and re-
ceived medals in 1886 and 1889. He painted portraits,
still lifes, and studies of animals, but his chief subjects
were humble family activities and kitchen scenes. In the
latter, Bail often depicted the cooks' assistants and scul-
lery boys amusing themselves by smoking, drinking, or
playing cards. *Les Bulles de Savon*, showing them blowing

bubbles in the soapy dish water, raises the genre to a
monumental scale.

The subject of a young boy blowing bubbles was given
prominence in French art by Chardin in the eighteenth
century and taken up by Couture and Manet in the
nineteenth.[2] Bail probably knew these prototypes, but
whereas the early treatments suggest an allegorical or
moralizing intention (usually a warning against sloth),
Bail's work appears to be a straightforward depiction of a
purely enjoyable pasttime. The fragile and transparent
surface of the bubble presents a special challenge to a
painter's skill. Bail has made his massive bubble the focal
point of the composition. Its painterly brilliance, along
with that of the highly polished vessels, recalls paintings
by Vollon, and led Thiébault-Sisson, in his notice on
the 1895 Salon, to refer to Bail as "a virtuoso of still
life." The critic went on to say of the painter and this
work:

No kitchen helper has ever polished the bottom of a cas-
serole more conscientiously; nor has the sun shone more
brightly on the enamel of the clay pots, or the copper basins
sparkled more gaily. But it is not only the utensils, it is also
the kitchen personnel that he shows us. He depicts with an
infectious delight the exploits of these apprentice sauce-
makers. His *Bulles de savon*, for its understanding of the
subject, and the richness of its color, is as fine as any of his
previous entries.[3]

[1]See Gabriel P. Weisberg, "Painters from Lyon: The Bails," *Arts
Magazine*, April 1981, pp. 155-159.
[2]See Albert Boime, *Thomas Couture and the Eclectic Vision*, New
Haven, 1980, pp. 336-339.
[3]Thiébault-Sisson, p. 38.

44

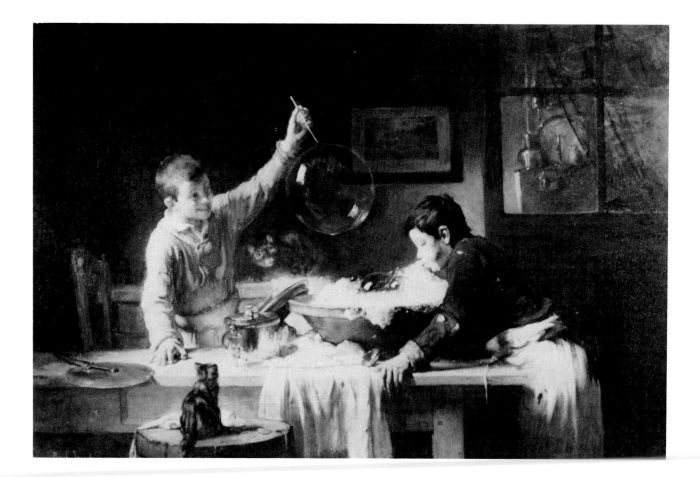

2. *Une Fileuse (Costume d'Alvito) (A Spinner, Costume of Alvito)*, 1846
Oil on canvas, 38¾ x 28½ inches (98.4 x 72.4 cm.)
Signed and dated at the lower right: *F. Barrias, Rome 1846*

The Ackland Art Museum, The University of North Carolina at Chapel Hill, Ackland Fund.

Provenance: Hazlitt, Gooden & Fox, Ltd., London.

Exhibitions: Salon, Paris, 1847, no. 82; *The Lure of Rome,* Hazlitt, Gooden & Fox, Ltd., London, Oct. 31 - Nov. 27, 1979, no. 88.

Bibliography: A.-H. Delaunay, *Catalogue Complet du Salon de 1847,* Paris, 1847, p. 11; Paul Mantz, *Salon de 1847,* Paris, 1847, p. 74; Bellier and Auvray, 1882, I, p. 47.

Barrias was born in Paris and studied with Leon Cogniet. In 1844 he won the Prix de Rome for his painting *Cincinnatus receiving the Deputies of the Senate.* From his residency in Rome, he sent works for exhibit at the Salon, beginning with three (including a nude *Sappho*) in 1847. Barrias remained a regular Salon contributor; most of his works were of classical subject matter. He also designed lithographs for editions of Horace and Virgil and painted frescoes for Parisian churches, the Grand Hôtel du Louvre, and various private houses. The critic Roger Ballu commented on one of the chapel commissions:

> In short, the decoration of the chapel of St. Geneviève, at the Trinity, is an excellent work—worthy of an artist who is always distinguished by a severe execution, a happy imagination, and a graceful conception of the whole effect. A painter of style, Felix Barrias has neither the solemnity nor the coldness of those who usually claim this title; very careful of the dignity of his art, in these times of easy painting, he has never made a compromise with the taste of the day, and for this reason, in every essay on decorative art, his name is written in advance.[1]

The painting exhibited here is one of the three with which the artist made his Salon debut. In addition to this and the *Sappho* (which drew most attention), there was also a *Jeune fille portant des fleurs (festa dell'fiorata) (Girl Carrying Flowers).* Thus, from the first Barrias revealed his talent as a creator of classical subjects and also as a realistic recorder of Italian figure types and costumes. Alvito is a town midway between Rome and Naples, and Barrias has composed his painting not only to record the girl's distinctive dress but to suggest her sentimental nature. By showing her as a spinner seated in a window, the artist places her in the tradition of many lovestruck nineteenth century Marguerites.

[1] In *GBA,* Feb. 1878. Quoted and translated in Clement and Hutton, I, 1884, p. 35.

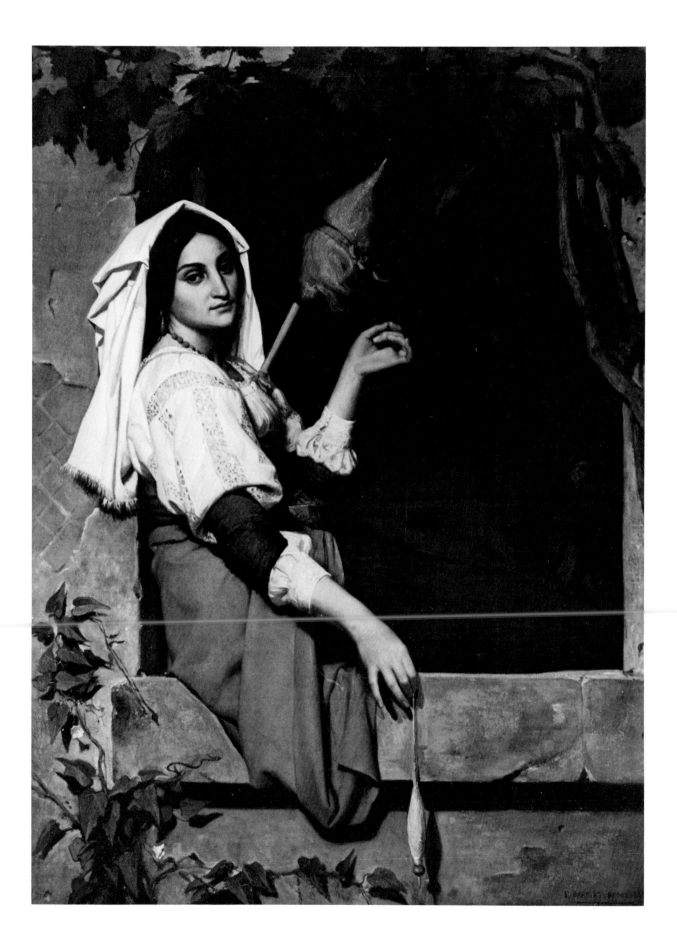

3. *Gioventù, primavera della vita (Youth, Springtime of Life)*, 1853
Oil on canvas, 29½ x 39 inches (71 x 99 cm.)

Museum of Fine Arts, St. Petersburg.

Provenance: Vicomte Daupias, Lisbon; Sale, Galerie Georges Petit, Paris, May 16-17, 1892, no. 71; Sale, Christie's, London, March 16, 1923, n. 88 (?); Sale, Hôtel Drouot, Paris, May 17, 1930, no. 17.

Exhibitions: *Exposition Paul Baudry: Catalogue des Oeuvres de Paul Baudry*, Paris, 1886, no. 9.

Bibliography: Montrosier, 1882, II, pp. 107 and 110; Charles Ephrussi, *Paul Baudry, Sa Vie et Son Oeuvre*, Paris, 1887, pp. 131, 158, 304, 305; A. Baraud, "Paul Baudry," *Les Contemporains*, n.d., p. 8; Bénézit, 1948-54, I, p. 470; Shepherd Gallery, 1975, p. 289.

Baudry was sent by the town council of his native La Roche-sur-Yon in the Vendée to study art in Paris in 1844. He entered the studio of Michel-Martin Drolling and was admitted the following year to the Ecole des Beaux-Arts. In 1850 he and Bouguereau shared the Prix de Rome for their paintings of *Zenobia Found on the Bank of the Araxes*. Baudry took advantage of the years in Italy to travel widely, studying the works of most of the great Italian masters—Raphael, Correggio, Titian, and Caravaggio.

The artist returned to Paris in 1856 and the following year scored a great success with his Salon entries *Fortune and a Child* and *Execution of a Vestal*, both purchased by the State. Baudry also began his highly successful career as a decorative painter, executing interior panels for various patrons. In addition, he painted some portraits.

At the Salon of 1861 Baudry exhibited his most powerful historical subject, *Charlotte Corday at the Bath of Marat* (Nantes, Musée des Beaux-Arts). Painted in a highly realistic and dramatic manner, it was the result of his typically thorough preparation; he studied the lives and times of the protagonists and, of course, the painting by David. After its showing, he won a first class medal and was made a Chevalier of the Legion of Honor. Two years later he displayed his other most famous painting, *The Wave and the Pearl*. This erotic depiction of a nude on the waves, like Cabanel's *Birth of Venus* in the same Salon, was purchased by the Emperor.

In 1864 Baudry learned that he would receive the enormous commission of decorating the foyer of the new Paris Opéra designed by his friend, Charles Garnier. To meet the demands of this immense task he returned to Rome to study the works of Michelangelo, especially the Sistine Chapel. The themes chosen by Baudry for his Opéra decoration were Poetry and Music; the project lasted from 1866 to 1874. When exhibited at the Ecole des Beaux-Arts before installation, his work received great acclaim.

In his later years, Baudry continued to paint portraits and decorative schemes, including those for the Hall of the Court of Appeals, the Panthéon, and the homes of the Vanderbilt family in New York.

The painting exhibited here dates from Baudry's first stay in Italy. After he had sent the *Fortune and the Child*, which contained, as he admitted, influences of Correggio, Titian, and Leonardo, Baudry turned towards Raphael and his next *envoi* was this impressive sketch, which has kept its Italian title. Ephrussi called it "a *première pensée* for a large oil which was never carried out but would have had a size analogous to Raphael's *School of Athens* or *Disputa*."[1] In correspondence quoted by Ephrussi, Baudry wrote of his intentions:

> I have sent a great allegorical composition destined for the salon of a rich person who has never existed. . . . This sketch is nothing more or less than an image of youth with all its joyous and melancholy passions. If you study this puzzle you will see that I have placed in the first row Poetry and Music.[2]

The idyllic setting of this *Springtime* is reminiscent of Raphael's *Parnassus*, but Baudry took his composition from several sources. One is reminded of the Ingres fresco *L'age d'or*, which was commissioned by the Duc de Luynes in 1839 for his Château de Dampierre. Although work on that project stopped in 1850 and it was never completed, it had a similar pastoral quality and shape.[3]

According to Ephrussi, the temple appearing as the backdrop in this painting was copied from an Ionian edicule in the Villa Borghese. Its inscription AMOR provides the theme for the festive participants in a classic Bacchic revel. On the steps before the temple are the Three Graces, perhaps a reminiscence of Prud'hon's famous painting. To their left is Terpsichore, the Muse of dance, and, lounging at the right, the young Bacchus receives wine from a nymph. In the light of Baudry's later fame as a decorative painter and the subjects he chose for the Opéra, this youthful work is notable in his development.

[1] C. Ephrussi, 1887, p. 157.
[2] Ibid., pp. 157-158.
[3] Georges Wildenstein, *Ingres*, London, 1954, p. 216, no. 251, pls. 84-85.

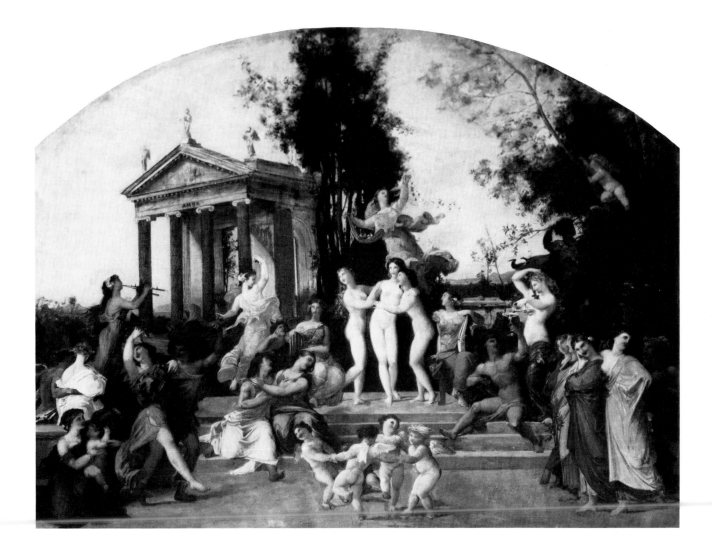

4. *Le Labourage nivernais: le Sombrage (Ploughing in Nivernais)*, 1850
Oil on canvas, 52½ x 102 inches (132.7 x 264.2 cm.)
Signed and dated at the lower right: *Rosa Bonheur 1850*

John and Mable Ringling Museum of Art, Sarasota.

Provenance: Viscount Hambledon; Sale, Christie's, London, March 1, 1929, no. 177; Mitchell; John Ringling, Sarasota.

Exhibitions: *Artists of the Paris Salon,* Cummer Gallery of Art, Jacksonville, Jan. 7 - Feb. 2, 1964, no. 2.

Bibliography: Anna Klumpke, *Rosa Bonheur, Sa Vie, Son Oeuvre,* Paris, 1908, p. 196; *Art Prices Current,* March 1, 1929, no. 6869; Suida, 1949, p. 347, no. 433.

Rosa Bonheur was one of the most famous *animaliers,* or specialists in the painting of animals, of the second half of the nineteenth century. She came from a talented family. Her mother was a musician and her father Raymond Bonheur was a sculptor and painter. He was also an advocate of Saint-Simonism, the French utopian socialist movement intent on the scientific reformation of the social order. One of the tenets of Saint-Simonism was equality for women; Rosa Bonheur's independent spirit was encouraged when she was a child and characterized her throughout her life.

Rosa's brothers and sisters also became artists, and Raymond Bonheur provided her first artistic training. She later studied briefly with Léon Cogniet. Her father and his second wife had a home near the Monceau Plain and there Rosa studied landscape. Even more importantly, the young artist was able to observe both the wild and domesticated animals of the countryside, studying their anatomy and movement, so that she could capture their individual qualities in paint. In 1841, she exhibited a painting and a drawing in the Salon. Her success came gradually in the 1840s as she continued to travel through the French provinces seeking subjects. In 1845 she exhibited six works and won a third class medal; in 1848 she showed six paintings and two sculptures and won a first class medal as well as critical praise.

This success led the government to commission a painting from her for 3000 francs. She said many years later that she had already had the "idea of painting a scene with three pairs of oxen at work as a kind of celebration of the furrows from which mankind receives the bread which nourishes it."[1] She felt it necessary to work directly from nature and spent the winter of 1848 at the home of her father's friend, the sculptor Justin Mathieu, in the Nièvre region. Back in Paris the following spring, the painting progressed with astonishing rapidity and when displayed at the Salon of 1849 *Labourage nivernais: le Sombrage* was a great success. Although originally intended for the Museum of Lyon, it

went instead to the more prestigious Musée de Luxembourg in Paris.

Rosa Bonheur's international reputation was firmly established in 1853 when she exhibited the enormous painting *The Horse Fair at Paris,* which was eventually purchased by Cornelius Vanderbilt and given to the Metropolitan Museum of Art in New York. That same year, she was accorded the right to exhibit at the Salon without first submitting works to the jury. With her success assured, Bonheur was able to purchase the Château of By. She worked there in privacy, no longer feeling it necessary to participate in the Salons. She pursued her own concerns, travelling to England, where her work was extremely popular, and looking after her extensive menagerie of animals, including the pet lions which were among her favorite subjects. Her fame was such that in 1865 the Empress Eugènie came in person to By to present the artist with the Cross of the Legion of Honor. In 1894 she was elevated to the rank of Officer of the Legion, the first woman to be so honored.

Rosa Bonheur was often compared to the writer George Sand, who devoted several of her novels to the humble life of farmers and peasants. It seems to have been the critic Emil Cantrel, writing in 1859, who first made this connection with regard to *Le Labourage nivernais.*[2] This was later embellished in an article by Henry Bacon[3] which stated that Bonheur had been inspired by the following passage from George Sand's *La Mare au Diable* of 1846:

> But what next caught my attention was a truly beautiful sight, a noble subject for a painter. At the far end of the flat ploughland, a handsome young man was driving a magnificent team. He had four pair of young beasts, with their dark tawny coats shot with a fiery sheen and with those short, curly heads that have still something of the wild bull; and they had the abrupt movement, the nervous, jerky pull that is still irritated by yoke and goad, and obeys the newly imposed mastery only with a shudder of rage. They were what are called "fresh-bound" oxen.[4]

However, Anne Klumpke, the last biographer to have known the artist personally, pointed out that there is no evidence to support this supposition.[5]

In any case, *Le Labourage nivernais* became one of the most popular paintings of the nineteenth century. In George du Maurier's novel *Trilby,* for example, it is mentioned as one of the most frequently copied works in the Musée de Luxembourg. The painter Julien Duprè recalled it as his favorite painting when he was a young man,[6] in 1880 Dézamy devoted one of his sonnets to it,[7] and a bronze relief of it was included in the monument to Rosa Bonheur designed by her brother Isidore, erected in 1901 on the Place Denecourt in Fontainebleau.

The original version of the painting is now in the Musée National de Château de Fontainebleau. In the

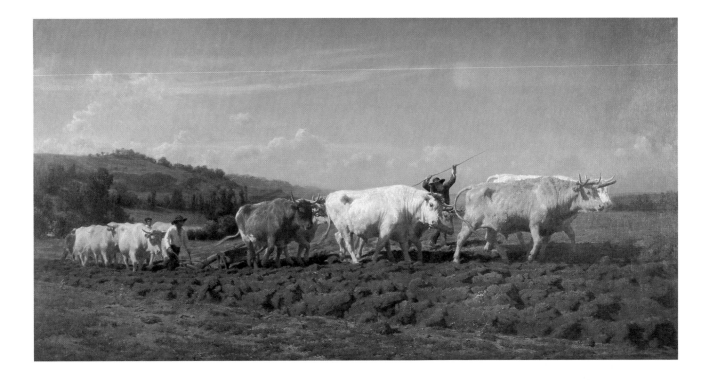

register of the artist's works kept by Rosa's companion, Mme. Micas, Klumpke found a record of a replica painted for a Mr. Marc for 4000 fracs. (Half of the money was given to her brother Auguste for his assistance.) Klumpke noted that the work differs from the original in the background at the left, and that it was in America.[8] The replica is undoubtedly this painting from the Ringling collection.

Still other versions have appeared, including one at the Musée Ingres, Montauban, one on panel signed by Auguste (sold at Sotheby Parke-Bernet, October 9, 1974), and a reduced version sold at William Doyle Galleries, New York, in 1980. What is perhaps an oil sketch for the composition is now at the R. W. Norton Art Gallery, Shreveport.

We may well wonder why this subject evoked such dramatic response when it first appeared. The reviewer Galinard observed that it was at the 1849 Salon—and chiefly through Rosa Bonheur's painting—that the public for the first time gave its attention to a landscape with animals.[9] The artist had elevated this genre to a new grandeur of treatment, and had captured in a convincing fashion an important nineteenth century theme: the harmonious union of man and nature. Eugène de Mirecourt wrote in 1856:

> In examining the paintings of Madamoiselle Bonheur, the public is surprised to discover a serious and truthful impression conveyed in these great red and white oxen . . . she conveys an almost ecstatic sensibility before these landscapes which are alive with a charm so melancholy, so dreamlike, so redolent of the perfume of the fields.[10]

[1]Anna Klumpke, 1908, p. 193.
[2]Emil Cantrel, "Mademoiselle Rosa Bonheur," in L'Artiste, 2, Sept. 1, 1859, p. 7.
[3]Henry Bacon, "Rosa Bonheur," The Century Magazine, Oct. 1881.
[4]George Sand, The Devil's Pool, trans. by Hamish Miles, London, 1929, pp. 25-26.
[5]Klumpke, 1908, p. 197.
[6]Theodore Stanton, ed., Reminiscences of Rosa Bonheur, New York, 1910 (reprinted 1976), p. xviii.
[7]Adrien Dézamy, Les Chefs-d'oeuvre d'art au Luxembourg, Paris, 1880.
[8]Klumpke, 1908, p. 196.
[9]Auguste Galinard, Examen du Salon de 1849, Paris, 1849, p. 129.
[10]Eugène de Mirecourt, Les Contemporains, Rosa Bonheur, Paris, 1856, pp. 46-47.

5. *L'Ecole des Frères (The Friars' School)*, 1873
Oil on canvas, 28¾ x 36¼ inches (73 x 92.1 cm.)
Signed and dated at the lower right: *F. Bonvin Avril 1873*

Museo de Arte de Ponce, Puerto Rico (The Luis A. Ferré Foundation). Purchase, 1958.

Provenance: M. S. Seure, Paris; Sale, Hôtel Drouot, Paris, March 9, 1888; Georges Lutz; Sale, Galerie Georges Petit, Paris, May 26-27, 1902, no. 20; Sale, Paris, Nov. 29, 1937.

Exhibitions: Salon, Paris, 1874, no. 216; *Exposition de tableaux et de dessins par François Bonvin*, Galerie D. Rothschild, Paris, May 10-31, 1886; Exposition Universelle, Paris, 1889, no. 78.

Bibliography: *Salon de 1874*, photo-reproductions by Goupil and Cie, Paris, 1874, I, no. 131; Paul Labarthe, *Le Carnet du Docteur au Salon de Peinture de 1874*, Paris, 1874, p. 20; Ernest Duvergier de Hauranne, "Le Salon de 1874," *Revue de deux monds*, June 1, 1874, p. 677; Nestor Paturot, *Le Salon de 1874*, Paris, 1874, p. 165; Claretie, *L'Art*, 1876, p. 261; *Exposition Universelle de 1889 Catalogue Illustré des Beaux Arts 1789-1889*, Paris, 1889, p. 44; Castagnary, 1892, II, pp. 98-99, 103; Marcel Nicolle, "La Collection Georges Lutz," *Revue de l'Art*, 1902, pp. 341-342; Etienne Moreau-Nélaton, *Bonvin raconté par lui-même*, Paris, 1927, pp. 89, 93, fig. 66; Held, 1965, pp. 16-17; Gabriel P. Weisberg, "François Bonvin and the Critics of his Art," *Apollo*, Oct. 1974, p. 310, fig. 11; Gabriel P. Weisberg, *Bonvin*, Paris, 1979, pp. 110-111, no. 58.

Bonvin received his early education at a Brothers' school. Although he associated with the painter François-Marius Granet, he was for the most part self-taught, spending much time in the Louvre copying Flemish and Dutch genre paintings. He derived his subject matter from his own humble life, concentrating on still lifes and scenes of everyday activity. He first exhibited at the Salon in 1847, when a portrait was accepted. The following year, two of his realist genre works were exhibited, and at the Salon of 1849 his painting *The Cook* won a third class medal and was praised by the critic Champfleury for its Chardinesque quality. Although friendly with Courbet, Bonvin did not convey a political attitude in his work and thus did not come in for the same harsh criticism. He received official recognition when the State commissioned a work and he painted *The School for Orphan Girls*, which was shown at the Salon of 1851 and won a second class medal. This was the first of a number of works he devoted to classrooms of poor children.

Even when several young realist artists were rejected from the Salon of 1859, Bonvin's paintings were exhibited and praised by the often acerbic critic Astruc, who called his *Kitchen Interior* "a work of rare perfectionism—one of the pearls of the Salon."[1] However, to show his support for his friends among the rejected artists—including Legros, Fantin-Latour, Whistler, and Ribot—Bonvin had a showing of their works in his own studio.

In 1867 Bonvin visited Holland and was able to study in greater depth the works of the seventeenth century Dutch painters who provided his inspiration. In the 1860s, he also produced etchings and began painting landscapes. In acknowledgement of his achievements, Bonvin was made a Chevalier of the Legion of Honor in 1870 but, with the outbreak of the Franco-Prussian War, he went to London. He returned to France in 1871, settling in Saint-Germain-en-Laye, not far from Paris, and took up his favorite themes until blindness ended his career.

In 1873 Bonvin painted *L'Ecole des Frères*—the most elaborate treatment of his classroom subjects. Unlike the earlier versions, it presents a scene in a boys school with a Christian Brother rather than a nun presiding over girls. The painting was exhibited at the Salon of 1874. Labarthe praised it for its liveliness of observation, noting the boy with his hand in the air "asking permission for you-know-what." De Hauranne described it as a "small *chef-d'oeuvre* . . . comparable to the best of Dutch painting" but he found the figure of the teacher "a little vulgar."[2] This is perhaps explained by the fact that, although Bonvin drew the classroom and students from a local school, he found the face of the actual master uninteresting and substituted the features of a former convict.[3] The name *Jarre* which appears on the wood basket at the lower right is that of the man who purchased the painting even before the Salon opened.[4]

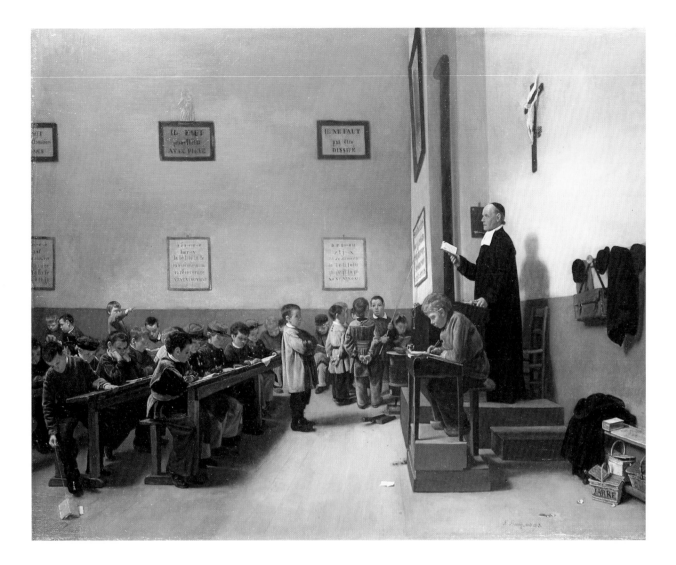

The painting evoked enthusiastic response from critics committed to the Realist aesthetic. Jules Claretie wrote:

> Do you want to see truth, sincerity, and reality in art? Then look at *L'Ecole des Frères* by M. François Bonvin. Here is a masterpiece, an honest work where the faithfulness of the impression has not prevented a finished composition. How powerful is the interior of this school; this painting is astonishing in its light and life, with a warm golden light bathing it to create an interior both comfortable and serious! And what, for heaven's sake, is this painting? Has the painter crossed the seas to find his subject? The children are seated in front of a Christian Brother, working. Nothing more. Anyone could find this within ten minutes of their own home. But what variety in the attitudes! What modeling in the shaven heads of the boys, blond and brunette! What peace, what majesty in the interior scene resembling an old painting, enveloped in the glorious patina of the future! Pieter de Hooch has done nothing better than this painting by François Bonvin, and it is certainly one of the few canvases which will survive the Salon of 1874.[5]

Bonvin's longtime friend and supporter, the writer Castagnary, praised the work thusly:

> Consider those little children seated in orderly rows, the schoolmaster standing, the posters that paper the walls, the light which illuminates the room, the position and countenance not only of the living creatures, but also and especially of the inanimate objects. Well, then. There you have a painting in the total and absolute sense of the word. It is a pictorial idea expressed through the resources of painting and admirably expressed. It is not possible to be more right and more simple. . . .[6]

[1]Zacharie Astruc, *Les 14 Stations de Salon, 1859*, Paris, 1859, p. 234.
[2]De Hauranne, 1874, p. 677.
[3]Revealed in a letter, quoted in Moreau-Nélaton, p. 89.
[4]Ibid.
[5]Claretie, *L'Art*, 1876, p. 261.
[6]Castagnary, 1892, p. 103.

6. *Le Remords (Orestes Pursued by the Furies)*, 1862
Oil on canvas, 89½ x 109⅝ inches (227.3 x 278.5 cm.)
Signed and dated at the lower right: *W. BOUGUEREAU*
1862

The Chrysler Museum, Norfolk. Gift of Walter P.
Chrysler, Jr., 1971.

Provenance: Purchased from the artist for Samuel P. Avery
by George A. Lucas, 1870; Mrs. Joseph Harrison,
Philadelphia, presented to The Pennsylvania Academy of
Fine Arts, Philadelphia, 1878; Giovanni Castano, Boston;
Walter P. Chrysler, Jr.

Exhibitions: Salon, Paris, 1863, no. 227; Dayton, 1960,
no. 43.

Bibliography: Paul Mantz, "Salon de 1863," *GBA*, 1863,
p. 488; Théophile Gautier, "Salon de 1863," *Le Moniteur
Universel*, June 20, 1863, p. 1; C. de Sault, *Essais de
critique d'art: Salon of 1863*, Paris, 1864, pp. 31-34; Louis
Auvray, *Exposition des Beaux-Arts, Salon de 1863*, Paris,
1863, p. 39; J. Girard de Rialle, *A Travers le Salon de 1863*,
Paris, 1863, pp. 67-68; Strahan, *Treasures*, 1881, II, p.
104; Bellier and Auvray, 1882, I, p. 135; Baschet, 1885,
pp. 24-26; Pennsylvania Academy of Fine Arts, *Descriptive
Catalogue*, Philadelphia, 1892, no. 401; *Album of Repro-
ductions*, Pennsylvania Academy of Fine Arts, Philadel-
phia, 1892, pl. 19; Vachon, 1900, p. 147; *Bouguereau,
Masters in Art*, Oct. 1906, p. 41; Helen W. Henderson,
The Pennsylvania Academy of Fine Arts, Boston, 1911, pp.
164-65, ill.; *Apollo*, 1978, p. 22, fig. 4; Randall, 1979, II,
pp. 320, 322-323, and 332; William Hauptman, "Charles
Gleyre: Tradition and Innovation," *Charles Gleyre 1806-
1874*, exhibition catalogue, Grey Art Gallery, New York,
1980, p. 50, fig. 63.

Shown in Norfolk only.

Bouguereau was born in the seaport city of La Rochelle
and remained attached to it throughout his life, al-
though much of his youth was spent with an uncle who
was the parish priest at the nearby village of Mortagne.
This uncle not only gave Bouguereau a religious educa-
tion but encouraged his interest in the arts and arranged
for him to receive lessons at the college at Pons from a
former student of Ingres. Bouguereau's father at first ob-
jected to his son's career in art, calling him to Bordeaux
to assist in business. But the young man, displaying the
diligence that characterized his whole career, entered
the Ecole des Beaux-Arts there and supported himself for
a time painting portraits, until his uncle helped him to
go to Paris in 1846. There he entered the studio of Picot

and after two months was admitted to the Ecole des
Beaux-Arts. His first Salon showing was in 1849 and the
following year he won the Prix de Rome.

Bouguereau remained in Italy for four years. In addi-
tion to studying the Italians and the Italian landscape,
he was influenced by the works of Raphael and Giotto.
In Rome he painted the *Triumph of a Martyr: St. Cecelia
Carried to the Catacombs*, a large multi-figured work of
great seriousness which, when shown at the Salon in
Paris, caused much comment, was purchased by the
State, and launched the young artist's career. He re-
ceived a series of private commissions and his salon en-
tries continued to be well received. He won a second
class medal at the 1855 Exposition Universelle, a first
class medal in 1857, and was made a Chevalier in the
Legion of Honor in 1859.

Bouguereau's Salon entries tended to be nudes, myth-
ological figures, religious themes, and occasionally clas-
sical history. In the Salon of 1863, for example, he had
three works, a *Holy Family* (purchased by Napoleon III),
a *Bacchante*, and the large classical subject entitled *Le
Remords*, (Remorse). While the first two won general
approval, *Le Remords* did not. The "remorse" is that of
the classical figure Orestes, given its most memorable
form in the tragedies by Aeschylus. Having murdered his
mother Clytemnestra to avenge her murder of his father,
the King Agamemnon, Orestes was confronted by the
three Furies or Eumenides—Alecto, Megaera, and
Tisiphore. These snakey-haired spirits of retribution
drove him first to Delphi and then to Athens in search
of purification. In the painting, Orestes covers his ears
so as not to hear their accusations, as they point
dramatically (like Fuseli's famous *Macbeth* witches) to
the corpse of Clytemnestra. The setting is night and one
fury (of whom a preliminary drawing is reproduced in
Vachon, p. 47) holds a torch which casts a lurid glow
over the grisly scene.

This subject was a throwback to a type of grandiose
neo-classical composition practiced earlier in the cen-
tury. As several critics noted, it probably derived from
Pierre-Paul Prud'hon's famous 1808 painting *Divine Jus-
tice Pursuing Crime* (now in the Louvre). Bouguereau's
work was felt to be less successful in capturing the sense
of the culprit's remorse, though Ernest Chesneau, in one
of the few flattering reviews, wrote that the painting,
although "a little melodramatic in conception," de-
served to occupy a choice location in a court of law.[1]

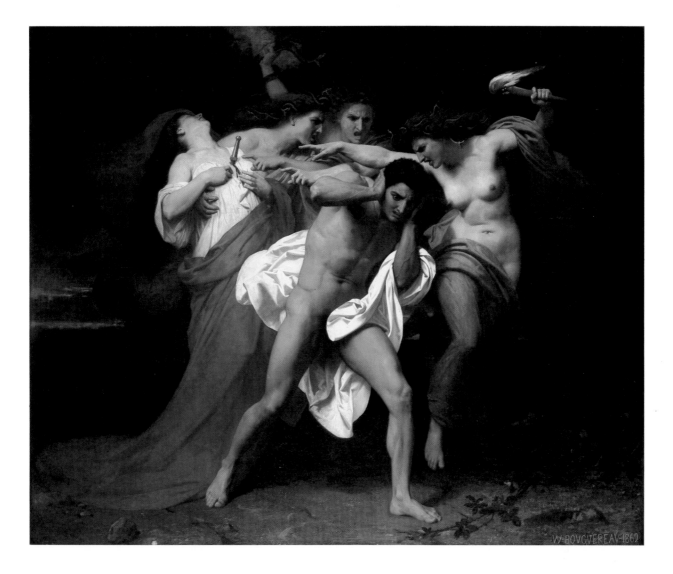

Most criticism, however, followed the line of Paul Mantz, who wrote in the *Gazette des Beaux-Arts:*

> Very few among the artists of the young academic school are capable of conceiving a great *ensemble* or finding a new motif. M. Bouguereau's *Remords,* where one sees a criminal pursued by the vengeful furies, is nothing more than a vulgar composition, one in which the search for melodrama has eliminated all vestiges of beauty.[2]

And the influential Théophile Gautier condemned the work, writing:

> From classicism M. Bouguereau has fallen into academism in the worst sense of the word. His large oil *Remorse* recalls too much a school composition. The artist instead of tapping his own originality seems to resort to imitation. . . . Without doubt the group is designed by a capable hand, but where are the fear, the secret, spiritual terror, the fantastic oppression that ought to motivate such a scene.[3]

The only other work in which Bouguereau had attempted to recreate such a dramatic classical scene with similar large-scale nudes was the *Battle of the Centaurs and the Lapiths* of 1853 (now Bouguereau family). Bouguereau, sensitive to criticism, did not return to this type of subject matter and commented later, "I soon found that the horrible, the frenzied, the heroic does not pay and as the public of today prefers Venuses and Cupids and I paint to please the public, it is to Venus and Cupid I chiefly devote myself."[4]

[1]Quoted in Baschet, 1885, p. 26.
[2]Mantz, *GBA,* 1863, p. 488.
[3]Gautier, *Moniteur Universel,* 1863.
[4]Quoted in Alfred Werner, "Great Boug-Bear of Academic Painting," *Antioch Review,* Dec. 1955, p. 490. Bouguereau made a similar statement in an interview in *L'Eclair,* May 9, 1891.

7. *Promenande à âne (Return from the Harvest)*, 1878
Oil on canvas, 95 x 67 inches (241.3 x 170.2 cm.)
Signed and dated at the lower left: *W. BOUGUEREAU 1878*

Cummer Gallery of Art, Jacksonville.

Provenance: Mrs. Cornelia M. Stewart, 1878; Sale, American Art Association, Chickering Hall, New York, March 25, 1887, no. 213; Elliot F. Shepard, New York; W. J. Scheiffelin, New York; New York Theatres Co., E. F. Albee; Hirschl and Adler, New York, 1963.

Exhibitions: *Muse or Ego: Salon and Independent Artists of the 1880s*, Pomona College Gallery, Claremont, California, 1963, no. 10; *Artists of the Paris Salon*, Cummer Gallery of Art, Jacksonville, 1964, no. 6; *The Past Rediscovered: French Painting 1800-1900*, The Minneapolis Institute of Arts, 1969, no. 6; *William Adolphe Bouguereau*, New York Cultural Center, Dec. 13, 1974 - Feb. 2, 1975, no. 14.

Bibliography: Strahan, *Treasures*, 1881, I, p. 44; Baschet, 1885, p. 58; *Catalogue of the A. T. Stewart Collection*, 1887, p. 104; *Artistic Houses*, New York, 1883, I, part I, p. 12; "William Adolphe Bouguereau," *The Art Amateur*, Jan. 1895, p. 54; Vachon, 1905, p. 153; Mahonri Sharp Young, "The Past Rediscovered at Minneapolis," *Apollo*, Aug. 1969, p. 158, fig. 1; Robert Rosenblum, "The 19th-Century Franc Revalued," *Art News*, 68, Summer 1969, p. 29; Albert Boime, *The Academy and French Painting in the Nineteenth Century*, London, 1971, p. 104, fig. 62 (as *Retour des moissons*); Cummer Gallery of Art, *Hand Book of the Permanent Collection*, Jacksonville, 1976, cover; *The Peasant in French XIX Century Art*, exhibition catalogue, Douglas Hyde Gallery, Trinity College, Dublin, 1980, fig. 15; Jay Cantor, "Rise of the Millionaire's Mansion," *Winterthur Portfolio*, 10, 1975, p. 188.

Shown in Atlanta only.

In the 1870s further honors flowed to Bouguereau. He was appointed a professor at the Ecole des Beaux-Arts in 1875, elected to the Institute and made an Officer in the Legion of Honor in 1876, and won a medal of honor at the Exposition Universelle of 1878. Bouguereau's success was international; he became very popular with American collectors. The New York merchant A. T. Stewart gave the artist a commission in 1874, "with the understanding that the painting was to be the artist's greatest work, and not a nude subject."[1] The result, *Promenade à âne*, was finished after Stewart's death in 1878, but was hung by his widow in a place of honor in his art gallery.

Despite the French title given by the artist, Strahan, in his discussion of the Stewart collection, refers to the work as *Return from the Harvest*. He notes that it was inspired by a painting in the Louvre of dancing peasants by Léopold Robert. Bouguereau's figures, however, are not shown returning from a harvest, but dancing in celebration of a vintage festival. Bouguereau might well have witnessed such a scene during his years in Italy. The celebrating peasants have selected a child to personify the infant Bacchus, pagan god of wine, crowned him with grape leaves and given him the thyrsus. But by placing him on the donkey accompanied by his melancholy mother, Bouguereau created what Strahan called "a pagan Madonna." Bouguereau often combined pagan and Christian elements in this way. He painted many scenes in which Italian peasants were given a classical grandeur, suggesting that they represented a kind of "living antique."

René Menard's 1875 assessment of Bouguereau is particularly apt in relation to this work:

Rusticity is not with this painter an instinctive sentiment, and if he paints a patched petticoat he yet suggests an exquisitely clean figure: the naked feet he gives to his peasant-women seem to be made rather for elegant boots than for rude sabots; and, in a word, it is as if the princesses transformed into rustics by the magic wand in the fairy tales had come to be models for his pictures, rather than the fat-cheeked lasses whose skin is scorched by the sun and whose shoulders are accustomed to heavy burdens. But, having made this reserve, it must be acknowledged that M. Bouguereau's children are delightful, and his composition charming; his drawing is correct, even to rigidity; he possesses a gracefulness and a fecundity of invention attested by the immense number of his pictures. To sum up in few words our impression of the painter's characteristics—whether he paints mythological subjects or rustic scenes, Bouguereau always exhibits three qualities which justify his reputation—knowledge, taste, and refinement.[2]

To achieve these qualities Bouguereau followed a careful academic routine of preliminary designs and oil sketches. An example of the latter in the collection of the artist's descendents shows the figures of this composition roughly blocked out but gives different poses to the two dancing peasants at the left.[3] In this sketch, the boy, reminiscent of a Murillo beggar, holds the tambourine, while in the finished painting it is given to the girl. In order to paint the surprisingly realistic donkey (which reappears in his *Flight into Egypt* in Saint Vincent-de-Paul), Bouguereau is said to have borrowed one from the extensive menagerie of his friend and neighbor Rosa Bonheur.

[1]*Catalogue of the A. T. Stewart Collection*, New York, 1887, p. 104.
[2]R. Menard, quoted in Clement and Hutton, I, pp. 80-81.
[3]Boime, 1971, fig. 61.

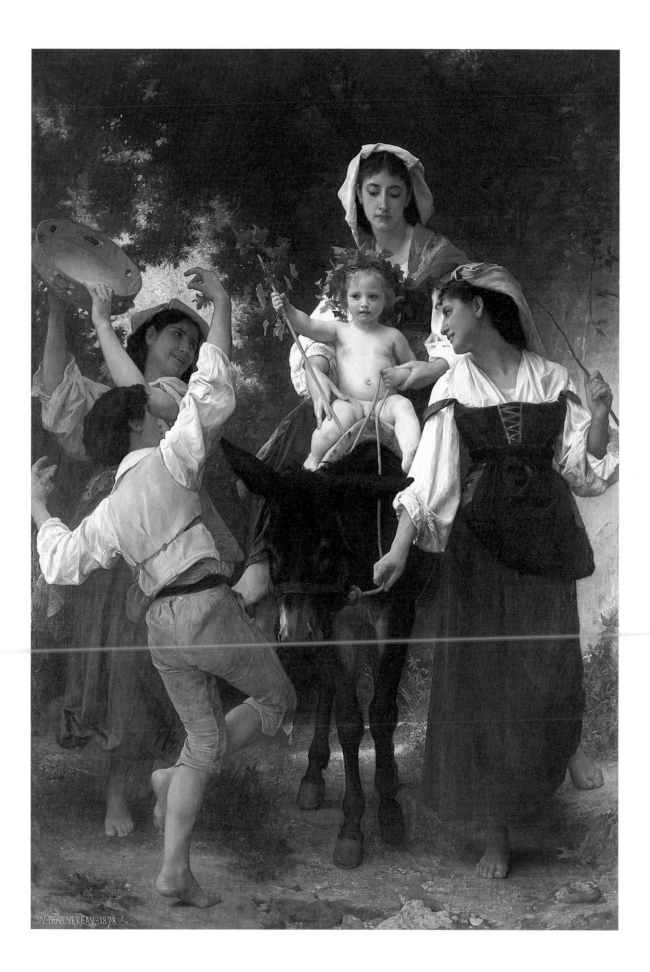

8. *Jeune fille se défendant contre l'Amour, (Girl Defending Herself Against Love)*, 1880
Oil on canvas, 63¼ x 44⅞ inches (160.7 x 114 cm.)
Signed and dated at the left on the rock:
W. BOUGUEREAU 1880

University of North Carolina at Wilmington.

Exhibitions: Salon, Paris, 1880, no. 444.

Bibliography: *Illustrated Catalogue of the Paris Salon*, London, 1880, p. 103; Armand Silvestre, "Le Nu," *L'Exposition des Beaux-Arts (Salon de 1880)*, Paris, 1880, n.p., pl. 26; Ph. de Chennevieres, "Le Salon de 1880," *GBA*, 1880, p. 510; Louis Enault, *Guide du Salon*, Paris, 1880, p. 7; Th. Veron, *Dictionnaire Veron: Salon de 1880*, Paris, 1880, p. 18-19; Emile Michel, "Le Salon de 1880," *Revue des deux mondes*, June, 1880, p. 678; H. Cochin, "Le Salon de 1880," *Le Correspondent*, 1880, p. 737; Ph. Burty, "Le Salon de 1880," *L'Art*, 1880, p. 154; Roger Ballu, *La Peinture au Salon de 1880*, Paris, 1880, pp. 62-63; Henri Olleris, *Mémento du Salon de Peinture en 1880*, Paris, 1880, p. 14; Charles Carroll, *The Salon (of 1880)*, New York, 1881, I, pp. 211-212; Baschet, 1885, p. 59; Vachon, 1900, p. 154; *Les Arts*, no. 49, January 1906, p. 26; Burton B. Fredericksen, *Catalogue of The Paintings in the J. Paul Getty Museum*, Malibu, 1972, no. 102; R. Isaacson, *Bouguereau*, exhibition catalogue, New York, 1975, p. 26; R. Isaacson, "The Evolution of Bouguereau's Grand Manner," *Minneapolis Institute of Arts Bulletin*, 1975, pp. 77, 83; *Four Centuries of French Drawings*, exhibition catalogue, The Fine Arts Museum of San Francisco, 1977, under no. 207.

At the Salon of 1880, Bouguereau, following his usual pattern, exhibited two dissimilar works: a powerful large-scale religious painting, *The Flagellation of Christ* (now in the Cathedral of La Rochelle), and this work, referred to by the Marquis de Chennevieres as "one of his best *mythologies*."[1] This *Jeune fille se défendent contre l'Amour* had disappeared until the present exhibition and was known only through an engraving by Leenhoff, a small replica formerly in the Watson collection and now in the J. Paul Getty Museum (Malibu), and an 1885 drawing after the original.[2]

Although the Salon critics devoted most of their attention to the *Flagellation*, for which they found Bouguereau's refined style unsuitable, those who did mention the *Jeune fille* found it to their liking. Armand Silvestre, for example, gave the following description:

In front of a vague luminous landscape, in the shade of a tree with calculatedly jagged foliage, a young girl is seated on a large rock, her back slightly curved, and with her two outstretched hands she repulses a winged child who with his right hand threatens her with an arrow, while, with his small left leg, he tries to scale the knees of his victim. The

drawing of the girl's body stands out agreeably against the background and the depiction of its lines is truly harmonious. The attitude of the arms have the rigidity of a conventional pose, but are not inappropriate. It is only the expression of the face, a little affected and simple, which lacks a certain charm. The feet balanced squarely upon the toes are charming. The body of the infant is weakly modeled, but has to it a very agreeable sentiment, and the amber tones of the skin make a pretty effect against the light background.[3]

And Lucy Hooper in the *Art Journal* wrote:

In . . . A *Young Girl Resisting the Attacks of Love*, the painter has found a more congenial theme and has treated it with his usual felicitous charm. The nude nymph who laughingly holds off at arm's length a rosy audacious Cupid who has swooped down upon her from mid-air, fully armed and ready for conquest, is exquisite in drawing and very lovely in color. Her warm, brunette coloring contrasts admirably with the rosy fairness of the God of Love.[4]

Having the original to study once again, we can agree that, although the struggle is unconvincing, the balance between form and color is masterly. Perhaps Bouguereau intended to suggest the thorny path of love by the prominent place given the bramble plant.

As was his practice, Bouguereau carefully prepared his composition in advance. A fine drawing of the nude girl was reproduced in several nineteenth century publications.[5] The idea for this composition may have been derived from Jules-Joseph Lefebvre's painting *Nymph and Bacchus*, shown at the Salon of 1866, in which the nymph is seated in a similar manner and playfully withholds a bow and arrow from the child Bacchus.[6] Bouguereau, however, made the theme his own, repeating it in several paintings.[7] The particular types that the painter employed here were also found in other works. The model for the young girl, as pointed out by Robert Isaacson, is the same one employed by the painter in another painting of that same year, *Temptation*, now in Minneapolis.[8] The adolescent Cupid with his mass of golden curls was Bouguereau's standard type for this figure and occurs in a number of paintings, such as the *L'amour désarmé* of the Salon of 1886.

[1]*GBA*, 1880, p. 510.
[2]See Isaacson, *Bouguereau*, 1975, no. 17; and *Four Centuries of French Drawing*, 1977, no. 207.
[3]Silvestre, *Salon de 1880*, n.p.
[4]Quoted by Isaacson, 1975, p. 16.
[5]René Ménard, "Bouguereau," *Grands Peintres français et étrangers*, Paris, 1884, I, p. 4; and *The Art Amateur*, Jan. 1895, p. 55.
[6]See *Le Musée du Luxembourg*, exhibition catalogue, Paris, 1974, no. 152.
[7]Stranahan, *History*, 1917, p. 404.
[8]Isaacson, *Minneapolis Institute of Arts Bulletin*, 1975, p. 78.

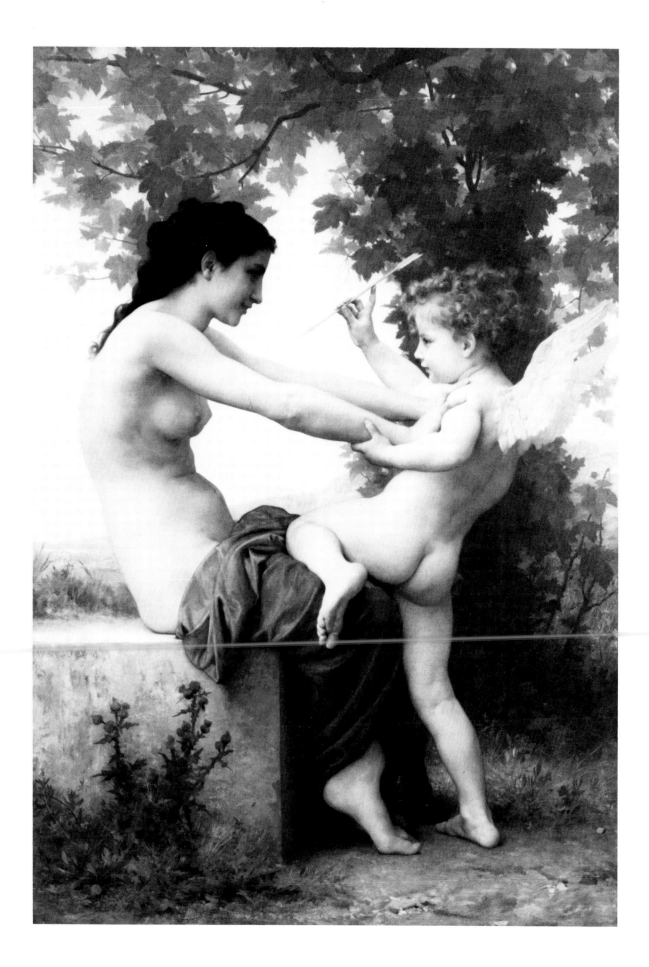

59

9. *The Annunciation,* ca. 1888
 Oil on canvas, 36 x 19¾ inches (91.4 x 50.2 cm.)
 Signed at the lower right: *W. BOUGUEREAU*

 Stuart Pivar Collection. Courtesy of the University of
 Virginia Art Museum, Charlottesville.

 Exhibitions: Hofstra, 1974, no. 10; *Christian Imagery in
 French Nineteenth Century Art 1789-1906,* Shepherd Gal-
 lery, New York, Spring 1980, no. 117.

In Italy, Bouguereau had studied Giotto and other early
painters, Renaissance masters such as Raphael, and the
mosaics at Ravenna. He sought to emulate their sense of
power and reverence in his own religious works, begin-
ning with the 1859 commission for scenes from the life
of Saint-Louis in the Saint's chapel at the Church of
Sainte-Clothilde. This work won the artist his appoint-
ment as a Chevalier of the Legion of Honor. His next
major religious commission came in 1866: the chapel of
Saints Peter and Paul in the Church of Saint-Augustin.

During the mid-1870s, Bouguereau painted two large
religious works to express personal grief: the *Pietà* of
1876 (Pivar Collection, New York) commemorates the
death of his son and the *Vierge consolatrice* of 1877 is in
memory of his first wife. The personal nature of these
works did not, however, prevent Bouguereau from ex-
hibiting them at the annual Salons, where they were
amply praised.[1]

In 1877, the council of Bouguereau's hometown of La
Rochelle commissioned the artist to decorate the local
cathedral's Chapel of the Virgin. Bouguereau worked on
the project over the following two years, depicting seven
traditional scenes from the Virgin's life, including (on
the vault) *The Annunciation.*

With this experience behind him, Bouguereau was
substituted for the painter Hebert to carry out the
large-scale works intended for another chapel devoted to
the Virgin Mary, in Saint-Vincent-de-Paul in Paris. His
sketches were submitted in 1881; the artist and his as-
sistants worked on the project until 1888.[2] *The Annunci-
ation* from this series was exhibited at the Exposition
Universelle of 1889 before being installed in the chapel.
The work exhibited here is a reduced version of that
Annunciation.

We can see here what Vachon described as
Bouguereau's "special type of Madonna, a woman grave
and sad, with large eyes half-covered by drooping lids or
absorbed in mysterious contemplation. The figure is en-
veloped in loose garments, the head covered by a thick
veil, allowing no view of hair or breast."[3] The work has
the delicacy and clarity of a painting by Fra Angelica.
Bouguereau combines traditional elements of Annunci-
ation imagery with his own invention. The Archangel
Gabriel arrives in the Virgin's quarters upon a large
cloud, and makes the traditional salutatory gesture,
pointing to the dove which symbolizes the Holy Spirit.
The angel holds the lily, symbol of purity and the Im-
maculate Conception of the Virgin. In her chamber are
a throne-like chair suggesting her status as Queen of
Heaven, the spinning wheel denoting her diligence, and
the rose bush, also symbolic of her purity. In the earlier
Annunciation at La Rochelle, the figures were shown
kneeling. Here, they stand humbly, barefooted, their eyes
cast down, conveying a sense of profound solemnity.

[1]See Th. Veron, *Memorial de l'art et des artistes de mon temps, Le Salon
de 1876,* Paris, 1876, pp. 27-29, and Baschet, 1885, pp. 53-57.
[2]L'Abbé Henri Doisy, *Saint-Vincent-de-Paul,* Paris, 1942, p. 710.
[3]Vachon, 1900, pp. 72-73.

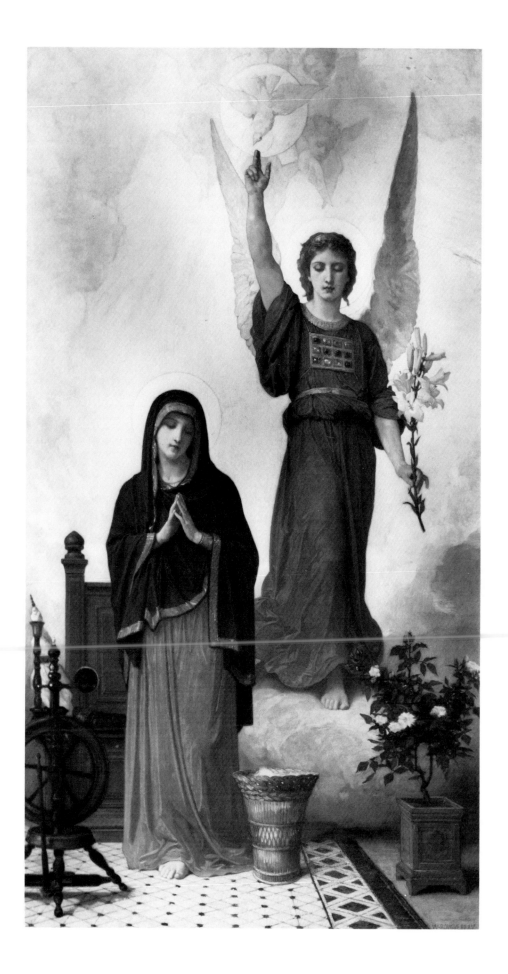

10. *Jeune fille et enfant (Girl and Child)*, 1877
Oil on canvas, 53½ x 39½ inches (135.9 x 100.3 cm.)
Signed and dated at the lower left: *W. BOUGUEREAU 1878*

Kimbell Art Museum, Fort Worth. Bequest of Kay Kimbell.

Provenance: Holland Galleries, Chicago; Kay Kimbell, Fort Worth, 1942.

Bibliography: Baschet, 1885, p. 56; Vachon, 1900, p. 153; *Handbook of the Collection*, Kimbell Art Museum, Fort Worth, 1981, p. 115.

11. *Inspiration*
Oil on canvas, 38¾ x 25½ inches (98.4 x 64.8 cm.)
Signed and dated at the lower right: *W. BOUGUEREAU 1898*

Columbus Museum of Arts and Sciences, Columbus, Georgia. Gift of Mrs. Richard Jennings, 1955.

Provenance: Mrs. Richard Jennings, Columbus.

Exhibitions: Salon, Paris, 1898, no. 273.

Bibliography: *Catalogue illustré, Paris Salon, 1898*, Paris, 1898, p. 247; Antonin Proust, *Goupil's Paris Salon, 1898*, Paris, 1898, p. 247; Vachon, 1900, p. 160.

According to Bouguereau's biographer Vachon,

few artists have represented childhood with more tenderness, charm, and spirit than Bouguereau. To portray the innocence, the mischief, the smiles, or the caresses of these dear little ones, to express the rose and white flesh tones, the curly hair, the attitudes, the gestures, so simple, so ingenuous, so graceful, he has invented the most picturesque, the most pleasing, the most original scenes of an almost endless variety.[1]

Indeed each year the painter produced some variation on the theme of motherhood or children playing together, and Vachon's sentimental appreciation gives us an idea of the response these paintings evoked. As in the present example, the large figures were usually placed in idyllic outdoor settings.

Although dated 1878, this painting is probably the 1877 work listed by both Baschet and Vachon as *Jeune fille et enfant*. It was often the artist's practice to date a work at the time he sold it rather than when it was painted, and in this case the girl seems too young to justify the title *Motherhood*, which has previously been applied to it.

Bouguereau was renowned for the perfect finish of his paintings, yet this work allows us to see rare example of a pentimento. The artist changed the position of the girl's right foot, but the original image can still be seen slightly to the left at the lower edge.

Bouguereau also often painted allegorical figures. Strahan described one of the earliest of these, *Art and Literature* of 1867, as by the "faultily faultless Bouguereau," and went on to say:

Whoever loves exalted refinement for its own sake, divested of imagination and originality, will have a feast in this effort of Bouguereau's at allegory. The Muses are depicted as young Greeks who have additionally acquired by some happy anachronism the modern repose of the Paris drawing room. . . . Literature, sitting with tablet and stylus, is serenely calm and will evidently turn out sophomore verses as correct as Bouguereau's pictures.[2]

Bouguereau continued to repeat the theme and the same type of idealized female figure he had used for Literature became the 1891 *Inspiration*—a young woman with tablet and stylus and crowned with an ivy wreath who gazes meditatively into the distance. In 1898 Bouguereau repeated the theme in a work called *La Rêve (The Daydream)* and also this version of *Inspiration* which was exhibited at the Salon that year. In this painting, the artist emphasizes the classical association through the ornamentation of the pedestal upon which the figure leans, as she receives her inspiration.

[1]Vachon, 1900, trans. in *Bouguereau, Masters in Art*, Oct. 1906, VII, p. 411.
[2]Strahan, *Treasures*, 1881, III, p. 76.

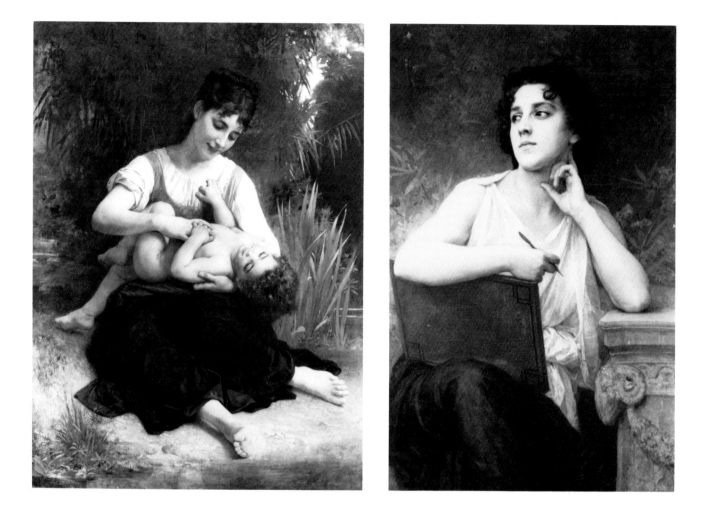

12. *Le Ravissement de Psyche (Abduction of Psyche),*
1895
Oil on canvas, 82 x 47 inches (209 x 120 cm.)
Signed and dated at the lower left: *W.*
BOUGUEREAU 1895

Stuart Pivar Collection. Courtesy of the University of
Virginia Art Museum, Charlottesville.

Provenance: Sale, Sotheby's, London, October 15,
1975, no. 19.

Exhibitions: Salon, Paris, 1895, no. 258.

Bibliography: *Catalogue illustré Salon de 1895,* Paris,
1895, p. 233; Thiébault-Sisson, *Salon de 1895,* Paris,
1895, pp. 24-25, ill.; *Figaro Salon,* no. 1, April 1900, p.
15; Vachon, 1900, p. 159; Letts, *The Hundred Best Pic-*
tures, 1901, p. 27; *Les Arts,* 1906, 49, p. 26; *Burlington*
Magazine, Dec. 1975, p. ii; *The Connoisseur,* Dec. 1975,
p. 997, no. 766, fig. 7; *Apollo,* Jan. 1976, p. 76, fig. 2.

Clear proof that Bouguereau maintained his mastery well
into his old age is provided by this ravishing painting
that he exhibited at the Salon of 1895. The myth of the
princess Psyche and the god Cupid, compiled in the 2nd
century A.D., had provided a source of inspiration for
French neo-classical artists such as Gerard, Picot, and
Prud'hon. In his painting now in the Louvre, Prud'hon
adheres to the story and shows the girl transported on
Cupid's order by Zephyrus, the West Wind. Bouguereau,
who dedicated several canvases to the subject,[1] instead
seeks to capture the general spirit of the myth and makes
his theme the triumph of love: Cupid himself carries off
the swooning girl. This is an adolescent Cupid, grown
up from his appearance in the earlier work of 1880 (cat.
no. 8). The highly polished finish of his muscular body
put the writer Thiébault-Sisson in mind of the sculptor
Canova, and in his description of the painting he man-
ages also to convey the tremulous eroticism that un-
doubtedly contributed to Bouguereau's continuing
popularity:

> It is Psyche carried off to heaven by love. She is truly
> pretty, this Psyche. We recognize in her the Italian model
> who has posed sometimes as a brunette, sometimes as a
> red-head, for the artist, in his most recent works. A Cupid,
> no less Italian, irreproachable in design, a little thin
> perhaps, but nevertheless well-proportioned, enwraps her
> in his strong arms, while the wings lift them triumphantly
> into the sky. In an ingenuous pose, not lacking in affecta-
> tion, Psyche, like a butterfly in flight, surrenders herself;
> her eyes closed, she inclines her head and with her hands
> she unconsciously covers her naked breasts that the rapture
> of love has caused to tremble. This is the kind of thing that
> young girls dream of.[2]

The richness of Bouguereau's color scheme, with the
purple of the luxurious drapery reflected in the tints of
the sky and water, is reminiscent of works by Lord
Leighton, the English Victorian artist *par excellence.*

A preliminary oil study for this composition was ex-
hibited at the Galerie Bretteau in Paris in 1965-66.

[1]Vachon, 1900, p. 84; one was exhibited in the Salon of 1889 and was
in the collection of Sir Thomas Nettleford, Melbourne, Australia
(1938). There was also a version in which both figures were shown as
children.
[2]Thiébault-Sisson, p. 25.

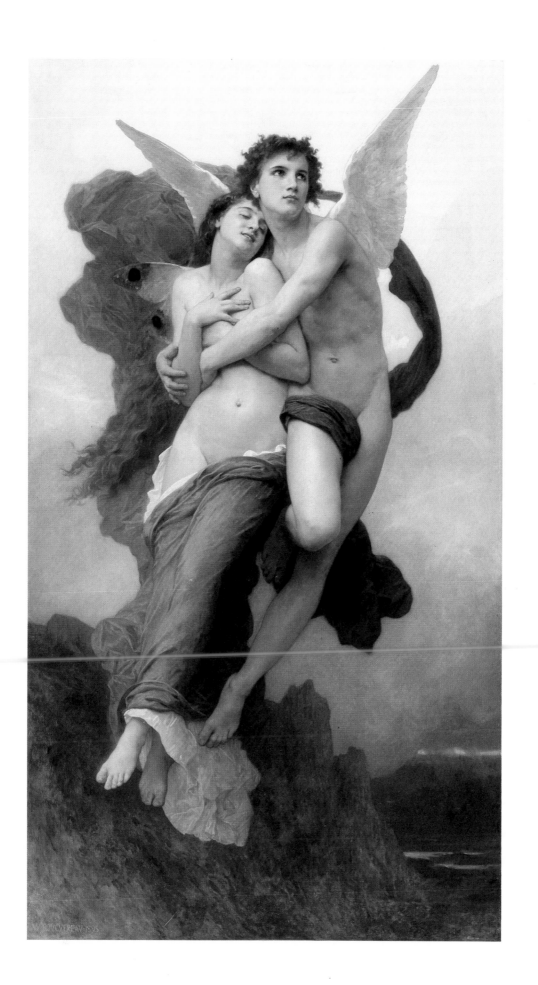

13. *La Saint-Jean (Festival of St. John),* 1875
Oil on canvas, 44 x 76¾ inches (111.8 x 194.9 cm.)
Signed, dated, and inscribed at the lower right: *Jules Breton Courrières 1875*

The Chrysler Museum, Norfolk. On loan from Walter P. Chrysler, Jr.

Provenance: Moet, Rheims; Comte de Vogue; Tedesco Frères, Paris; Walter P. Chrysler, Jr.

Exhibitions: Salon, Paris, 1875, no. 297; Dayton, 1960, no. 45.

Bibliography: Anatole de Montaiglon, "Salon de 1875," *GBA*, July 1875, p. 16; Th. Veron, *De l'art et des artistes de mon temps; Salon de 1875*, Paris, 1875, p. 71; Amedée Besnus, *Salon de 1875*, Paris, 1875, pp. 13-14; Stephan Renal, *Lettres sur le Salon de 1875*, Brest, 1875, pp. 45-47; A. de la Fizelière, *Mémento du Salon de Peinture . . . en 1875*, Paris, 1875, p. 18; P. de la Flécherye, *Le Salon de 1875*, Paris, 1875, pp. 9-10, 131; Lucy H. Hooper, "The Salon of 1875," *The Art Journal*, p. 190; Mario Proth, *Voyage au Pays de peintres*, Paris, 1876, p. 16; *Salon de 1875: Reproductions des principaux ovurages accompagnées des sonnets par Adrien Dézamy*, Paris, Goupil and Co., 1876, p. XII; Claretie, *L'Art*, 1876, pp. 309-310; Montrosier, 1882, 3, p. 55; *Criticisms From Foreign Journals upon Jules Breton's Salon Picture of 1882*, New York, 1883, pp. 12, 66; Marius Chaumelin, *Portraits d'Artistes*, Paris, 1887, p. 94, no. 42; Castagnary, 1892, pp. 162-163; J. Breton, *Nos Peintres du siècle*, Paris, 1899, p. 210; E. Montrosier, "Jules Breton," *Grands Peintres français et etranges*, Paris, 1895, I, pp. 33, 48; Roger Peyre, *La Peinture Française*, Paris, n.d., p. 183; Doucet, 1905, p. 195; Stranahan, *History*, 1917, p. 386; M. Vachon, *Jules Breton*, Paris, 1919, pp. 94-95, 138, 144, rep. opp. p. 72; Hollister Sturges, Annette Bourrut-Lacouture, *Jules Breton and the French Rural Tradition*, exhibition catalogue, Joslyn Art Museum, Omaha, 1982, pp. 19, 30, 132, 135.

Shown in Norfolk only.

Jules Breton was born to a prosperous family in the village of Courrières and, although he made his reputation in Paris, it was to this village that he frequently returned for inspiration. He received his first formal art training in Belgium and then in Paris at the atelier of Michel-Martin Drolling, where he became friendly with Henner. His earliest major works in the realist manner depicted the despair and misery of the poor. In 1853 he exhibited *Return of the Reapers*, the first of his many works detailing the activities of rural life. The artist established a small atelier in Courrières and there conceived the idea for *The Gleaners*, which brought his first official recognition: a third class medal at the 1855 Salon.

Breton was primarily interested in recording the traditions, rituals, and festivals of rural life, and treated these themes in such large-scale works as *Blessing the Wheat* (Salon of 1857), *Dedication of a Calvary* (1858) and *The Great Pardon in Brittany* (1869). He was ex-coriated by Zola and others for the lack of realism in his calculated, romanticized compositions. But Gautier sensed "a profound sentiment in the rustic beauty of Breton's work, which distinguished him from other painters of peasant life," and went on to observe:

> This artist, truly worthy of the great name he has today, understood the severe, serious, and strong poetry of the countryside, which he renders with love, sincerity and respect. The essential work of man has its grandeur and sanctity; who knows better how to regard these people; they solemnly carry out in the proper fashion their religious rites, with almost hieratic forms and attitudes, as if they were celebrating the rites of the ancient Cybele.[1]

Breton eventually broadened his style and sought more classical proportions. He also travelled to other regions of France, including Brittany, to study and record local customs and color. At the Exposition Universelle of 1867, he exhibited ten paintings, was awarded a first-place medal, and was made a Commander of the Legion of Honor.

In 1875 Breton published a volume of poems, *Les Champs et la mer*, and several of the critics at that year's Salon recognized that his large painting *La Saint-Jean* seemed to be described in one of these poems, a verse of which reads:

> *Tandis que dorment les faucilles*
> *Aux hangers, vers la fin du jour,*
> *Autour des feux les jeunes filles*
> *Dansent en rond au carrefour.*[2]
>
> (When the sickles are laid
> in the sheds at the end of the day,
> The girls dance in a circle
> around the bonfire at the crossroads.)

The annual festival of St. John, celebrated on June 24 with a large bonfire, was also fondly remembered by Breton in his autobiography: ". . . all the women and girls assemble at the crossroads of the village and dance and sing roundelays in the twilight, often prolonging their festivities far into the night."[3] Breton has localized the scene, by including the church spire of Courrières, as he had done in *The Gleaners*.

The painting was generally well received and particularly admired for its sensitive blending of the twilight with the glow of the fire. Veron called it the "most complete genre painting in the exhibition."[4] But de la Flécherye pointed out there was a certain *opéra-comique* quality to the peasant girls and observed that if the work were placed next to one by Millet, Breton's figures would be easily overshadowed.[5] A replica of this painting is in the Philadelphia Museum of Art.

[1] Quoted in *Equivoques*, 1973.
[2] Quoted in Renal, 1875, p. 45.
[3] Jules Breton, *The Life of an Artist*, trans. by Mary J. Serrano, New York, 1890, p. 71. For a discussion of the celebration see Charles le Goffic, *Fêtes et Coutumes populaires*, Paris, 1923, pp. 79-86.
[4] Veron, 1875, p. 71.
[5] P. de la Flécherye, 1875, p. 131.

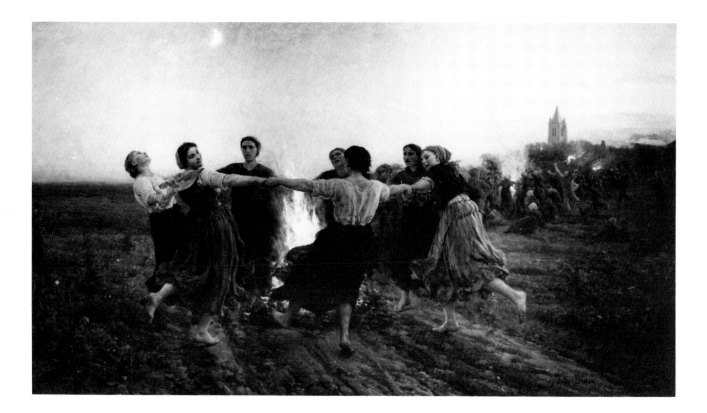

14. *Othello recontant ses batailles (Othello Relating His Adventures)*, 1857
Oil on canvas, 45½ x 51½ inches (115.6 x 130.8 cm.)
Signed at the lower right: *ALEX. CABANEL*

The J. B. Speed Art Museum, Louisville.

Provenance: B. Fould, Paris, 1857; H. Shickman Gallery, New York, 1971.

Exhibitions: Salon, Paris, 1857, no. 420; *The Neglected 19th Century, Part II,* H. Shickman Gallery, New York, Oct. 1971, no. 3.

Bibliography: Edmond About, "Salon de 1857," *Le Moniteur Universel,* Sept. 24, 1857, p. 1048; Alice Meynell, "Alexandre Cabanel," *Magazine of Art,* 9, 1886, pp. 272-273; Georges Lafenestre, "Alexandre Cabanel," *GBA,* 1889, p. 272; Tabarant, p. 243; Saunier, II, p. 131; Bénézit, II, p. 238; *J. B. Speed Art Museum Handbook,* ed. by John F. Martin, Louisville, 1973, p. 24; Shepherd Gallery, 1975, p. 245.

Shown in Atlanta only.

Born in Montpellier, Cabanel showed an aptitude for drawing at a remarkably early age. Winning first prize in a local competition allowed him to go to Paris in 1840. There he entered the studio of François Picot and trained for four years. He first exhibited at the Salon in 1844 with *The Agony of Christ.* The following year he competed with *Christ on Trial* for the Prix de Rome and, although he finished second, a vacancy at the Villa Medici allowed him to receive a five-year pension. Inspired by Raphael and Michelangelo, the works he sent back to Paris were powerful religious subjects, *The Preaching of St. John the Baptist* and *The Death of Moses,* which received a second class medal at the Salon of 1852.

On his return to Paris, Cabanel received a number of important commissions, including *Allegories of the Months* for the Hôtel de Ville, and the *Apotheosis of Saint Louis* for the chapel in the Château of Vincennes. The latter was displayed in a place of honor at the Exposition Universelle of 1855 and won the artist a first class medal, as well as entry into the Legion of Honor. Cabanel also executed many private commissions during

this time for such patrons as the banker Emile Pereire.

In the later 1850s, Cabanel turned from religious subjects to literary and historical themes for his Salon entries—in 1857, his two entries were *Michelangelo Visited in his Studio by Pope Julius II* and *Othello Relating His Adventures,* which is exhibited here. The Salon *livret* printed a condensation in French of Othello's speech in Act I, scene 3, in which he explains his marriage:

Her father lov'd me, oft invited me;
Still question'd me the story of my life
From year to year—the battles, sieges, fortunes
That I have pass'd. . . . This to hear
Would Desdemona seriously incline.

A bit later in the same speech Othello says the more famous lines:

She lov'd me for the dangers I had pass'd;
And I lov'd her that she did pity them.

Cabanel was thus not illustrating a scene that takes place in the play but one which is only described.

On the marble portico of a Venetian palazzo, Othello is shown in the midst of his narration. He wears Moorish clothing and has an enormous battle sword. Desdemona listens to him enraptured, leaning on the knee of her father Brabantio. The costumes, the rugs, draperies, and pillows are luxurious. Hidden from their sight, but gazing fixedly at the viewer from the lower left is a malevolent figure whom we assume to be Iago. His presence at this moment is not noted in Othello's narration, but makes excellent sense dramatically, for from the very first scene of the play Iago is plotting the Moor's downfall. Here we can sense his determination to destroy the lovers at the very moment when love is born.

The large figures in clearly recognizable attitudes (especially Desdemona) recall the art of Delaroche. Shakespearian subject matter had been popularized by the Romantic French painters. Both Delacroix and Chassériau illustrated scenes from *Othello.* Cabanel's choice of this particular moment may have served as the inspiration for some later painters of the subject such as Dehodencq at the Salon of 1873, the German painter Carl Becker in 1880, and Benjamin Constant, whose work (formerly in the Yerkes collection) sets the scene in a gondola.

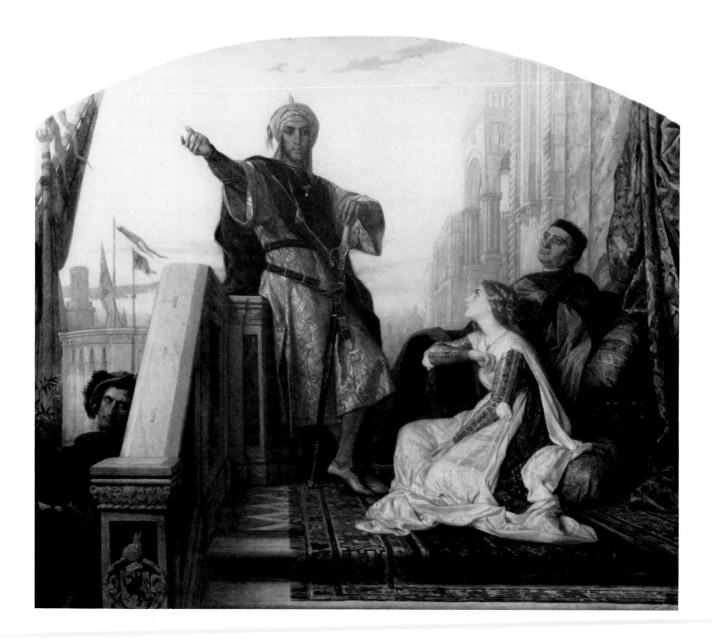

15. *Cléopâtre essayant des poisons sur des condamnés à mort (Cleopatra Testing Poisons on Condemned Prisoners)*, 1887
Oil on canvas, 32 x 56 inches (81.3 x 142.2 cm.)
Signed and dated at the lower left: *Alex. Cabanel 1887*

Stuart Pivar collection. Courtesy of the University of Virginia Art Museum, Charlottesville.

Provenance: Cabanel atelier sale, Galerie Georges Petit, Paris, May 22-25, 1889, no. 1.

Exhibitions: Hofstra, 1974, no. 18; *Orientalism*, Memorial Art Gallery of the University of Rochester and Neuberger Museum, Purchase, New York, Aug. 27 - Dec. 23, 1982, no. 9.

Bibliography: Henri Fouquier, *Catalogue de Tableaux provenant de l'atelier Alexandre Cabanel*, Paris, 1889, p. 16; H. Mireur, *Dictionnaire des vents d'art*, Paris, 1915, II, p. 1; Bénézit, 1948-55, II, p. 238; Patrick Bode, *Femme Fatale*, 1979, pp. 28, 123, 127; Peter Sager, "Femme Fatale," *Zeit Magazin*, no. 14, March 1980, p. 33.

In the early 1860s Cabanel achieved considerable fame with several erotic works inspired by the revival of interest in the eighteenth century. Both the *Nymph Abducted by a Satyr* of 1861 and the even more famous *Birth of Venus* of 1863 were purchased by the Emperor. Then in 1865 Napoleon III commissioned Cabanel to paint his portrait. The artist's achievement in giving a friendly countenance and casual air to the Emperor, who was depicted dressed in a black tailcoat, added to Cabanel's renown, and he was henceforth in demand as a portraitist. His skill at endowing his clients, many of whom were wealthy Americans, with an elegant air can be seen in the 1876 *Portrait of Catharine Lorillard Wolfe* (Metropolitan Museum). Cabanel also continued to receive important public commissions, including the ceiling of the Pavillion de Flore at the Tuileries and scenes from the life of Saint Louis for the Panthéon.

In 1863 Cabanel was not only elected to the Institute but was also appointed, along with Gérôme and Pils, as one of the professors of painting in the reorganized Ecole des Beaux-Arts. Because of his reputation as one of the most distinguished representatives of the academic manner and his influence (between 1868 and 1888 he served on seventeen Salon juries), his atelier was one of the most popular in Paris for aspiring painters. Those of note who passed through it include Benjamin Constant, Fernand Cormon, Pierre-Auguste Cot, and Bastien-Lepage. Such was Cabanel's status by 1870 that an

enthusiastic critic could effuse: "M. Cabanel is not an artist; he is a saint. He doesn't make art; he makes perfection. He does not deserve criticism; he deserves paradise."[1]

Beginning in the 1870s, Cabanel produced a remarkable series of paintings, each of which featured a melancholic female figure in an exotic setting. Among these are *Death of Francesca da Rimini and Paolo Malatesta* (1870, medieval), *Thamar and Absalom* (1873, Oriental), *Phèdre* (1880, classical), and *Cléopâtra essayant des poisons sur des condamnés à mort* (1887, Egyptian). The original Salon painting of this last subject is now in the Museum of Antwerp.[2] It was such a success that Cabanel also painted this reduced replica, which was still in his atelier at the time of his death.

The source for this unusual subject was printed in the Salon *livret*. The lines are from Plutarch's *Life of Antony*, chapter LXXX:

After the defeat of Actium, Cleopatra, realizing the end of her reign was imminent, gathered deadly poisons which she had tested on prisoners condemned to death, in order to determine which would cause the least suffering for her own death.[3]

The text goes on to relate that Cleopatra, finding that "quick poisons always worked with sharp pains, and that the less painful were slow, she next tried venomous animals, and watched with her own eyes whilst they were applied, one creature to the body of another." She concluded "nothing was comparable to the bite of the asp, which without convulsions or groaning brought on a heavy drowsiness and lethargy, the senses being stupefied by degrees."[4]

Nineteenth century France had previously shown considerable interest in Cleopatra and Cabanel had various sources to draw upon, including a lyric scene by Berlioz, a short story by Gautier ("Une Nuit de Cléopâtre") that described identical details such as the slave with a "large fan of ibis feathers," and, most importantly, Gérôme's 1866 painting *Cleopatra before Caesar*. Cabanel's choice of this incident, however, seems to be unique. He treats the grim subject and the Queen's reaction to it with dispassion. Fanned by her attendant, she plays with a lotus as her victims writhe in agony and are carried away. To capture the "Egyptian" flavor, Cabanel has shown Cleopatra in profile. A study of her figure alone is in the Musée de Beziers. Her pet leopard mirrors her impassivity and grace, and may have reminded contemporaries of the great actress Sarah Bernhardt, who for a time had a pet leopard of her own.

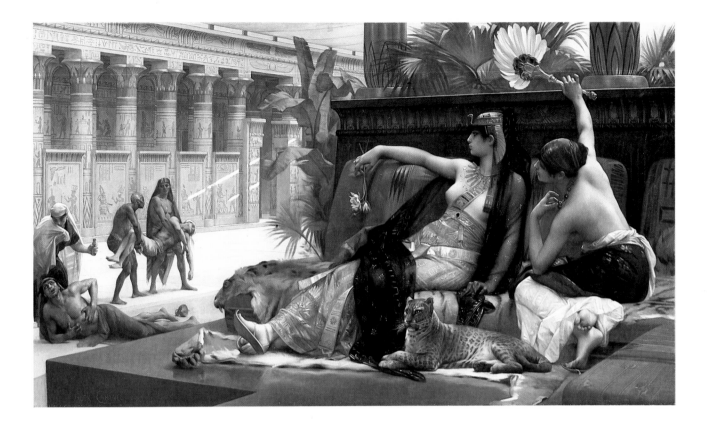

Performances by the Divine Sarah in Racine's play had probably provided the inspiration for Cabanel's *Phèdre*, and in 1890 Sardou wrote her a stage version of the Cleopatra story.

The dead victim carried out before a colonnaded facade is certainly a reminiscence of Tintoretto's famous *Removal of the Body of St. Mark* which, coincidently, was also set in Alexandria. Cabanel has modeled his facade (even including the hieroglyphics) on that of the Temple of Horus at Edfu, which he must have seen in early photographs.[5] The most striking element about this work, however, is the artist's use of color—the variety of pinks, purples, and reds is extraordinary. Also impressive is Cabanel's rendering of the diaphonous shimmer of Cleopatra's garments and jewels.

[1]Camille Lemonnier, *Salon de Paris 1870*, Paris, 1870, p. 30.
[2]Salon, Paris 1887, no. 406. See *Salon de 1887, Catalogue illustré*, Paris, 1887, p. 81; Paul Lambert, *Le Salon 1887–paru dans le Journal "La Nation,"* 1887, p. 46; *Le Livre d'or*, Paris, 1887, p. 36; G. Ollendorf, *Salon de 1887, Cent Planches en photogravure par Goupil and Cie*, Paris, 1887, pp. 29-30; Vento, 1888, pp. 210-211; Georges Lafenestre, "Alexandre Cabanel," GBA, 1889, I, ser. 3, p. 278; *One Hundred Crowded Masterpieces of Modern Painting*, description by J. E. Reed and others, Philadelphia, I, no. 16; Lorinda Munson Bryant, *French Pictures and Their Painters*, New York, 1922, pp. 202-203; Richard Muther, *The History of Modern Painting*, London and New York, 1907, pp. 280 and 283.
[3]*Plutarch's Lives*, Harvard Classics, ed. by Charles W. Eliot, New York, 1909, v. 12, p. 378. Cabanel's painting is reproduced as the frontispiece.
[4]Ibid.
[5]See Kurt Lange and Max Hirmer, *Egypt*, 1968, pls. 262-266.

CAROLUS-DURAN (CHARLES-EMILE-AUGUSTE DURAND), 1838-1917

16. *Portrait of Lucy Lee Robbins, 1884*
Oil on canvas, 67¼ x 50¼ inches (170.8 x 127.6 cm.)
Signed and dated lower right: *Carolus-Duran 1884*

The Chrysler Museum, Norfolk. Gift of Walter P. Chrysler, Jr., 1971.

Provenance: Lucy Lee Robbins (later Mme. Van Rinckhuysen); Paul Foinet, Paris; Galerie Bernard Lorenceau, Paris, 1953; Walter P. Chrysler, Jr.

Exhibitions: Salon, Paris, 1885, no. 465; Exposition Universelle, Paris, 1889, no. 257; *Exposition des oeuvres de Carolus-Duran*, Musée National de Luxembourg, Paris, July - Aug., 1919, no. 68; Dayton, 1960, no. 49; *The Controversial Century, 1850-1950, Paintings from the Collection of Walter P. Chrysler, Jr.*, Chrysler Art Museum, Provincetown and the National Gallery of Canada, Ottawa, 1962.

Bibliography: F. G. Dumas, *1885 Catalogue illustré du Salon*, Paris, 1885, p. xvii; *Le Livre d'or du Salon de Peinture*, Paris, 1885, pp. 35-36; Albert Wolff, *Figaro Salon*, Paris, 1885, p. 23, rep.; Lionel G. Robinson, "French Art," *The Art Journal*, London, 1886, p. 22, rep. p. 21; Vento, 1888, p. 291; Cook, 1888, p. 117, rep. p. 116; *Catalogue Général officiel, Exposition Universelle Internationale de 1889*, Lille, 1889, I, p. 11; L. de Fourcaud, "L'Art Contemporain, Ecole Française," *Revue de l'Exposition universelle de 1889*, Paris, 1889, I, p. 21.

Carolus-Duran was from Lille, where he received his training from a former pupil of David, François Souchon. After a period of extreme poverty in Paris, he returned to Lille and received some commissions for portraits, eventually winning a local competition that allowed him to return to the capital. From the same source he also won a pension to study in Italy, and there he painted his first Salon entry, *Evening Prayer* (1863).

Back in France, Carolus-Duran had little success except for the sale of one work which gave him enough money to travel to Spain where part of his family had originated. The manner of the Spanish painters, particularly Velázquez's loose, spontaneous technique, impressed him and when he returned to France in 1868 he combined it with the more academic approach. His personal style first evidenced itself in a portrait of his future wife, the enamel painter Pauline Croizat, as *The Woman with a Glove*. The painting won a medal at the Salon of 1869 and was purchased for the Musée de Luxembourg. This was the first in a long series of grandiose portraits of women in elaborate costumes which brought Carolus-Duran renown. Occasionally he produced a work like the highly realistic *Glory*, commemorating his participation in the Battle of Champaigny, but he specialized in portraits, especially of "the *parisienne*, the French woman of fashion at her best."[1]

Carolus-Duran established a free studio in 1872. It became immensely popular, especially with English and American students, including John Singer Sargent, who painted a lively portrait of Carolus-Duran (now in Sterling and Francine Clarke Art Institute, Williamstown). This is a portrait of one of the students, the New York-born Lucy Lee Robbins, who had gone to Paris in 1880. Carolus-Duran gives no indication of her profession, but seats her in a period chair, wearing an elaborate hat and gown. The result, however, is not a dull "fancy portrait" but a work of great *panache*, as the sitter's vivacious personality triumphs over these studio props.

[1]Carrol Beckwith, "Carolus-Duran," *Modern French Masters*, ed. by John C. van Dyck, New York, 1896, pp. 76-77.

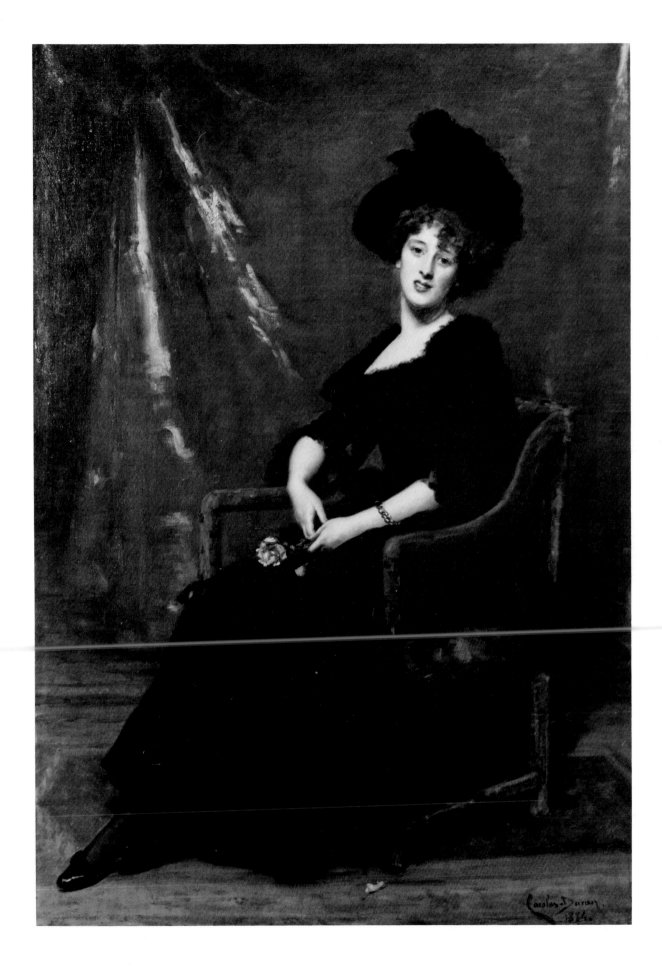

17. *The Favorite Toy*, ca. 1887
Oil on canvas, 25¾ x 20½ inches (65.4 x 52 cm.)
Signed at the lower left: *Eugène Carrière*

Norton Gallery of Art, West Palm Beach.

Provenance: Barbizon House, London; Anderson Art
Galleries, Chicago.

Exhibitions: *Masterworks of the Nineteenth Century*, The
Lowe Art Museum, University of Miami, Coral Gables,
April 26 - June 3, 1979.

Bibliography: *Catalogue of the Collection, Norton Gallery
of Art*, West Palm Beach, 1979, p. 98, no. 236.

Carrière, the son of a Flemish father and an Alsatian
mother, received his early training in Strasbourg. When
he was nineteen the family moved to Saint Quentin,
where there was a museum devoted to works by the
famous eighteenth century pastelist Quentin de La Tour.
This master's brilliant technique and insightful portraits
made a lasting impression on Carrière.

In 1870 Carrière went to Paris and had just enrolled in
Cabanel's classes at the Ecole des Beaux-Arts when the
Franco-Prussian War began. Returning to Strasbourg, he
was sent to the front, captured, and interred near Dres-
den for eighteen months. Fortunately, a medic who had
formerly been a curator in Munich recognized his talent
and allowed him to study the great collection of old
masters in the Dresden Museum.

In 1872 Carrière re-entered the Ecole des Beaux-Arts
and spent time in the atelier of Cabanel and the lithog-
raphy shop of Jules Chéret. He made his Salon debut in
1876 with a portrait of his mother but failed in the Prix
de Rome competition. He then decided to work in Eng-
land and spent eight difficult months there, redeemed
only by seeing the works of Whistler. These—along with

advice from a fellow Alsatian artist, Jean-Jacques
Henner—helped Carrière develop his own distinctively
misty and atmospheric style. At the Salon of 1884, his
painting *Child with Dog* received an honorable mention.
The following year, *The Sick Child* won a medal and was
bought by the State, marking the beginning of his great
success.

Carrière sought to evoke a mood of quiet reverie, a
mysterious dream-like state comparable to that evoked
in many of the works by his friends among the Symbolist
writers. His wife and children—either recognizably
themselves or generalized in his many *Maternités*—were
Carrière's most frequent subjects.

The Goncourts' *Journal* gives the following account of
a visit to an exhibition of Carrière's work in 1891:

> The first impression is a bit nightmarish: the feeling of
> entering a room full of ghostly portraits with great pale
> hands, gray flesh, and pale colors as if seen in moonlight.
> Then the eyes adjust to the night of these figures of the
> crypt. . . . And in the middle of all these faces you are
> drawn by the figures of children with glowing temples and
> wrinkled brows, their lively eyes smiling out—faintly
> visible, encircled by black—the tiny dark holes of the nos-
> trils, the slight red of a soft mouth half-opened, the
> smoothness of the milky flesh, barely contained by the out-
> line.[1]

The child in this painting has been identified (in con-
versation) by Carrière's grand-daughter, Mme. Jeannie
Dumesnil-Nora, as the artist's daughter Marguerite.
Since she was born in 1882, this work must date from
about 1887. Typically, the definition of form is vague,
and it is difficult to clearly identify the child's toy—if
indeed it is a toy.

[1]Edmond and Jules de Goncourt, *Journal*, XVII, Paris, 1903, p. 22.

18. *Hàidée,* 1873

Oil on canvas, 39 x 25 inches (99 x 63.5 cm.)
Signed and dated at the lower right: *Ch. Chaplin 1873*

The Chrysler Museum, Norfolk. Gift of Walter P. Chrysler, Jr., 1971.

Provenance: Catharine Lorillard Wolfe, 1873-1887; Bequest to the Metropolitan Museum of Art, New York; Sale, Parke-Bernet, New York, March 27-28, 1956, no. 133; Walter P. Chrysler, Jr.

Exhibitions: Salon, Paris, 1873, no. 266; Hofstra, 1974, no. 20.

Bibliography: *Explication des ouvrages . . . exposés au palais des Champs-Elysées,* Paris, 1873, p. 44; Georges Lafenestre, "Salon de 1873," *GBA,* July 1873, p. 45; Ernest Duvergier de Hauranne, "Le Salon de 1873," *Revue de deux mondes,* 1873, pp. 633-664; Claretie, *L'Art,* 1876, p. 116; Montrosier, 1882, I, p. 10; Strahan, *Treasures,* 1881, I, pp. 131, 134, rep. opp. p. 123; Vento, 1888, pp. 145-146, Paul Lefort, "Charles Chaplin," *GBA,* Jan. 1891, p. 251; *The Metropolitan Museum of Art Hand Book, No. 1, The Catharine Lorillard Wolfe Collection and Other Modern Paintings,* New York, 1895, p. 8, no. 6; *Catalogue of Paintings, The Metropolitan Museum of Art,* New York, 1905, p. 425; Thieme and Becker, 1912, VI, p. 374; Bryson Burroughs, *Catalogue of Paintings, The Metropolitan Museum of Art,* New York, 1914, p.39 and 1931, p. 50.

Chaplin, the son of an English father and a French mother, was exceedingly popular as a painter of women. He was a pupil of Drolling and early in his career painted religious subjects, landscapes, and portraits, before turning to the graceful, often erotic, genre subjects that made him renowned. He first exhibited at the Salon in 1845. He received a third class medal in 1851, and a second class medal for *Peasant and his Sister* the following year. His *L'Aurora* of 1859 was actually refused by the Salon; her nudity was too shocking. But this did nothing to impede his career, and in 1865 Chaplin won a first class medal. He was made a Chevalier in the Legion of Honor in 1879 and an Officer in 1881. In addition to his painting, Chaplin designed decorations for the Salon des Fleurs in the Tuileries and the rooms of the Empress Eugènie in the Elysée Palace. He was an extremely successful teacher and especially popular with women.

Baudelaire proclaimed Chaplin "an excellent painter," who had a sense of eighteenth century elegance.[1] Certainly Boucher, Greuze, and Chardin were all influences upon him. In *Hàidée,* Chaplin's neo-rococo taste for gauzy fabrics, diffused light, and inviting gazes is combined with an almost Oriental luxuriance. Haidée was the daughter of the Greek pirate King who rescued and fell in love with the hero of Lord Byron's unfinished epic poem, *Don Juan.* The Salon *livret* quoted the following lines from Byron's rapturous descriptions:

> And the striped white gauze baracan that bound her,
> Like fleecy clouds about the moon flow'd round her.
>
> (Canto III, LXX)

The earlier verses describing Haidée also may have supplied the painter with detail to fire his imagination:

> Her dress was many-colour'd, finely spun;
> Her locks curl'd negligently round her face,
> But through them gold and gems profusely shone:
> Her girdle sparkled, and the richest lace
> Flow'd in her veil, and many a precious stone
> Flash'd on her little hand . . .
>
> (Canto II, CXXI)

> She wore two jelicks—one was of pale yellow;
> Of azure, pink, and white was her chemise—
> 'Neath which her breast heaved like a little billow;
> With buttons form'd of pearls as large as peas,
> All gold and crimson shone her jelick's fellow . . .
>
> (Canto III, LXX)

Jules Claretie's review of *Hàidée* when it was shown in the Salon of 1873 still seems a just assessment of the work:

> Chaplin is a painter of agreeable nudes, somewhat like Boucher, but more modern and more *worldly.* He has disrobed his pubescent girls with artistry and is at once modest and provocative. He has made this his sweet specialty. One could hardly blame him, for what he does is charming. But how removed this is from *life,* life that is serious and passionate. His adorable *meringues,* his sweet treats, nevertheless, have their worth. There is, for example, talent, and a lot of it, in the figure *Hàidée.* But Byron would scarcely recognize his heroine in this pretty blond who has nothing Oriental about her except her costume, a comic opera Haidée ready to sing the piece that she has just learned at the conservatory.[2]

The charm of this characteristic painting was not lost on the American collector Catharine Lorillard Wolfe, who purchased it from the artist in Paris in 1873 and bequeathed it to the Metropolitan Museum of Art in New York.

[1]Baudelaire, "The Salon of 1859," trans. in *Art in Paris* by Jonathan Mayne, 1981, p. 180.
[2]Claretie, *L'Art,* 1876, p. 116.

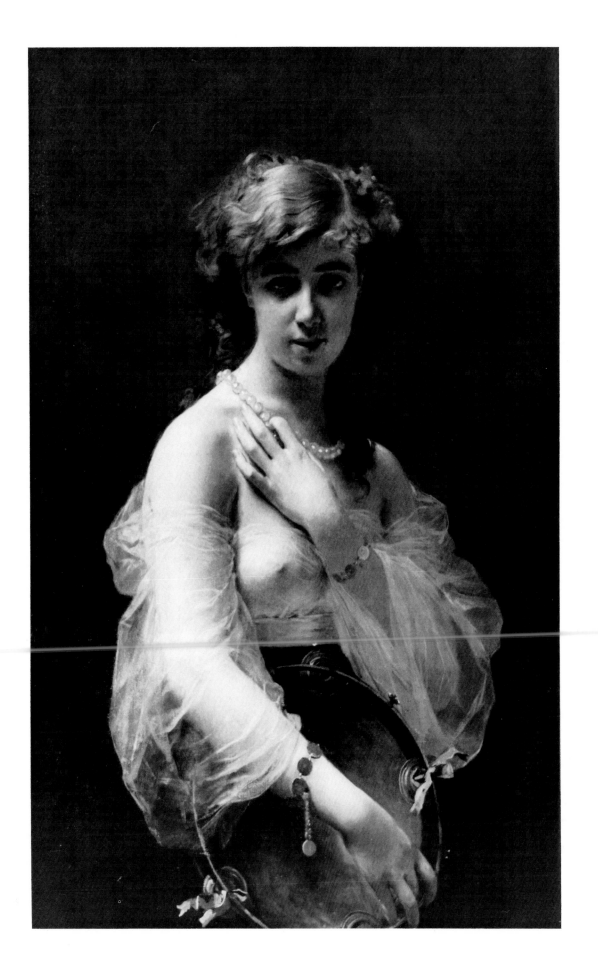

19. *Portrait of Mrs. J. B. Henderson,* 1895
Oil on canvas, 37 x 26¾ inches (94 x 67.9 cm.)
Signed at the right edge: *Benjamin Constant '95*

National Portrait Gallery, Smithsonian Institution, Washington, D.C. Transfer from the National Gallery of Art. Gift of the heirs of the Henderson estate through Dr. Charles Moore, 1935.

Constant spent his youth in Toulouse and attended the Ecole des Beaux-Arts there. In 1865 he won the Toulouse Prix-du-Concours, which allowed him to go to Paris. He entered the Ecole des Beaux-Arts in Cabanel's studio. Constant made his Salon debut in 1869 with *Hamlet and the King,* which was purchased by the State. In 1872 he accompanied Charles Tissot, the ambassador to the Sultan, on a trip to Morocco. Fascinated by the country, he remained there for two years. As a result, he became a leading Orientalist painter, specializing in languid harem scenes and magnificent triumphal entries. In 1878 his work won a third class medal at the Exposition Universelle and he was nominated for the Legion of Honor, eventually becoming a Commander of the order.

Constant had a winning personality, and his Paris atelier became a meeting place for the *haute monde.* He was also adverturous and was one of the first successful artists to visit America, traveling here first in 1889 and then again in 1893. On the first occasion he painted the portrait of Jay Gould, which proved a decisive event for him. He later commented:

It is America which made me a portrait painter. Until I went there I was almost solely a painter of subject pictures. I had made one or two attempts at portraiture, which I had not deemed satisfactory. I need not tell you that I was received in the United States with the most exquisite courtesy. And little by little I acquired confidence in myself, and portrait painting soon became more interesting to me than anything else.[1]

Among the international array of distinguished individuals who sat for Constant were the Duchess of Marlborough, the opera singer Emma Calvé, Pope Leo XIII, and Queen Victoria. An oval portrait of Mrs. S. W. Bridgham is in the Museum of the City of New York.

The subject of this portrait, Mrs. John B. Henderson, was born Mary Newton Foote in New York in 1842. She married Senator Henderson of Missouri in 1868. He is perhaps best remembered as the man who offered the joint resolution to abolish slavery, which became the Thirteenth Amendment. Mrs. Henderson was involved in both women's rights and the arts. In 1876 she was president of the Woman's State Suffrage Association of Missouri and organized the St. Louis School of Design. From 1881 to 1885 she studied art at Washington University in St. Louis. She also went to Paris and studied painting in the studio of Charles Chaplin.[2]

When Mrs. Henderson died in 1931, her large collection of contemporary European and American paintings was bequeathed to the original National Gallery of Art in Washington, D.C. Among the works were four by Constant, including two portraits of herself and one of her husband.[3] This informal, brushy oval portrait of her is not a pendant to the full-dress painting of Mr. Henderson also now in the National Portrait Gallery. Rather, it seems a study intended to capture the lively spirit of Mrs. Henderson, who, in addition to her other activities, was the author of *Practical Cooking and Dinner-Giving* and *Diet for the Sick.*

[1]Quoted in E. S. Cameron, "The Art of Benjamin-Constant," *Brush and Pencil,* July 1902, pp. 243-244.
[2]"John Brooks Henderson," *The National Cyclopaedia of American Biography,* XIII, p. 50.
[3]Charles B. Degges, "National Gallery not excited over Henderson Art Gifts," *The Evening Star,* July 21, 1931.

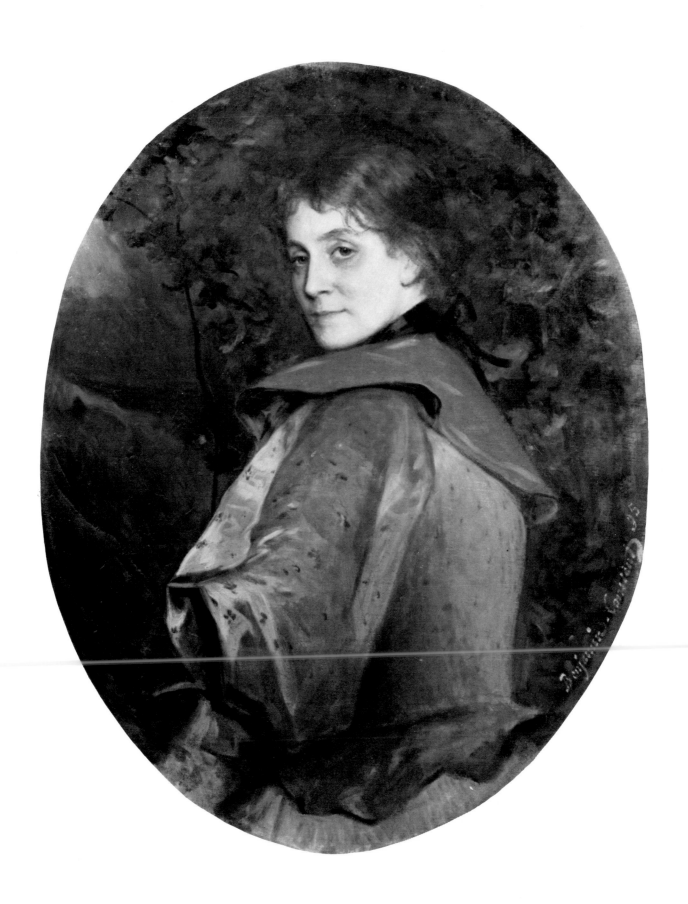

79

20. *Saint Sébastien secoure par les saintes femmes*
 (Saint Sebastian Succored by the Holy Women),
 1874
 Oil on canvas, 51¼ x 33⅝ inches (130.2 x 85.4 cm.)
 Signed at the lower right: *COROT*

National Gallery of Art, Washington, D.C., Timken
Collection, 1959.

Provenance: Gellinard collection, Paris, by 1878; Sale,
Paris, March 19, 1888, no. 42; Victor Desfosses, Paris;
Sale, Paris, April 26, 1899, no. 17; E. F. Milliken, New
York; Sale, American Art Galleries, New York, Feb. 14,
1902, no. 24; Cottier and Company; Arthur Tooth;
Sale, American Art Galleries, New York, Feb. 19, 1925,
no. 68; William R. Timken, New York.

Exhibitions: Exposition Universelle Internationale,
Paris, 1878, no. 202; *Exposition d'oeuvres de Corot a l'Oc-
casion de son Centenaire*, Paris, Palais Galliera, May -
June, 1895, no. 62.

Bibliography: *Catalogue Officiel Exposition Universelle In-
ternationale de 1878 à Paris*, Paris, 1878, I, p. 20; Paul
Mantz, "Exposition Universelle, La Peinture française,"
GBA, 1878, p. 421 and also published in *L'Art Moderne à
l'Exposition Universelle de 1878*, Paris, 1878, p. 24; David
Croal Thomson, *Corot*, London, 1892, p. 40; Alfred
Robaut, *L'Oeuvre de Corot*, Paris, 1905, I, p. 311; III,
p. 360; IV, p. 278, no. 202; p. 291, no. 62; p. 347, no.
243; Etienne Moreau-Nélaton, *Corot Raconté par lui-
même*, Paris, 1924, p. 89, fig. 256; Germain Bazin,
Corot, Paris, 1951, pp. 25-26, 75; National Gallery of
Art, *Summary Catalogue*, Washington, D.C., 1965,
p. 30, no. 1556; National Gallery of Art, *European
Paintings*, Washington, D.C., 1975, p. 76, no. 1556.

Corot began painting at age twenty-six. Following his
first trip to Italy in 1825, he worked in a bright neo-
classical manner. Most of his paintings were landscapes,
which he first exhibited at the Salon in 1827, winning a
medal in 1833. Beginning in the 1830s, Corot also
began to incorporate Biblical and classical subjects in
the large-scale landscapes he painted for Salon show-
ings. In 1835 there was *Hagar in the Wilderness* (now
Metropolitan Museum of Art), a *Saint Jerome* was shown
in 1837, and in 1840 a *Flight of the Holy Family*. Corot's
work, however, was still not widely accepted and, in
1843, his *Burning of Sodom* was rejected by the Salon
jury. In 1845, the Salon accepted two works with classi-
cal subjects, *Homer and the Shepherds* and *Daphnis and
Chloe*, which led Baudelaire to place him "at the head of
the modern school of landscape."[1] With the reorganiza-
tion of the Salon jury following the Revolution of 1848,

Corot was not only elected to serve on the jury in 1849
but his *Christ in the Garden of Olives* was purchased by
the State for the museum at Langres.

About 1850, when he exhibited *Morning, the Dance of
the Nymphs*, Corot turned from his crystalline, neo-
classical style to a romantic, hazy manner. His land-
scapes, now more delicately and richly nuanced, depict
an ideal arcadia as the setting for his Biblical and
mythological scenes.

The subject of Saint Sebastian, tended by Saint Irene
after being shot with arrows on the order of the Roman
Emperor Diocletian, was given memorable form in the
seventeenth century by Georges de la Tour. Corot may
not have been aware of this when he painted this subject
in 1853, but he was familiar with a painting by De-
lacroix, shown at the Salon of 1836. Although set out-
of-doors, Delacroix's treatment of St. Sebastian focused
on the figures. Corot, on the other hand, set smallish
figures in a clearing, dominated by a cathedral-like forest
towering above them. The work has a hushed and rever-
ential quality, and this religious aura was enhanced by its
original arched top—like that used previously by Corot
for the *Baptism of Christ* and *Christ in the Garden of
Olives*. Corot's *Saint Sebastian* was exhibited at the Salon
of 1853, but he worked on it again before the showing at
the Exposition Universelle of 1867. He reworked it again
in 1873, when he donated it to a lottery for the benefit
of the orphans created by the Franco-Prussian War. It
was hoped the painting would be purchased by the State,
but it was privately purchased and is now in the Walters
Art Gallery, Baltimore.

This return to the subject in 1873 apparently revived
Corot's interest. By this time he had become the estab-
lished figure of "Papa Corot," a highly successful artist
with many students and a country retreat at Coubron.
He had two of his students, Robaut and Desmarest,
begin a reduced replica of the *Saint Sebastian* in his Paris
studio. He then took it to Coubron and on October 23,
1874, wrote to Robaut, who was to be his biographer
and cataloguer, stating that he had finished the paint-
ing. It was exhibited along with a large group of his
works at the Exposition Universelle of 1878. Paul Mantz
wrote that Corot had created in these "a totally en-
chanted world, which is made real by the light, and
which is touching because it is permeated by poetry."[2]

[1]Baudelaire, "The Salon of 1845," in *Art in Paris 1845-62*, trans by
Jonathan Meyne, 1965, p. 24.
[2]P. Mantz, "Exposition Universelle," GBA, 1878, p. 421.

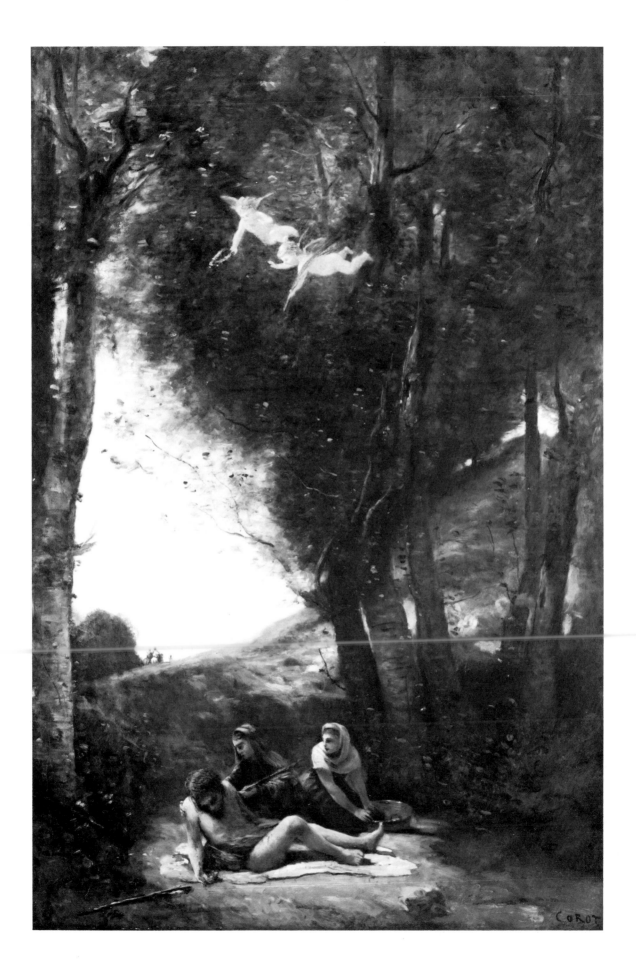

21. *Pierrot Politique (Pierrot the Politician)*, 1857
Oil on canvas, 44½ x 58 inches (113 x 147.3 cm.)
Initialed and dated at left center: *TC 1857*

The Chrysler Museum, Norfolk. Gift of Walter P.
Chrysler, Jr., 1971.

Provenance: Collection V. J., Paris, 1857; William T.
Blodgett; Sale, Chickering Hall, New York, April 27,
1876, no. 64; Darius Mills; Mrs. Ogden L. Mills; Sale,
Parke-Bernet, New York, Jan. 23, 1952, no. 49; John
Levy, New York; Walter P. Chrysler, Jr.

Exhibitions: Dayton, 1960, no. 23; Hofstra, 1974, no.
32; Wildenstein, 1978, no. 17.

Bibliography: L. Lurine, *Catalogue des Tableaux Modernes
Composant de Cabinet de M.V.J.*, Paris, 1857, p. 14;
Strahan, *Treasures*, 1881, II, p. 99; Thomas Couture and
Bertauts-Couture, *Thomas Couture*, 1932, p. 40; *Wallace
Collection Catalogue of Pictures and Drawings*, London,
1968, p. 73; *Apollo*, 1978, pp. 22-24, pl. XII; Albert
Boime, *Thomas Couture and the Eclectic Vision*, New
Haven and London, 1980, pp. 309-312, pl. IX; Anne
Ingersol Davenport, *Thomas Couture, The Leader of
"L'Ecole de Fantaisie at The Galerie Deforges,"* disserta-
tion, University of Pennsylvania, 1981, pp. 238, 262-
266, pl. 38.

Couture, the son of a shoemaker from Senlis, decided to
become an artist at age fifteen and entered the studio of
Baron Gros. He remained there, learning the neo-
classical manner, until the master's death in 1835. He
then entered the atelier of Delaroche but the relation-
ship between the two was not satisfactory. Couture soon
left, although he was undoubtedly influenced by De-
laroche's eclectic style. The young artist competed for
the Prix de Rome, but failed to win. He had more suc-
cess at the Salon. In 1840, his first exhibited painting,
Young Venetian after an Orgy, was singled out by Gautier
for its brilliant color and the brushy style that set it apart
from the generally cool and lifeless works on view.

Couture became the embodiment of a *juste milieu*
painter, striving to reconcile conservative and modernist
tendencies. He solidified his position with the melodra-
matic allegory *Love of Gold*, which won a third class
medal in 1844. Then for three years he worked on his
monumental *Romans of the Decadence*, which brought
him a gold medal and considerable fame. Couture was
able to establish his own atelier and teach his method of
painting. He exhibited less frequently at the Salons,
became a recognized master of portraiture, and received
several major official commissions—including the huge
project of *The Enrollment of the Volunteers of 1792* (1848)
and the *Baptismal Ceremony of the Imperial Prince* (1856).
These works, however, were not completed. In 1851 he
was commissioned to design murals for the Chapel of the
Holy Virgin in the church of Saint-Eustache, and these
were ready for public viewing in October 1856. For
many critics, Couture's abilities were not suited to reli-
gious subjects.

The artist closed his Paris studio in 1860 and moved
back to Senlis. There, for the last part of his career, he
concentrated on genre, landscape, and moralizing satiri-
cal paintings that brought him popularity, especially
with American collectors. Among these works are a
group Couture referred to as *arlequinades*. The artist
claimed that he was inspired to begin these pictures
when, working late one night in Saint-Eustache, he saw
the apparition of a dancing harlequin who, as he de-
scribed it, "jumped upon my palette and turned a
cartwheel."[1] After this hallucination, he discovered a
book called *La Vie de Dominique, l'harlequin célèbre des
Comediens Italiens*. It is true that the famous eighteenth
century actor Dominique was buried in Saint-Eustache,
but it is more likely, as Albert Boime has documented,
that Couture was simply reflecting the widespread taste
for the characters of the *commedia dell'arte*, who also
appeared in works by Daumier, Gavarni, and Gérôme.
Pierrot and Harlequin, the two chief *commedia* charac-
ters, also became popular as disguises at the many fash-
ionable masked balls held in Paris. Couture employed
them in works mocking the bourgeois life and society of
Paris, as indicated by the titles of his other works from
the series: *Pierrot on Trial, The Sick Pierrot, Supper à la
maison d'or*, and *The Duel after the Masked Ball*.

Couture carefully developed his compositions to in-
clude as many telling details as possible. For the present
painting, variously called *Pierrot and Harlequin, Pierrot
politique*, and *The Two Politicians*, there is a preliminary
oil sketch in The Wallace Collection, London, and a
finished drawing (with a number of differences) in the
Cummings collection, Detroit. In both the drawing and
the finished painting, the poster on the wall advertises
the *Bal Molière* Couture was undoubtedly intending to
call to the viewer's mind the greatest of all French

satirists, Molière, with whom the painter identified.

Although the setting of the scene is not specific, it seems logical to assume that the two men have put aside their usual evening clothes—the top hats and cloaks piled at the right—to don the costumes of the *commedia* figures and are attending this very costume ball. Certainly this is how the contemporary L. Lurine viewed the painting, proclaiming:

> You are tempted to cry out to those two masks: "I know you; you no longer have anything young except your face; you've nothing joyful except your costumes of the occasion; on a day of recreation, you are not even thinking of drinking, you are devouring the news of the *Moniteur*, while thinking about the stock market of the following day."[2]

Couture's satire remains effective after more than a century, but perhaps even more remarkable is the convincing atmospheric setting. Strahan, discussing the picture when it was in the Mills collection, commented:

> The scale of the picture allows the painter to develop the breadth and the serenity of his style . . . and the delicate elegance of Couture's best period is revealed in the chalky guileless face of Pierrot, the muscular grace of Harlequin and the play of reflected lights and rich grey shades on the linen suit or the richer costume of the other.[3]

[1]Couture and Bertants, *Couture,* 1932.
[2]L. Lurine, 1857, quoted and translated in Boime, *Couture,* 1980, p. 310.
[3]Strahan, *Treasures,* 1881, II, p. 99.

22. *Cour de Ferme (Farm Yard)*, 1849
Oil on canvas, 19¼ x 16⅛ inches (48.9 x 41 cm.)
Signed and dated at the lower left: *Decamps 49*

The High Museum of Art, Atlanta. Gift of Mrs. J. W. Simpson.

Provenance: Baron Corvisart, Paris; S. Goldschmidt, Paris; Sale, Galerie Georges Petit, Paris, May 17-19, 1888, no. 3; Mr. Blumenthal, Paris; John W. Simpson, New York, 1942; Mrs. J. W. Simpson, Craftsbury, Vermont.

Exhibitions: Exposition Universelle, Paris, 1855, no. 2870; Exposition Centennale de l'art Français, Paris, 1889.

Bibliography: *Visites et Etudes de SAI Le Prince Napoléon au Palais des Beaux-Arts ou Description Complète de cette exposition*, Paris, 1856, p. 123; Adolphe Moreau, *Decamps et Son Oeuvre*, Paris, 1869, p. 164; Dewey F. Mosby, *Alexandre-Gabriel Decamps 1803-1860*, New York, 1977, I, p. 266; II, p. 528.

Decamps received his first artistic training in Paris with Francois Bouchot and then Abel de Pujol, whose studio he left about 1820. In 1827 he made his Salon debut. Later that year he went on an extensive journey through Asia Minor and North Africa, and when he returned he began to specialize in small-scale genre and Oriental scenes. At the same time, Decamps developed his distinctive manner of rapidly applying thick paint. He never perfected an academic precision of design, and his freedom of handling and richness of color (along with his choice of subjects) marked him as an early champion of Romanticism.

Decamp's first large-scale Oriental subject was *The Turkish Patrol* of 1831. Then in 1833 his large historical subject, *The Defeat of the Cimbrians*, won a first class medal. He traveled to Italy in 1835, paying particular attention to the work of Raphael; for although his most popular subjects were his genre scenes—especially those of animals and hunting—Decamps hoped to be a painter of Biblical scenes. Also in the 1830s, the artist began his series of *singeries*, humorous paintings of monkeys in the guise of humans. By 1839, when he was named a Chevalier of the Legion of Honor, Decamps was generally considered a master. Balzac, for example, had written: "Decamps possesses to the highest degree the art of interesting the eye, whether he represents a stone or a man. . . . Decamps has in his brush what Paganini has in his bow, a magnetically communicative power."[1]

In 1845 Decamps showed a group of drawings illustrating the life of Samson, but his hopes of receiving official commissions were not fulfilled, and the following year the jury rejected all but his genre and Oriental subjects. The Revolution of 1848 brought him additional difficulties, since he had been patronized by the Orléans family. He did not reappear at the Salon until 1850-51, when he was appointed to the jury with *hors* *concors* status and exhibited ten paintings, gaining elevation to the rank of Officer of the Legion of Honor. He then received a commission from the State for a painting for the Musée de Luxembourg and produced two versions of *Job and his Friends*, a Biblical scene set in a realistic courtyard. The work was never given to the State, and by 1853 Decamps had lost not only his desire to be a Bible painter but, for a time, to be a painter at all. He sold the effects of his Paris studio and moved to the region of Fontainebleau, which he had been frequenting since the 1840s. He resumed painting only sporadically, and died as a result of a hunting accident.

At the Exposition Universelle of 1855 there was a major retrospective of Decamps's works—fifty-nine examples—and he, Delacroix, and Ingres won medals of honor. Included in this exhibition was the *Cour de Ferme* shown here. Decamps liked to rework certain of his favorite motifs and that of the farm yard was no exception. He painted this work in 1849 but exhibited a different *Interieur de cour* at the Salon of 1850—probably the painting now in the Louvre. Also in the Louvre is another painting titled *La cour de ferme*, which is dated 1850. The setting is the same as in the High Museum's painting, but the woman is shown raising the bucket from the well and instead of the turkeys there is a small dog.

Within the box-like space created by the horizontals and verticals of the building, Decamps used his rough technique to capture the light and texture that give depth and atmosphere to this scene. Reviewing the works exhibited in 1850, Delacluze commented:

M. Decamps . . . treats all sorts of subjects in his own manner, with distinction and often with superiority. I have spoken of his landscapes; at this time I will single out two of his genre paintings, *Interieur de cour* and his *Troupeau de Cannis*, two works in which he has pushed to the limit the power of color and the effects of the light and chiaroscuro.[2]

The intimacy of the space in this painting reveals the artist's debt to the Dutch painters of the seventeenth century. Baudelaire recognized this when he wrote that "sometimes the splendour and triviality of Rembrandt were Decamps's keen preoccupation."[3] And despite his repudiation of the artist's late work, Baudelaire also wrote: "Decamps's pictures were full of poetry, and often of reverie; what others like Delacroix would achieve by great draughtmanship, by an original choice of model, or by broad flowing color, Decamps achieved by intimacy of detail."[4]

[1]Honoré de Balzac, *Oeuvres complètes . . . L'Interdiction*, Paris, 1892, p. 249, translated in Mosby, 1977, I, pp. 5-6.
[2]E. J. Delacluze, *Exposition des Artistes Vivants 1850*, Paris, 1851, pp. 193-194.
[3]Baudelaire, "The Salon of 1846," trans. in *Art in Paris*, 1981, by Jonathan Mayne, p. 74.
[4]Ibid, p. 75.

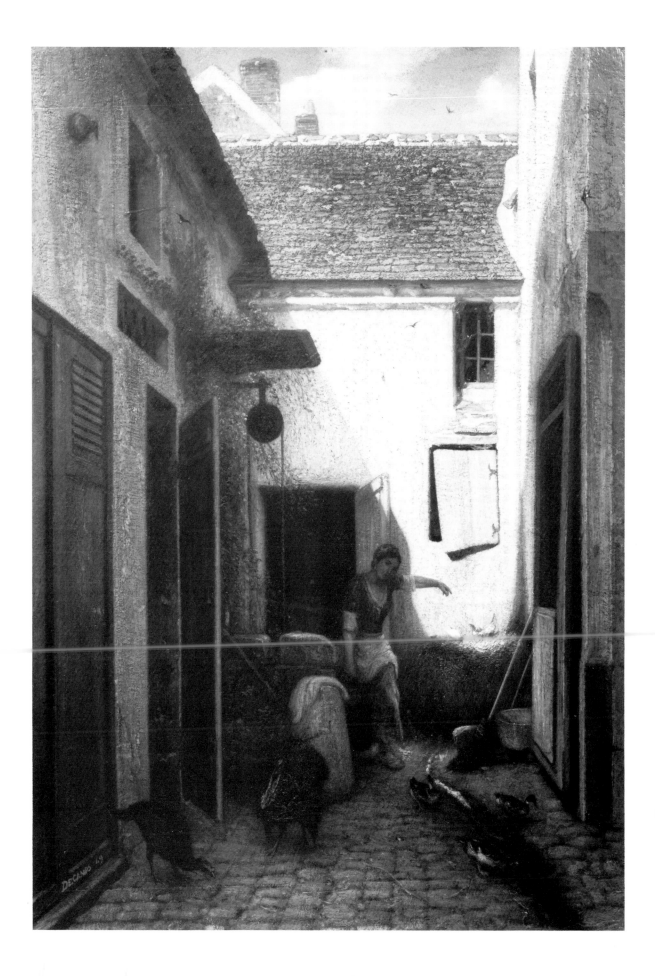

PAUL DELAROCHE, 1797-1856
and CHARLES-FRANCOIS JALABERT, 1819-1901

23. *La Jeune Martyre (The Christian Martyr)*, ca.
1855
Oil on canvas, 21⅞ x 18⅜ inches (55.6 x 46.7 cm.)
Inscribed in pencil at the upper left: *Esquisse Delaroche*
and in pencil at the upper right: *finit par Jalabert*
and in pencil at the lower left: *D'aprés P. Delaroche,
CFJalabert*

The Walters Art Gallery, Baltimore.

Provenance: W. T. Walters, Baltimore.

Bibliography: Clement and Hutton, 1884, p. 197; *Collection of W. T. Walters*, Baltimore, 1884, p. 8, no. 9; Champlin and Perkins, 1888, III, p. 212; "The Walters Collection of Art Treasures," *Magazine of American History*, April 1892, p. 251; *The Walters Collection*, Baltimore, 1901, p. 10, no. 9.

Delaroche had studied with Baron Gros before making his Salon debut in 1822. He soon became a master of history painting, rendering such strikingly melodramatic moments as *Joan of Arc in Prison, Cromwell Gazing into the Coffin of Charles I*, and *The Children of Edward IV in the Tower*. Reproduced in prints, these works brought him great fame, and in 1832 Delaroche was elected to the Institute and the following year received a professorship at the Ecole des Beaux-Arts.

When, in 1837, his entries to the Salon were not well received, Delaroche withdrew from further official exhibitions and concentrated instead on the painting of portraits and religious subjects. That same year, he received his most important commission, the enormous painting of the *Hemicycle* in the theatre of the Palais des Beaux-Arts. The subject he chose was an encyclopedic array of the world's great artists from the time of Pericles to Louis XIV. To prepare for what was to be a four-year project, he went to Italy to study the works of Raphael.

Delaroche's fame attracted a great many students to his atelier; among those he trained were Aubert, Gérôme, Hamon, Couture, and Daubigny. The death of a student in a hazing incident in 1844, however, led to his closing the studio. Later that year, accompanied by the young Gérôme, he again traveled to Italy. Delaroche remained in Rome for two years and began painting religious works in addition to some portraits and historical subjects, most notably several involving Napoleon I.

According to Delaroche's biographer Ulbach, it was a dream the artist had in the course of an illness in late 1853 that provided the subject of the painting known as *The Young Martyr*.[1] He made many preparatory drawings, and an oil study dated 1853 is now in The Hermitage, Leningrad.[2] The large painting (67⅛ x 58¼ inches) was completed in 1855. It was purchased after Delaroche's death by the banker Baron d'Eichtal, whose descendents gave it to the Louvre.

The painting does not depict a specific saint. Delaroche actually debated whether or not to give her a name, but in the end referred to her simply as a Christian martyr of the time of Diocletian.[3] She has been thrown into the Tiber with her hands bound because she refused to worship pagan gods.

Delaroche's finished painting was sent to Goupil's to be engraved and both there and in the posthumous exhibition of his works at the Ecole dex Beaux-Arts in 1857, the critics had a chance to study the work. As some observed, the composition may be indebted to the *Ophelia* by the English painter John Everett Millais, shown at the Exposition Universelle in 1855. Several writers, including Gautier, even referred to Delaroche's painting as a "Christian Ophelia."[4] Although he had severely criticized Delaroche's work previously, Gautier was deeply affected by this painting and attributing its power to a mystical inspiration bestowed upon the artist called it a "fitting swan song of a painting."[5]

Gautier lavished his greatest enthusiasm on the figure of the young girl:

> Under the radiant halo, supported by the greenish pillow of the waves, amidst the loosened hair curling like rushes, floats a face of virginal purity and divine beauty: her eyes with pearly lids suggest she is sleeping, and on her half-opened mouth an ineffable smile of ecstasy quivers with a deathly grace. These beautiful lips seem to murmur as in a dream, the name of her heavenly husband; nothing is more chaste, more agreeable, more tender, more suffused with emanations and transparencies, than that charming head, the silver pallor of which makes one think of Correggio or of Prud'hon.[6]

Delaroche, assisted by his students, often painted replicas of his popular paintings, including *The Young Martyr*. A painting in the collections of John Graham and Janus Price in the late nineteenth century[7] may be identical with that now in the Delaware Art Museum, Wilmington, and one by Delaroche and Prziaporski is in the Stuart Pivar collection in New York.

According to Champlin and Perkins, in the replica exhibited here the face and hands were painted by Delaroche and the remainder by his devoted follower Jalabert, who was with him when he died.[8] Delaroche had actually written to Jalabert about his decision to paint this subject in January 1854:

> I haven't worked for a month, I haven't even looked at my color box. I have made, however, a new composition with which I am not displeased. The subject is original, poetic, and Christian.[9]

[1] L. Ulbach, "Paul Delaroche," *Revue de Paris*, 36, April 1857, p. 91.
[2] See Norman D. Ziff, *Paul Delaroche, A Study in Nineteenth-Century French History Painting*, New York, 1977, pp. 251-302, and fig. 156.
[3] Ulbach, *op. cit.*
[4] Alfred Busquet, "Paul Delaroche," *L'Artiste*, 1856, p. 319; and Alphonse de Calonne, "Delaroche et son oeuvre," *Revue Contemporaine*, April 1, 1857, p. 518.
[5] Théophile Gautier, "Une Martyre. Dernier tableau de Paul Delaroche," *L'Artiste*, Feb. 13, 1857, pp. 145-146.
[6] *Ibid.*
[7] H. Mireur, *Dictionnaire des ventes d'art*, Paris, 1911, II, p. 433.
[8] For Jalabert, see the exhibition catalogue of the Musée des Beaux-Arts, Nimes, Oct. - Dec. 1981.
[9] E. Reinaud, *Charles Jalabert, L'Homme, L'Artiste*, Paris, 1903, p. 93.

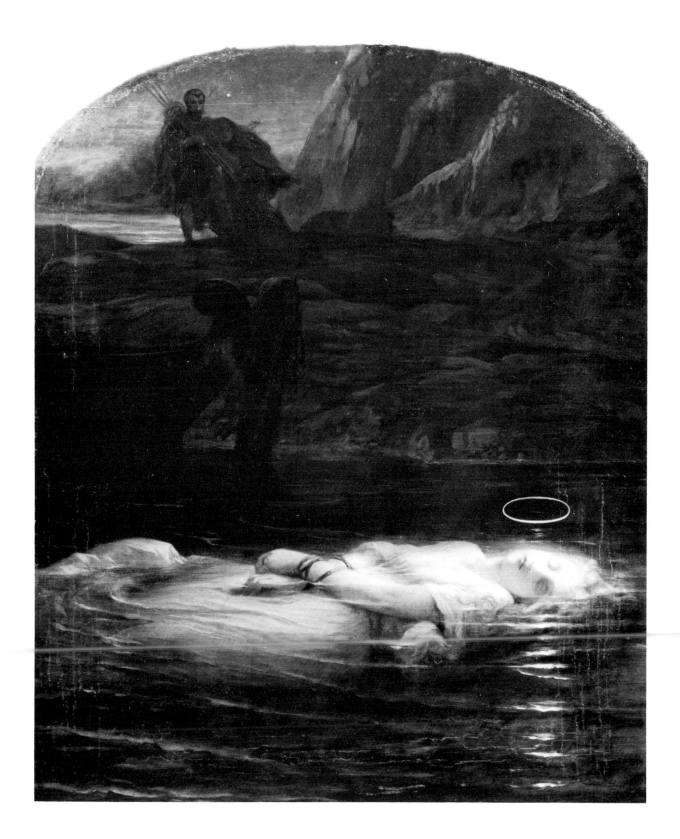

24. *En retraite (The Retreat),* 1873
Oil on canvas, 49 x 63 inches (124.5 x 160 cm.)
Signed and dated at the lower left: *Edouard Detaille 1873*

John and Mable Ringling Museum of Art, Sarasota.

Provenance: Goldschmidt collection, Paris; William Astor, New York; J. J. Astor, New York; Sale, American Art Association, New York, April 20-21, 1926, no. 434; John Ringling, Sarasota.

Exhibitions: Salon, Paris, 1873, no. 477; *Artists of the Paris Salon,* Cummer Gallery of Art, Jacksonville, Jan. 7 - Feb. 2, 1964, no. 12; *Paris in the Belle Epoque: People and Places,* Museum of Fine Arts, St. Petersburg, March 1 - April 6, 1980, no. 26.

Bibliography: *Salon de 1873,* Goupil and Co., Paris, plate 42; Georges Lafenestre, "Salon de 1873," *Revue de France,* June 30, 1873, p. 613 and *GBA,* 1873, II, p. 38, reprinted in Georges Lafenestre, *L'Art vivant, la peinture et la sculpture aux Salons de 1808 a 1877,* Paris, 1881, I pp. 319-320; Bathilde Bouniol, "L'Amateur au Salon," *Revue de Mond Catholique,* 1873, p. 339; Ernest Duvergier de Hauranne, "Le Salon de 1873," *Revue de deux mondes,* pp. 650-651; A. Duparc, "Le Salon de 1873," *Le Correspondent,* v. 91, p. 817; Georges Duplessis, "M. Edouard Detaille," *GBA,* May 1874, p. 432; Louis Gonse, "Salon de 1874," *GBA,* July 1874, p. 25; Claretie, *L'Art,* 1876, pp. 63, 65, 155-159; Gustave Goetschy, *Les jeunes Peintres militaires,* Paris, 1878, n.p.; Montrosier, 1882, II, p. 27; Strahan, *Treasures,* 1881, II, p. 78; Bellier and Auvray, 1882-87, supplement, p. 199; Claretie, *Peintres,* 1884, pp. 259-260; Clement and Hutton, 1884, I, p. 202; Frederic Messon, "Edouard Detaille et Son Oeuvre," *Les Lettres et les Arts,* Nov. 1886, pp. 219-220; Jules Richard, *En campagne,* Paris, n.d., no. 4; Roger Peyre, *La Peinture Française,* Paris, n.d., p. 266; Marius Vachon, "Edouard Detaille, Lettres et notes personnelles," *GBA,* 1897, pp. 425-432; Marius Vachon, *Detaille,* Paris, 1898, pp. 29-31, 165; Haller, 1899, pp. 75 and 125; J. Valmy-Baysse, *Edouard Detaille,* Paris, 1910, n.p.; Suida, 1949, p. 354, no. 446; Shepherd Gallery, 1975, p. 373; Jean Humbert, *Edouard Detaille, l'héroïsme d'un siècle,* 1979, p. 81; Gavin Musgrave, "Le Regiment qui passe . . . ," *Connoisseur,* Dec. 1979, p. 220.

Detaille was born in Paris and showed an early interest in both drawing and the military. At the age of seventeen he was introduced to Meissonier, who took him on as a pupil. The older artist, with his strict methods and dedication to detail, gave Detaille a firm grounding in "proper artistic methods." The student long remembered Meissonier's "marvelous lessons," which always ended with the advice, "Follow my example; reality, always reality ('*la nature, toujours la nature*')."[1] This influence was seen in Detaille's first Salon piece, *A Corner of Meissonier's Studio* of 1867. The following year he exhibited the first in his extensive production of military

subjects, *Halt of the Infantry.* This brought him some notice as a talented pupil of Meissonier, and the next year he truly established himself with *Le Repos pendant la Manoeuvre, Camp de St. Maur, en 1868,* which was singled out for praise by critics such as Edmond About, Paul Mantz, and Théophile Gautier. This resulted in so many commissions that Meissonier encouraged him to establish his own studio. Detaille continued for the remainder of his life to paint military scenes, drawn from both contemporary events and French history, notably the campaigns of Napoleon.

In 1870 Detaille embarked on a sketching tour of Spain and Algeria, but with the outbreak of the Franco-Prussian War he returned to France and enlisted in the Home Guard of the Seine. He was assigned to the Staff of General Appert to make topographical plans of the environs of Paris, which gave him an excellent opportunity to witness the daily life of the soldiers. He made innumerable drawings and sketches. The first major work to come out of this experience was *En Retraite,* shown at the Salon of 1873, for which he was made a Chevalier of the Legion of Honor. Also based on this war experience were two large panoramas painted in collaboration with de Neuville. Detaille's love of military subjects—and the fact that he made many highly finished watercolor studies—is readily apparent in the illustrations he provided for the two volume *Types et Uniformes de l'Armée française,* published in 1883

Detaille was one of the most famous artists of the Belle Epoch in Paris and perhaps his most famous painting was *Le Rêve (The Dream,* Musée de l'Armée, Paris), shown at the Salon of 1888. It does not depict a specific battle but rather shows a row of soldiers sleeping on the ground, while above them in the clouds is seen the glorious military triumph of the soldiers of the Premier Empire. This collective dream of patriotism was made well known through engravings. In Proust's novel *A la recherche du temps perdu,* Detaille is introduced at a party as the creator of *Le Rêve.* The work won for Detaille a medal of honor, presented to him by his old master Meissonier. Other honors followed: appointment to the Institute in 1892 and, five years later, elevation to the rank of Commander in the Legion of Honor.

When *En Retraite* was shown at the Salon of 1873, the critic Georges Duplessis wrote in the *Gazette des Beaux-Arts* that the work, "exhibited five years after the first picture of Detaille appeared at the Salon, makes all the praises which have been given this young artist appear reasonable. The hopes which his first pictures excited have been fully realized."[2] It was Detaille's mastery of detail, combined with his ability to capture the appropriate mood that impressed his contemporaries and made this one of his best-known works. Examples of some of his preliminary studies are reproduced in Vachon's

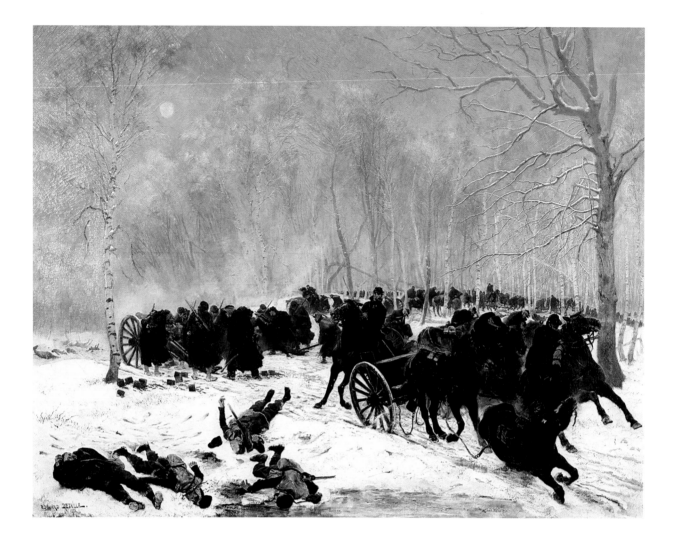

monograph. The most detailed explication of the subject is that given by Claretie:

> It is an episode of the campaign in the bitter winter of 1870-71. The foot soldiers posted in the forest, tried to drive out the enemy crouching in the bushes. They fought bravely. The cadavers of men and horses, fallen here and there, stiffen in the snow. But, despite their efforts, nothing can be done: it is necessary to retreat, to abandon to the enemy the forest which they had defended. The soldiers file quickly, running along the footpaths, passing before the birch trees with their white trunks scarred by bullets. . . . What cannot be praised enough is the general effect of the painting, the gray ground of the snow-covered forest, enveloped with fog, the sun appearing through the mist, red and round like a cannon ball from a forge; on the snowy terrain the feet of the combatants have made their imprints, and the wheels of the wagons have made ruts in the ground. . . .

And where did this action of which M. Detaille has made such a moving and powerful drama take place? I thought at first of an incident from the fighting in December, near Paris; but the artist tells us that he did not want to pinpoint the location of this *Retraite*. A retreat from battle in the East with Bourbaki, or those of the Loire with Chanzy, it doesn't matter. The painter wanted to summarize in a single episode the essence of the horrible scenes of "the year of deadly winter." He has succeeded powerfully and this canvas is a decisive step in the already glorious career of the young artist.[3]

[1]Quoted in *War à la monde, Military Pictures . . . from the Forbes Magazine Collection*, exhibition catalogue, 1977, p. 13.
[2]Duplessis, 1874, p. 432.
[3]Claretie, *L'Art*, 1876, pp. 155-157.

25. *Le Rendez-vous dans la Forêt, (Gathering in the Forest)* 1856
Oil on canvas, 32 x 25½ inches (81 x 65 cm.)
Signed and dated: *N Diaz 1856*

The Henry Morrison Flagler Museum, Palm Beach. Gift of Mrs. Jean Flagler Matthews.

Provenance: C. de Camondo, Paris; Sale, Galerie Georges Petit, Paris, Feb. 1-3, 1893, no. 56; Keith Albee; Owen Kenan; Sale, Trosby's, Palm Beach, Jan. 22, 1964; Mrs. Jean Flagler Matthews.

Diaz de la Pena was the son of Spanish emigrants who settled in Bordeaux. He was primarily self-taught, though he worked as a painter in a porcelain factory and studied briefly with François Souchon. The style that he evolved blended Romantic and Orientalist traits from Delacroix and Decamps, the eighteenth century rococo taste espoused by Gautier, and (after his meeting with the Barbizon painter Théodore Rousseau in 1837) an interest in landscape. Diaz's subjects were mostly landscapes with figures of a fanciful sort—nymphs, peasants, and gypsies.

Diaz first exhibited at the Salon in 1831. His work was criticized by Baudelaire and others over the years for its lack of precise drawing, but he never faced the outright rejection of his work suffered by some of the other Barbizon painters, perhaps because he painted *scenes galantes* as well as pure landscapes. In the Salon of 1848, Diaz exhibited five works and won a first class medal. Official approval of his work was evidenced in 1850 when he was made a Chevalier of the Legion of Honor. He last exhibited at the Salon in 1859, but continued working in his same manner until his death.

In 1844 Diaz had exhibited a major work entitled *The Descent of the Bohemians*, showing a group of lively gypsies with their dogs on a hillside. Variations on this theme repeatedly recurred in his work. Apropros of his 1850 showing, Delacluze wrote:

As for M. Diaz, . . . his *Bohemians* is a sort of fantasy which attracts and dominates our eyes and charms them, like those brilliant cloths of many colored silks made by the young girls in the convents. Certainly one does not have great thoughts when seeing these Bohemians, but the harmonious balance of lively and brilliant colors which the painter has randomly thrown together draws and holds the eye, like the unexpected sounds, often dissonant, but sometimes powerful, of the Aolian harp, astonishing and captivating the ear. M. Diaz is like Eugène Delacroix in this regard; perhaps they are best compared to those musicians who improvise beautiful preludes, but from whom we still wait for a finished composition.[1]

In the work exhibited here, we see similar "bohemian" figures in a pastoral setting. There is no specific subject—the title employed is the one used at the time of the work's sale in 1893. What concerned the artist most was the creation of a charming *fantasie,* and in the distribution of pools of glowing color over the surface he has created a rich tapestry-like effect.

[1]Delacluze, *Exposition des Artistes Vivants,* Paris, 1851.

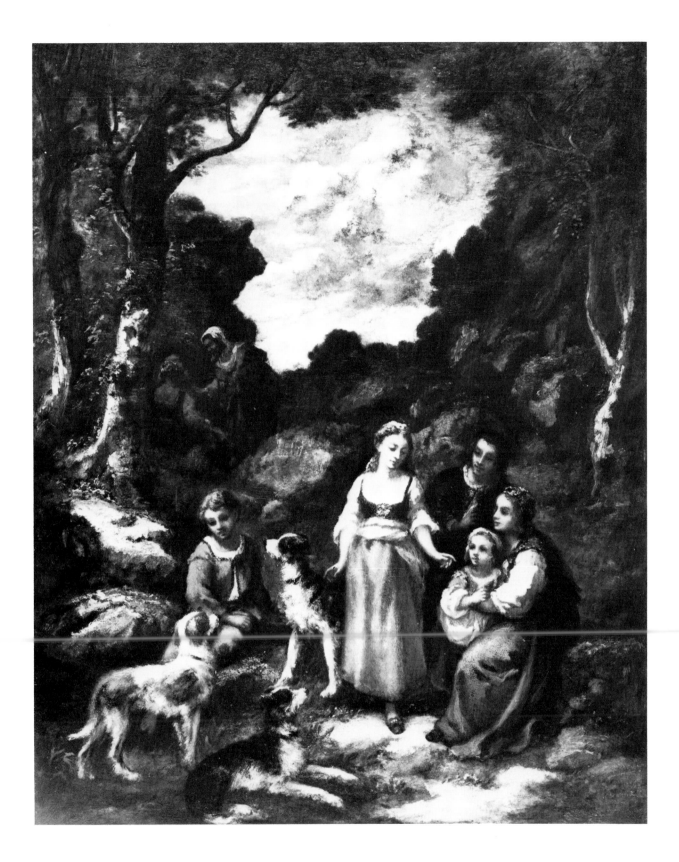

26. *La Maison de Caïphe (The House of Caiaphas),*
1875
Oil on canvas, 42 x 69 inches (106.7 x 175.3 cm.)
Signed in red at the lower left: G. *Doré*

Museum of Fine Arts, Houston. Purchase, Lawrence H. Favrot Bequest Fund, 1971.

Provenance: Central Picture Galleries, New York.

Exhibitions: Salon, Paris, 1875, no. 689; Doré Gallery, London, 1876-1892; The Doré Collection exhibit in Carnegie Music Hall, New York and Chicago, 1892-93, no. 17.

Bibliography: Lucy H. Hooper, "The Salon of 1875," *Art Journal,* 1875, p. 190; Francis Roubiliac Conder, *The Doré Gallery, Descriptive Catalogue of the Pictures by M. Gustave Doré on view at 35 New Bond St.,* London, 1877, p. 14; Blanche Roosevelt, *Life and Reminiscences of Gustave Doré,* New York, 1885, pp. 343, 345; *The Doré Collection,* Carnegie Music Hall, New York, 1892, p. 40; *Doré Gallery: Illustrated Descriptive Catalogue,* Chicago, ca. 1893, p. 23; Stranahan, *History,* 1917, p. 423; Henri Leblanc, *Catalogue de l'Oeuvre complet de Gustave Doré,* Paris, 1931, pp. 541, 551.

Gustave Doré was born in Strasbourg and it is often suggested that the Gothic elements of his art stem from having spent his early years in the shadow of that city's great cathedral. He was a compulsive draughtsman from the beginning, and after his family moved to Paris in 1847, he made his Salon debut with an ink drawing of a landscape. He soon became a popular contributor to the satirical *Journal pour rire.* He launched his successful and prolific career as a book illustrator with an 1854 edition of Rabelais and there followed his well-known editions of Balzac, Dante, Cervantes, Milton, and The Bible.

Doré's style was vivid, direct, often grotesque, but always exuberant, and this was a natural expression of his personality. He loved performing and music. Among his wide circle of friends were Rossini, whom Doré sketched on his deathbed, and Sarah Bernhardt, whom he taught how to sculpt.

The Salon of 1851 marked Doré's debut as an oil painter. He sent Biblical scenes to the Salons of 1855 and 1857, but the first painting that brought him attention was *Paolo and Francesca* of 1863. Philip Hamerton's response to Doré's paintings of that year was typical:

> Doré is not a painter in the true sense. He paints as well as many reputed "painters" of the French school, but his color will not bear the least comparison with that of real painters such as Cabanel or Paul Baudry. His pictures are conceived simply as *designs,* and all pictures so conceived inevitably fail. . . . Doré's pictures are, of course, always very impressive, very great inventions, but that is not enough.[1]

In addition to historical themes, Doré painted landscapes and some genre subjects, but he aspired to immortality as a painter of religious subjects. His compositions grew increasingly crowded and monumental. The French critics and public were not impressed; Zola characterized the paintings as "colored prints of inordinate size."[2]

Doré found a more receptive audience in England, which he visited for the first time in 1868. After this trip, the Doré Gallery in London opened, devoted to displaying his works. Doré was referred to as the "Preacher-Painter," because in the 1870s he produced a series of huge theatrical canvases on the life of Christ. In 1892, after being seen by two-and-a-half million people, the remaining contents of the Doré Gallery were sent to America for exhibition in New York and Chicago. Included among these works was *La Maison de Caïphe.*[3] When it was first shown at the Salon of 1875, the *livret* had printed as explanation a text taken from St. Luke (22:1-4):

> Now the feast of Unleavened Bread drew near, which is called the Passover. And the chief priests and the scribes were seeking how to put Him to His death; for they feared the people.
>
> Then Satan entered into Judas called Iscariot, who was of the number of the twelve; he went away and conferred with the chief priests and captains how he might betray Him to them.

And in the catalogue of the Doré Gallery, London, there was printed the following quote from the *Art Journal* describing the painting: "the covenenting of Judas Iscariot with the priests for the thirty pieces of silver, an imaginative scene, *full of power and of character,* in which M. Doré has followed the example of the great Flemish painters in the splendor of his costumes."[4]

This painting, smaller and less bombastic than many of Doré's other religious canvases, presents a most effective original composition, somewhat reminiscent of Rembrandt, whose prints Doré collected. The figure of the greedy Judas is cast in shadow. The brooding High Priest Caiaphas and his advisors are in luxurious glimmering robes, picked out of the darkness in Doré's characteristic method of linear highlighting. In contrast the distant scene of Christ preaching to his followers in Jerusalem is bathed in radiant light.

[1]Philip G. Hamerton, "Salon of 1863," *Fine Arts Quarterly Review,* London, 1863, p. 247.
[2]E. Zola, *Emile Zola Salons,* Geneva and Paris, 1959, p. 178.
[3]*Illustrated Descriptive Catalogue,* Doré Gallery, Chicago, ca. 1893, p. 23, no. 17, in which the painting is reproduced and the measurements given coincide with those of the Houston painting.
[4]Conder, 1877, p. 14.

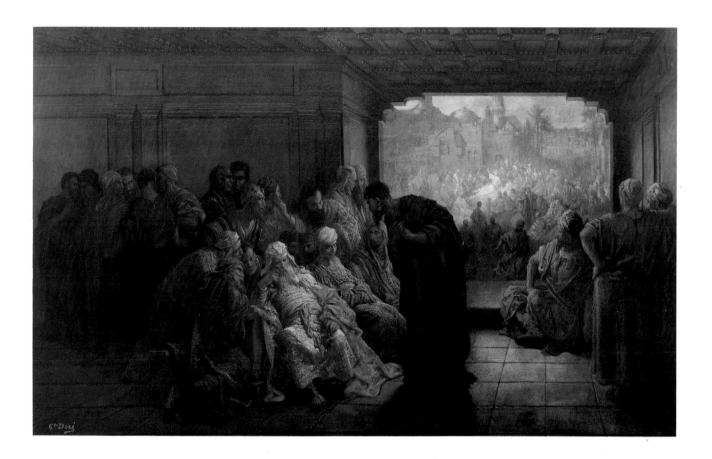

27. *Au Pâturage (In the Pasture)*, 1883
Oil on canvas, 53 x 78 inches (134.6 x 198.1 cm.)
Signed and dated at the lower left: *JULIEN DUPRE 1883*

University of Kentucky, Carnahan House Conference Center, Lexington.

Provenance: Findley Galleries, Chicago; Mr. and Mrs. Henry H. Knight, Lexington, 1958.

Bibliography: Jo Leadingham, *University of Kentucky, Carnahan House Conference Center, The Paintings in the Knight Room*, Lexington, 1973.

Julien Dupré achieved success by combining elements of the Barbizon and realist traditions. He was especially known for his paintings of farm scenes with animals, which he rendered with impeccable fidelity. He had received his formal training from Isidore Pils, Laugée, and Henri Lehmann, and also learned the Barbizon landscape tradition as practiced by his famous uncle Jules Dupré. Julien made his Salon debut in 1876 with *La Moisson en Picardie (Harvest in Picardy)*. In 1880 he received a third class medal for the *Faucheurs de luzerne (The Grass Cutter)* and the following year a second class for *La Rocolte des foins (Hay Gathering)*. At the Exposition Universelle of 1892 he was awarded a gold medal for his devotion to rural subject matter.

One of Dupré's most popular paintings was *Au pâturage (In the Pasture)*, exhibited at the Salon of 1882. Like many of his works, it came to America and is presently (although in poor condition) in the collection of Washington University, St. Louis. The text accompanying an etching by Edmond Yon of the picture states that *Au pâturage*

is one of the largest and most important of his [Dupré's] works, and was one of the best canvases in the Salon of 1882; it was received as a surprising advance on his exhibit of the preceding year—as marking a "complete revolution in his talent." "The design is concise," said *L'Art*, "the execution sound, the mimicry of Nature excellent, the tonality very acceptable." The composition, however, excellent as it is, is not altogether original with the painter, but is borrowed from an admirable bronze group by the sculptor Leon Mignon, which was exhibited in 1881. M. Dupré substituted a peasant woman for the ox-driver. The effective color device of the red head-dress against the rich, warm tones of distant foliage is one that he has repeated in other canvases, with the same excellent effect. . . .[1]

The popularity of *Au pâturage* is attested to not only by Yon's etching, but also by a sketch of the composition reproduced in the *Figures contemporaines* of the *Album Mariani*, and by this large painted replica of 1883. There are some minor differences from the original: a barn has been placed in the background at the left and the chain on the stake in the foreground hangs on the left side, but for the most part the works are identical. The appeal of the composition undoubtedly derives from the powerful but unequal struggle of the two protagonists—the sturdy farm girl in her wooden shoes and the immense cow, anxious to join her companions. That the characters are drawn from sculpture is apparent, as they stand like a monument set in the fields. Their placement is nicely balanced by the large hammer and stake in the foreground. Dupré's treatment of farm figures is in the romanticized vein of Jules Breton and his types provided a clear model for the American painter Daniel Ridgeway Knight.

[1]*L'Eau-Forte*, pl. XVII, in the files of the Art Department, Public Library, New York City.

28. *The Moor*, 1894

 Oil on wood, 18¼ x 14⅞ inches (46.4 x 37.8 cm.)
 Signed and dated at the lower right: *R. Ernst -94*

 The Lowe Art Museum, Coral Gables. Estate of Homer
 S. Rhode.

 Exhibitions: *Masterworks of the Nineteenth Century*, Lowe
 Art Museum, University of Miami, Coral Gables, April
 26 - June 3, 1979.

The son of the Viennese painter Leopold Ernst,
Rudolphe studied at the Vienna Academy. After a
period of travel in Italy, Spain, Morroco, and Turkey,
he exhibited his work in Vienna and Munich. In 1876,
Ernst settled in Paris, adopted French nationality, and
began exhibiting at the Salon. The works he showed at
first were mostly portraits and European interiors, but
from 1882 onward he devoted himself to Orientalist
subjects similar to those by his compatriot Ludwig
Deutsch. He won a bronze medal in 1900.

Ernst specialized in painting scenes set in mosques,
harems, and palaces. He delighted in depicting the
elaborate patterns of intricately carved wood, tiled walls,
and Persian rugs, and built up complex compositions of
great richness. This is evident in the example shown
here, although its somewhat sketchy character, lacking
the highly polished quality of Ernst's finished works,
indicates that it is a preliminary study. This belief is
substantiated by the fact that a larger version of this
composition—also painted on panel but with an addi-
tional figure and several changes in the decor—was sold
at Christie's, London, November 3, 1977.

29. *Still Life with Flowers*, 1869
Oil on canvas, 18¾ x 15¼ inches (47.6 x 38.7 cm.)
Signed and dated at the lower right: *Fantin 69*

The Dixon Gallery and Gardens, Memphis.

Provenance: Edwin Edwards, London; Heseltine, London; Mrs. Tempelaere; Lawson Peacock, London; William and Son, London; The Lefevre Gallery, London; Ian MacNicol, Glasgow; Galerie Georges Petit, Paris, 1920; Christie's, London, July, 1949; Scott and Fowles, New York, 1952; Hugo M. Dixon, Memphis.

Bibliography: Henri Floury and Mme. Fantin-Latour, *Catalogue de l'oeuvre complet de Fantin-Latour*, Paris, 1911, p. 46, no. 326; Michael Milkovich, *Catalogue of Paintings and Sculpture, The Dixon Gallery and Gardens*, I, Memphis, 1977, p. 34.

Fantin-Latour received his first training from his father, who was a painter in Grenoble. Then, beginning in 1850, he studied for six years at the Ecole de Dessin with Horace Lecoq de Boisbaudran, who espoused a method of drawing from memory rather than life. After an unsuccessful attempt to enroll in the Ecole des Beaux-Arts, Fantin-Latour devoted himself to copying the works of the old masters in the Louvre. There he met Manet, Berthe Morisot, and Whistler. When, in 1859, his three submissions to the Salon were refused, he showed two of them at Bonvin's studio along with rejected works by Whistler, Legros, and Ribot. That same year, on Whistler's invitation, he went to England and was introduced to the lawyer and painter Edwin Edwards who, with his wife, shared Fantin's love of music. They developed a lasting friendship and the Edwardses in effect became his English agents, helping to place his works in English collections.

In 1863 Fantin exhibited in both the official Salon and the Salon des Refusés. Inspired by Delacroix's death, he painted the first of his large-scale multi-figured group portraits, *Hommage à Delacroix*, which was shown at the Salon of 1864. It depicted a group of artists and writers seated before a framed portrait of the great master. In front, Whistler is seen holding a bouquet of flowers; it was in this year that Fantin-Latour began to paint studies of flowers and fruit. These works were immediately successful—two were accepted in 1864 by the Royal Academy in London—and Fantin continued to produce them until about 1896.

Fantin's flower still lifes, as in this painting of 1869, often have a near photographic realism, and Jacques-Emile Blanche gave the following description of his method:

> Fantin studied each flower, each petal, its grain, its tissue, as if it were a human face. In Fantin's flowers, the drawing is large and beautiful; it is always sure and incisive. . . . It is an individual flower and not simply one of a type. He dissects, analyzes and reconstructs and is not just content to communicate an impression. Some canvases are worthy of Chardin.[1]

[1]Jacques-Emile Blanche, "Atelier de Fantin-Latour," *Propos de Peintre, de David à Degas*, Paris, 1919, p. 44, trans. in *Henri Fantin-Latour*, exhibition catalogue, Smith College Museum of Art, 1966.

30. *La Toilette*, 1896
Oil on canvas, 25⅞ x 21¾ inches (65.7 x 55.2 cm.)
Signed at the lower right: *Fantin Latour*

The Corcoran Gallery of Art, Washington, D.C. Bequest of Edward C. and Mary Walker, 1937.

Provenance: Purchased from the artist by Mrs. Edward Walker, Washington, D.C., 1904.

Exhibitions: Salon, Paris, 1896, no. 782; *The Edward C. and Mary Walker Collection*, The Willistead Art Gallery, Windsor, Ontario, Oct. 8-29, 1958, no. 5.

Bibliography: *Catalogue illustré de Peinture et Sculpture, Salon de 1896*, Paris, 1896; Thiébault-Sisson, *Le Salon de 1896*, Paris, 1896, p. 24; Roger Marx, "Souvenirs sur Fantin-Latour," *Les Arts*, Oct. 1904, p. 5; Frank Gibson, *The Art of Henri Fantin-Latour*, n.d., p. 215; Adolphe Jullien, *Fantin-Latour: Sa Vie et ses Amities*, Paris, 1909, p. 209; Henri Floury and Mme. Fantin-Latour, *Catalogue de l'oeuvre complet de Fantin-Latour*, Paris, 1911, p. 171, no. 1612; Michelle Verrier, *Fantin-Latour*, New York, 1978, p. 24.

Shown in Atlanta, Norfolk, and Raleigh only.

Fantin-Latour achieved official success gradually, winning a third class medal in 1870 and a second in 1875. His Salon entries in 1879 prompted Huysmans to describe him as "one of the best artists that we possess in France."[1] That same year, he was made a Chevalier of the Legion of Honor.

Fantin owes his lasting fame and popularity to his portraits and still lifes, but he also painted a category of works which the French call *fantasies*. These are figurative works—often based on musical subjects, allegory, or myth—treated in a filmy insubstantial manner reminiscent of Correggio and Prud'hon. Fantin's earliest example of this genre was *Féerie* (Enchantment, now Montreal Museum), a large-scale work of no specific subject but inspired by Watteau. It was rejected from the Salon of 1863.

At first Fantin concentrated these flights of fancy in his lithographs, which he began producing in the 1860s and exhibited at the Salon from 1877 onwards. In 1869, however, he wrote to his English friend Edwin Edwards that he was going to paint more in this imaginative vein.[2] Later, Fantin stated that his artistic aim was "to represent with the greatest possible reality the dreams that pass for a moment before my eyes."[3] In reviewing the paintings shown in the Salon of 1895, Roger Marx wrote: "Fantin-Latour must be placed among the *imaginatifs*; in these times when *photographisme* has made its appearance, he tries to invent."[4]

In the 1890's Fantin concerned himself with the theme of *La Toilette*. In addition to this painting, exhibited at the Salon of 1896, there was a large *Toilette of Venus*, showing the nude goddess attended by eight women.[5] The inspiration may have come, like so many of Fantin's works, from a musical source. Venus had appeared in his *fantasie* of 1864 *Scene de Tannhauser* (Los Angeles County Museum of Art). These late *fantasie* compositions recall mythological scenes by Titian, but they have been transmuted from fleshy revels into gentle reveries.

[1]Huysmans, *L'Art Moderne*, Paris, 1883, p. 72.
[2]See *Henri Fantin-Latour, 1836-1904*, exhibition catalogue, Smith College Museum of Art, 1966, n.p.
[3]Quoted in Adolphe Jullien, 1909, p. 50.
[4]Roger Marx, "Les Salons de 1895," *GBA*, p. 455.
[5]Reproduced in color in *L'Aube du XXe Siècle*, exhibition catalogue, Petit Palais, Geneva, 1968, I, no. 27.

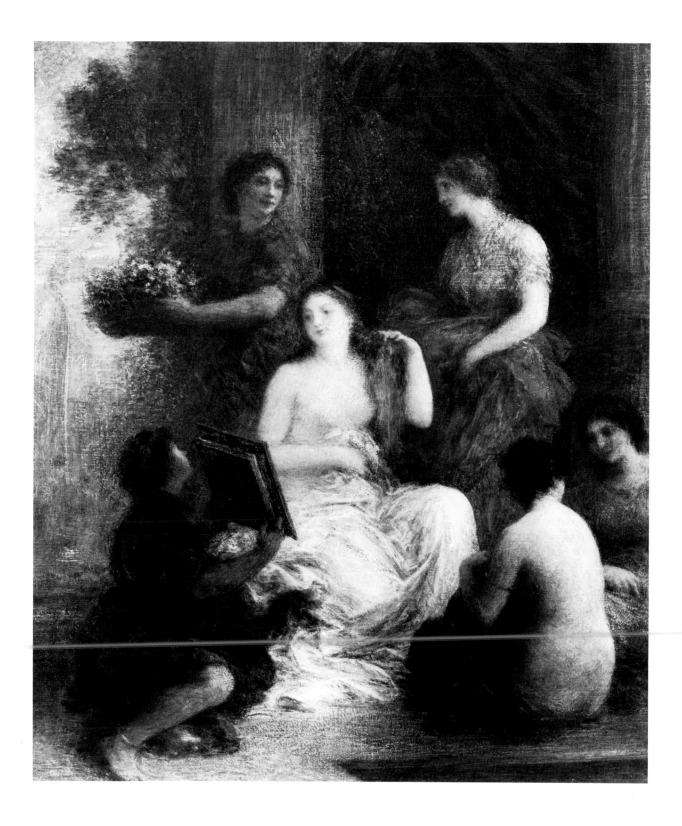

31. *Tribu nomade en marche vers les paturages du Tell (Arabs on the way to the Pastures of the Tell)*, 1866
Oil on canvas, 25 x 41⅞ inches (63 x 103.8 cm.)
Signed and dated at the lower right: *Eug. Fromentin 1866*

The High Museum of Art, Atlanta. Gift of Mrs. Floyd McRae in memory of Frank D. Stout.

Provenance: The Prince Khalil-Bey, Paris; Sale, Hôtel Drouot, Paris, Jan. 16-18, 1868, no. 27; Henry Say, Paris; Sale, Galerie Georges Petit, Paris, Nov. 30, 1908, no. 9 (as *Le Passage du Gué*); Boussod et Valadon; Mr. and Mrs. Frank D. Stout, Atlanta; Mrs. Floyd McRae, Atlanta.

Exhibitions: Salon, Paris, 1866, no. 759; Exposition Universelle, Paris, 1867, no. 282; *Exposition des cent chefs-d'oeuvres*, Paris.

Bibliography: Charles Blanc, "Salon de 1866," GBA, 1866, p. 40; Felix Jaher, *Salon de 1866*, Paris, 1866, p. 43; Charles Beaurin, "Le Salon de 1866," *Revue du XIXe siècle*, June 1, 1866, p. 474; Léon Lagrange, "Le Salon de 1866," *Le Correspondent*, May 21, 1866, p. 210; Théophile Gautier, *Salon 1866*, *Le Moniteur Universel*, July 17, 1866, p. 1; M. Duc, "Le Salon de 1866," *Revue des Deux Mondes*, June 1, 1866; Edmond About, *Salon de 1866*, Paris, 1867, pp. 37-38; *Paris Universal Exhibition, 1867, Complete Catalogue*, London, 1867, p. 11; *Exposition Universelle de 1867, Catalogue Général*, Paris, 1867, I, p. 24; Maxime du Camp, *Les Beaux-Arts a l'Exposition Universelle et au Salons de 1863-67*, Paris, 1867, pp. 223-224; Paul Mantz, "A l'Exposition Universelle," GBA, 1867, p. 330; Olivier Merson, "M. Fromentin," in *L'Exposition Universelle de 1867, Illustrée*, ed. M. F. Ducuiny, Paris, 1867, 2, p. 54; Théophile Gautier, "Collection de S. Exc. Khalil-Bey," *Catalogue des Tableaux*, Hôtel Drouot, Paris, 1868, pp. 19-20; Louis Gonse, "Eugène Fromentin," GBA, 1879, p. 291; L. Gonse, *Eugène Fromentin, Peintre et Ecrivain*, Paris, 1881, pp. 29 and 81; Bellier and Auvry, 1882-87, I, p. 594; Georges Beaume, *Fromentin*, New York, 1913, pp. 42-43; Prosper Dorbec, *Eugène Fromentin*, Paris, 1926, p. 72; Maxime Revon, ed., *Oeuvres Complets de Eugène Fromentin: Un Eté dans Le Sahara*, Paris, 1938, p. 318; A. Tabarant, 1942, p. 380; A. Lagrange, *L'Art de Fromentin*, Paris, 1952, p. 147; *Masterpieces in The High Museum of Art*, Atlanta, 1965, p. 33; Fouad Marcos, *Fromentin et l'Afrique*, thesis, University of Paris, 1954, published Montreal, 1973, p. 140; *Selected Works in The High Museum of Art*, Atlanta, 1981, p. 17.

Fromentin was equally famous as a writer and painter, and his circle of acquaintance in Paris included such leading cultural figures as George Sand, Gustave Moreau, the Goncourts, Flaubert, and Sainte-Beuve. He was born in La Rochelle and his father, a physician who was also an amateur painter, gave him his first instruction. Sent to Paris in 1839 to study law, Fromentin did pursue a legal career for a while, but his unhappiness and his constant drawing and sketching finally convinced his father to allow him to study painting—first with the landscape painter Jean-Charles-Joseph Remond and then with the more distinguished Nicolas-Louis Cabat.

After seeing the works of G.-A. Decamps and Prosper Marilhat, Frometin developed an interest in the East. When the watercolor painter Emile-Charles Labbé offered him the oportunity to accompany him on a trip to Algeria in 1846, Fromentin readily seized it. Two days after he arrived in Blidah, Algeria, he wrote, "The more I study nature here the more convinced I am that, in spite of Marilhat and Decamps, the Orient is still waiting to be painted."[1] The first examples of Fromentin's own Orientalist painting were exhibited at the Salon of 1847 and were well received. He returned to Algeria in 1848 and again in 1852 with his wife. Fromentin was particularly fascinated by the lives of the nomadic Arabs inhabiting the untamed region, and his impressions were published in two books, *A Summer in the Sahara* (1857) and *A Year in the Sahel* (1859), as well as in a series of major canvases.

In 1859 Fromentin was made a Chevalier in the Legion of Honor and won a first class medal for the painting *The Simoom*. He continued his dual career as writer and painter, publishing a romantic novel *Dominique* in 1863, the same year he sent to the Salon one of his most famous paintings, *The Arab Falconer*. In 1869 Fromentin was elevated to Commander of the Legion of Honor. The year before his death, he published his major work of art criticism *Les Maîtres d'autrefois*, which, when translated into English in 1888, had a great impact on perceptions of Flemish and Dutch art.

The High Museum's painting was exhibited at the Salon of 1866 and again in a group of seven pictures shown by the artist at the Exposition Universelle of 1867, for which he was awarded another first class medal. Most writers, then and subsequently, have agreed with Eugène About that it is a *"chef d'oeuvre."* Du Camp called it "a symphony," Gautier in his review in *Le Moniteur Universel* thought it Fromentin's most distinguished work and later described it as "a true pearl," and George Sand wrote in a letter to the painter that it was "the discovery of the Salon and a fine diamond." The subject—an Arab tribe or *smala* on the move to-

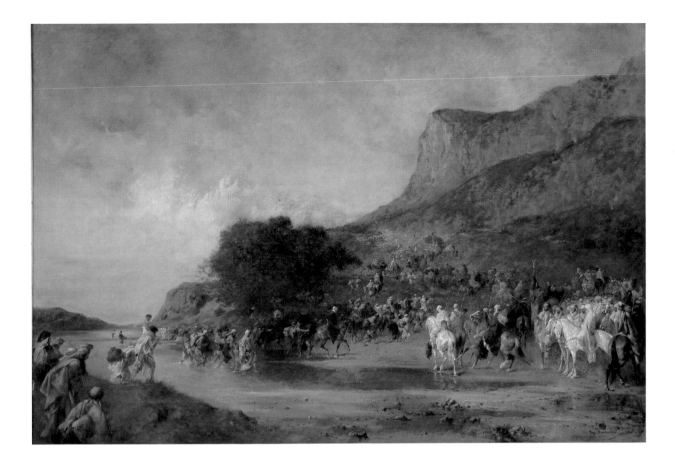

wards the fertile fields of the Algerian Tell—was, according to Charles Blanc, a veritable illustration of a scene witnessed by Fromentin and described in his book *A Summer in the Sahara.* Maxime Revon pointed to an account of a caravan found in Fromentin's *Carnets de voyage (Traveler's Notebook)* of 1848:

> We broke camp (the scheik El-Arab had given the order in writing the previous evening). In half-an-hour the tents were taken down and rolled up and all the goods organized for the caravan—all done by the women. The horses are saddled. The horsemen in full costume, the guns at the ready, all their showy ammunition in their belts, mounted on their horses bedecked in long blankets of colored silk, they await the signal to depart. . . . The horsemen proceed and follow the procession slowly, for the immense caravan, divided into groups, is composed of seven hundred camels, of women on foot, of servants and children (a total of at least a thousand persons).
>
> It is about 9 o'clock, the sky and the plain are flooded with an incomparable light.
>
> We arrive at the edge of the river. Its steep banks are in the shade of tamarind trees. We establish ourselves on the far bank to assist the sheik in presiding over the crossing of the entire caravan. It is an indescribable procession, one contingent following another. Each new group is a painting.[2]

[1]Quoted in Shepherd Gallery, 1975, p. 219.
[2]Fromentin, *Un Eté dans le Sahara,* 1938, ed. by M. Revon, p.318.

32. *Le Combat de coqs (The Cock Fight)*, ca. 1846
Oil on canvas, 15¾ x 22 inches (40 x 56 cm.)
Initialed at the lower right: *J.L.G*

The Chrysler Museum, Norfolk. On loan from the collection of Walter P. Chrysler, Jr..

Provenance: Count d'Acquile, Paris; Sale, Feb. 1868; Arthur Lenars & Co., Paris; Walter P. Chrysler, Jr.

Exhibitions: Dayton, 1960, no. 21.

Bibliography: Gerald M. Ackerman, *Jean-Léon Gérôme*, exhibition catalogue, Dayton, 1972, p. 30.

At the age of sixteen, Gérôme the son of a successful goldsmith from Vesoul near Basle, went to Paris, where he studied with Delaroche. He accompanied the master on a trip to Rome in 1844. Returning to Paris, the young artist entered the atelier now run by Gleyre. Gérôme competed unsuccessfully for the Prix de Rome in 1846. With Delaroche's encouragement, however, he entered a large work of a classical genre subject in the Salon of 1847. This was the *Combat de coqs*, and although it was hung high on a wall, the work was singled out for praise by the influential Théophile Gautier. Gérôme won a third class medal and was suddenly famous. The painting, one of the largest and most important examples of the *Neo-Grec* style practiced among Gleyre's students, is now in the Louvre.

The painting's success led the publisher Goupil to issue a photogravure reproduction, and for this purpose Gérôme painted a replica on a smaller scale with some minor differences. Gerald Ackerman has identified the work now in the Chrysler collection as this replica. Later Goupil, who was to become Gérôme's father-in-law, published a photogravure after the large version as well.

The unusual subject of the work is probably derived from an ancient Hellenistic terracotta, such as that of a cock fight watched by two putti now in the Walters Art Gallery. The depiction of the two birds in the painting is nearly identical to the terracotta, but in place of the putti Gérôme has painted a young boy and girl.

Gautier, seeing the large version for the first time, perceived it as something new and fresh:

> Let us congratulate ourselves that the jury apparently through inattention has admitted a charming picture full of delicacy and originality by a young man of whom we hear for the first time. . . . This subject, apparently trivial, has, under his fine and delicate handling of pencil and brush, taken on a rare elegance and an exquisite individuality. It is not as one might think, from the theme chosen, a canvas of small dimensions, as is usual. The figures are lifesize, treated in an entirely historical manner. A great deal of talent and resourcefulness have been necessary to elevate such a common scene to the level of a noble composition.[1]

Gautier concludes that this work, "one of the most charming canvases in the exhibition, would make a wonderful over-door decoration in the dining room of some king." Théophile Thoré followed suit, writing,

> we have discovered another young man who presents a quite distinguished personal style even though he comes from the atelier of Delaroche. . . . The young Grecian maiden reclining daintily looks with a refined expression at the two cocks stirred up by her half nude brother. . . . The drawing of these figures is correct without being cold, the color well-balanced, true, and harmonious.[2]

Most of the other Salon critics agreed but some could not refrain from pointing out certain faults: Paul Mantz did not find the figures at all Greek and thought the torso of the young man abounded in shabby details and that the pale bodies were "far from seductive." Clement de Ris also expressed some reservations, finding that the young girl "whose head is charming" is not very much in touch with the scene that takes place before her.[3]

Although in this reduced version we lose the monumental scale that was one of the chief novelties of the painting, we can still appreciate Gérôme's mastery of technique and the remarkable finish that led Gautier to say "one might take it for an ancient colored bas-relief."[4] In 1872, Henry James saw a "small" version of the subject, possibly this painting. He wrote:

> Though small and of simple elements, this picture is a capital example of the master, and presents in remarkably convenient shape the substance of his talent—that indefinable *hardness* which is the soul of his work. The present picture is equally hard in subject and in treatment, in feeling and in taste. A young man, entirely naked, is stooping upon one knee, and stirring two bristling gamecocks to battle. A young woman, also naked—more than naked, as one somehow feels Gérôme's figures to be—reclines beside him and looks lazily on. The room and the accessories are as smartly antique as Gérôme alone could have made them. The picture is, of course, painted with incomparable precision and skill; but the unloveliness of the subject is singularly intensified by the artist's sentimental sterility.[5]

[1]Théophile Gautier, "Le Salon de 1847," in *La Presse*, March 1847, translated in Hering, 1892, p. 52.
[2]Quoted in Pierre Angrand, "*Oedipe Enfant* et *Le Combat de Coqs*, J.-F. Millet, Léon Gérôme et la Critique en 1847," GBA, 86, 1975, pp. 145-146.
[3]*Ibid.*
[4]Théophile Gautier, "Exposition de 1859," *Le Moniteur Universel*, April 23, 1859.
[5]Quoted in Henry James, *The Painter's Eye*, John L. Sweeney ed., London, 1956, p. 51.

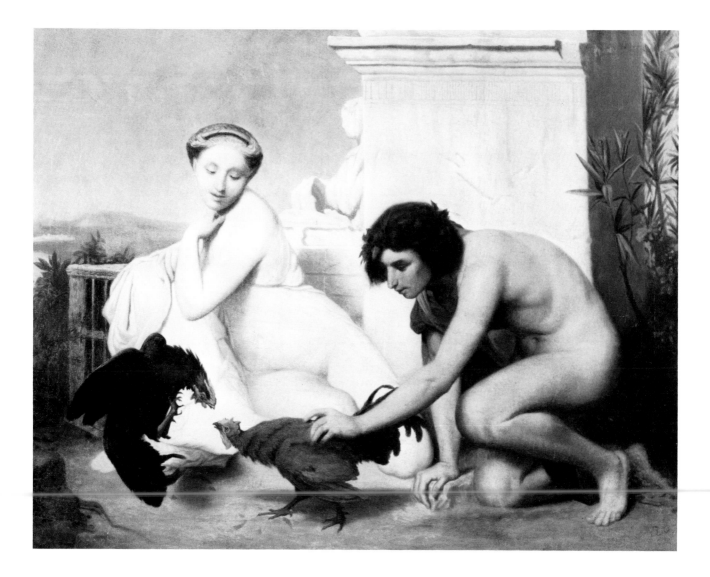

33. *Le Roi Candaule (King Candaules)*, 1859

Oil on canvas, 26½ x 39 inches (67.3 x 99 cm.)
Signed and dated at the lower left on the base of the sculpture: *J. L. GEROME MDCCCLIX*

Museo de Arte de Ponce (The Luis A. Ferré Foundation), Ponce, Puerto Rico.

Provenance: Wilson Collection, Paris; Sale, Paris, March 1882; Mayer Collection; Sale, April 27-28, 1886; Capt. J. R. De Lamar, New York; Sale, Plaza Hotel, New York, Jan. 29, 1920, no. 30; William Randolph Hearst; Hearst Corporation; Sale, Parke-Bernet, New York, March 21, 1963, no. 82.

Exhibitions: Salon, Paris, 1859, no. 1239; Dayton, *Gérôme*, 1972-73, no. 8.

Bibliography: Théophile Gautier, "A travers l'ateliers," *l'Artiste*, 62, 1858, p. 18; Charles Baudelaire, "Salon de 1859," *Revue Française*, June - July 1859 (reprinted in *Art in Paris*, 1965, pp. 175-176); Théophile Gautier, "Exposition de 1859," *Le Moniteur Universel*, April 23, 1859, p. 1; M. de Belloy, "Salon de 1859," *l'Artiste*, 1859, p. 258; Paul Mantz, "Salon de 1859, III," *GBA*, pp. 196-198; H. Delaborde, "Le Salon de 1859," *Revue des deux mondes*, June 1859, pp. 504-505; Charles Perrier, "Le Salon de 1859," *Revue Contemporaine*, pp. 298-299; Ernest Chesneau, "Salon de 1859," *Revue des Races Latines*, 1859, p. 46; Louis Jourdan, *Les Peintres français, Salon de 1859*, Paris, 1859, p. 39; Mathilde Stevens, *Impressions d'une femme au salon de 1859*, Paris, 1859, p. 17; M. H. Dumesnil, *Le Salon de 1859*, Paris, 1859, p. 93; Edward Strahan, *Gérôme*, New York, 1881, I, ill.; Claretie, *Peintres*, 1884, p. 67; Cook, 1888, I, p. 30; Hering, 1892, p. 87; Stranahan, *History*, 1917, p. 318; Held, 1965, p. 73; *Gérôme . . . ses oeuvres conservées dans collections françaises*, exhibition catalogue, Musée de Vesoul, Aug. 1981, p. 110.

Throughout the 1850s, Gérôme developed his art in a variety of directions. He painted religious murals for Parisian churches, designed a great Sèvres urn in 1853, and executed a huge allegory—*The Age of Augustus, the Birth of Christ* (1855)—which won him a second class medal and an appointment as an Officer of the Legion of Honor. Its sale for 20,000 francs allowed the artist to take his first trip to Egypt. Thereafter, Near Eastern subject matter became one of Gérôme's prime concerns.

During this period, Gérôme's home became a popular gathering place for many artists, including the painters Baudry, Cabanel, and Hebert, the famous actress Rachel, and the writers George Sand and Théophile Gautier. It was a Gautier story written in 1844 that provided the subject for one of Gérôme's major *Neo-Grec* paintings, *Le Roi Candaule*, which was shown in the Salon of 1859.

Gautier based his story on an incident related in the first book of Herodotus's *History*. King Candaules of Lydia had a beautiful wife, but as the Lydians "reckoned it a deep disgrace, even to a man, to be seen naked,"[1] she wore copious garments and no one except her husband could appreciate her. This disturbed the proud King and he arranged that one of his followers, Gyges, hide behind the door of the royal bedroom and watch the Queen disrobe. Gyges reluctantly did this, but was espied by the Queen as he departed. To avenge the offense, she gave Gyges the choice of either being killed or of killing Candaules and gaining thereby both herself and the throne. Gyges chose the latter course and that very night hid again in the bedroom, and slew the sleeping King with a dagger provided by the Queen.

The scene depicted in the painting, as Gautier observed in his 1858 article,[2] is the second visit of Gyges. Gautier named the queen Nyssia, and describes her disrobing in breathless detail:

At last, seeming to nerve herself for a sudden resolve, she doffed the tunic in its turn; and the white poem of her divine body suddenly appeared in all its splendour, like the statue of a goddess unveiled on the day of a temple's inauguration. Shuddering with pleasure, the light glided and gloated over those exquisite forms, and covered them with timid kisses.[3]

The painting's almost claustrophobic abundance of splendidly rendered objects and decorations also owes much to Gautier's elaborate flights of fantasy:

Along the walls . . . stood tall statues of black basalt in the constrained attitudes of Egyptian art, each sustaining in its hand a bronze torch into which a splinter of resinous wood had been fitted.

Near the head of the bed, on a little column, hung a trophy of arms, consisting of a visored helmet, a two-fold buckler made of four bull's hides and covered with plates of brass and tin, a two-edged sword, and several ashen javelins with brazen heads. . . . Opposite to the trophy stood an armchair inlaid with silver and ivory upon which Nyssia hung her garments.

To assist in designing what Paul Mantz aptly described in his *Gazette des Beaux-Arts* review as the "luxurious greco-asiatic interior," Gérôme consulted the architect Bougerel. As pointed out at the time by Dumesnil, the painting's composition "recalls from afar" Ingres's 1840 painting of *Antiochus and Stratonice*, another classical scene set in an elaborately detailed bedchamber.[4] Gérôme made several oil studies which focus primarily on the pose of the nude—one is in the Museum of Vesoul,[5] and another was formerly at the Schweitzer Gallery, New York.[6] A replica of the painting is in the Pushkin Museum in Moscow.[7]

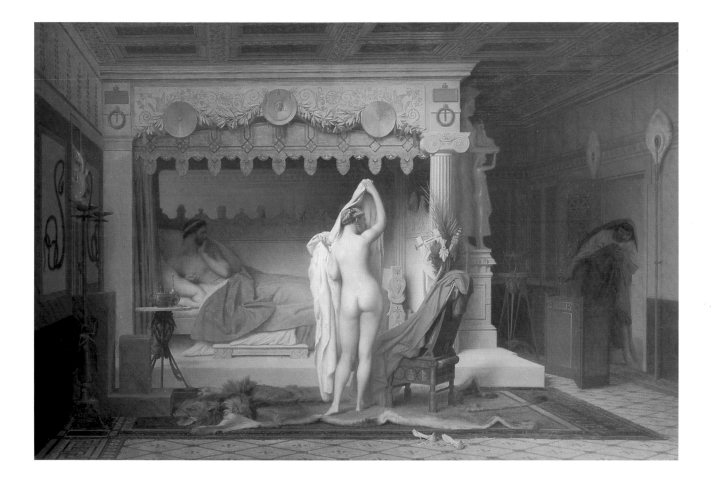

Gautier was pleased with the artist's treatment of his story and wrote:

> Had we not an ideal which guarantees us against all self-love, we might be proud of our little antique novellete, *King Candaules*, which has inspired Pradier to make a statue and Gérôme to paint a picture. Marble and canvas have portrayed our Nyssia in a manner far superior to words. . . . [In Gérôme's work] the form from which the drapery is just slipping is exquisite in its divine marmorean pallor.[8]

Other critics did not share Gautier's enthusiasm. Baudelaire, wrote:

> [Gérôme's] *King Candaules* is once again a snare and a distraction. Many people go into ecstasies in front of the furnishings and the decoration of its royal bed. Just look, an Asiatic bedroom! what a triumph! But is it really true that his terrible queen, who was so jealous of her own person that she considered herself no less polluted by a glance than by the touch of a hand, looked like this flat marionette?[9]

Today we are perhaps less concerned with the accuracy of modeling. The nude Nyssia seems the ideal focal point, balancing the attitudes of the two men. The splendid bedchamber is permeated by an ominous atmosphere that suggests the impending act of murder.

[1]*The History of Herodotus,* translated by George Rawlinson, New York, 1947, p. 2.

[2]Gautier, "A Travers l'Ateliers," *L'Artiste,* 62, 1858, p. 18.

[3]This and following quote from *Tales from Gautier,* ed. George Saintsbury, London, 1927.

[4]Georges Wildenstein, *Ingres,* London, p. 211, no. 232, pl. 82.

[5]J.-L. *Gérôme . . . dans collections françaises,* exhibition catalogue, Musée de Vesoul, 1981, no. 125.

[6]Reproduced in *Gérôme,* exhibition catalogue, Dayton, 1972-73, no. 47.

[7]Reproduced in *Le Peinture française au musée Pouchkine, Moscow,* Paris, and Leningrad, n.d., no. 138.

[8]Gautier, *Le Moniteur Universel,* 1859, and quoted in part in Hering, 1892, p. 87.

[9]Baudelaire, "The Salon of 1859," quoted in *Art in Paris,* trans. by Jonathan Mayne, 1981, pp. 175-176.

34. *La Promenade de Harem (Excursion of the Harem)*, 1869
Oil on canvas, 47½ x 70 inches (120.6 x 177.8 cm.)
Signed on the boat at the left: *J.L. GEROME*

The Chrysler Museum, Norfolk. Gift of Walter P. Chrysler, Jr., 1971.

Provenance: E. Pinkus, New York, 1963; Walter P. Chrysler, Jr.

Exhibitions: Salon, Paris, 1869, no. 1027; Hofstra, 1974, no. 46; Nashville, 1977, no. 34; Wildenstein, 1978, no. 15; *Eastern Encounters*, Fine Art Society, London, June 26 - July 28, 1978, no. 109.

Bibliography: Théophile Gautier, "Le Salon de 1869," *L'illustration*, May - June 1869 (reprinted in *Tableaux à la plume*, Paris, 1880, pp. 304-305; Jean Dolent, *Avant le Déluge*, Paris, 1869, p. 56; Paul Casimir Perier, *Propos d'art à l'occasion du Salon de 1869*, Paris, 1869, pp. 204-205; Castagnary, 1892, p. 358; Claretie, *L'Art*, 1876, p. 158; Georges Lafenestre, *L'art vivant, La peintre et la sculpture aux Salons de 1868 à 1877*, Paris, 1881, I, pp. 129-130; Strahan, *Gérôme*, 1881, I, rep. pl. XLVIII; George W. Sheldon, *Hours with Art and Artists*, New York, 1882, p. 88; *Oeuvres de J.L. Gérôme*, Goupil and Co., Paris, nd, no. 1048; Hering, 1892, pp. 209-210; Haller, 1899, p. 98; Stranahan, *History*, 1917, p. 318; Philippe Jullian, *The Orientalists*, Oxford, 1977, pp. 64-65; *Apollo*, 1978, p. 22, pl. XI.

On his first visit to Egypt, Gérôme and his traveling companions spent four months on a houseboat on the Nile and another four living in Cairo. He was thus well acquainted with the city and the river and used them as subjects for a great many genre scenes. One of his most famous works set on the Nile was *The Prisoner*, painted in 1859. It shows an open boat crossing the Nile at dawn; the handcuffed prisoner accompanied by guards rowing and a musician singing. The calm of the river and the early morning light endow the scene with an eerie character.

The success of *The Prisoner* (a second version was done in 1861) may have led the artist to create this painting, *Le Promenade de Harem*, in which he combines the boat motif with another of his favorite themes—the cloistered life of the harem. It was exhibited at the Salon of 1869, the year Gérôme made his fifth visit to Egypt, this time to attend the festivities on the occasion of the opening of the Suez Canal.

Gérôme's Egyptian subjects display a very distinctive quality of light and atmosphere, quite different from his earlier *Neo-Grec* productions, and Gautier noted this in his sympathetic review:

> The picture shows us a *caique* flying swiftly along the Nile under the united effort of ten oarsmen; in a cabin on deck is a group of mysterious beauties half visible behind the curtains and crouching in the stern a musician chants to the accompaniment of his *guzla* . . . The boat slips over the clear transparent water, along the misty shore in a sort of luminous fog which produces a magical effect. The bark seems to float at the same time in the water and in the air. These effects which appear almost improbable to eyes that are not accustomed to the delicate tones of the "land of light" are rendered by Monsieur Gérôme with absolute fidelity.[1]

Castagnary also praised Gérôme for foregoing the sensational subjects he usually painted and submitting "one of the best things that he has painted." He thought the landscape "finely drawn," and the whole "like an impression of reality, well grasped and well rendered."[2]

The subtle balance of the different modes of movement—the boat gliding on the water, the caravan of camels on the shore, and the flight of the birds in the sky above—is marvelous. We can understand why the Empress wished to buy the work, but also sympathize with her reluctance to pay the high asking price of 30,000 francs. An oil sketch attributed to Gérôme, on the Parisian art market in 1980, combined the harem boat with the background of *The Prisoner*.

[1]Gautier, 1869, p. 305.
[2]Castagnary, 1892, p. 358.

35. *Tiger on the Watch*, ca. 1888
Oil on canvas, 25 x 35½ inches (63.5 x 90.5 cm.)
Signed at lower left of center: *J. L. GEROME*

The Museum of Fine Arts, Houston.

Provenance: Felix Isman, Philadelphia; Sale, American Art Association, New York, Feb. 3, 1911, no. 8; R. C. Rose; John Levy Galleries, New York, 1917; George M. Dickson, Houston; Bequest to Houston Art League.

Bibliography: Daniel Catton Rick, *Henri Rousseau*, New York, 1942, p. 29; A. Boime, "Jean-Leon Gérôme . . .," *Art Quarterly*, Spring, 1971, pp. 8, 23.

Gérôme's affinity for animals was evident from the time of his *Cock Fight* of 1849, but he especially liked to paint large felines. In 1851 he produced a *Black Panther on the Watch*, which belonged to Théophile Gautier and is now in the Museum of Fine Arts, Boston. Most of his cat paintings, however, date from the 1880s, when his concern with sculpture may have led him to reconsider the works of such *animaliers* as his friend, the sculptor Barye. Also, the precedent established by Delacroix of representing lions and tigers should not be forgotten.

Gérôme's greatest fondness was for lions, usually single heroic male specimens.[1] In the course of his many travels, he also had the opportunity to see and hunt the beasts in their native habitat. The beautifully patterned fur of tigers also appealed to Gérôme, as is evidenced in such works as *The Dead Tiger* and *Seller of Skins (Cairo)*.[2] Most of Gérôme's paintings of tigers in the wild show a female with her cubs, as in the Metropolitan Museum of Art's *Tiger with Cubs* or his *Night in the Desert*, shown at the 1884 Salon.[3]

This *Tiger on the Watch*, however, is similar to several of the lions of the 1880s, such as *Lion on the Watch* (Cleveland Museum), in which a single beast is shown high up on a promontory regarding his prey in the valley below. The Houston painting was also at one time entitled *In Search of Prey*.[4] Here the tiger views what seems to be an extensive military formation, suggesting a parallel between the tiger on the prowl and these human predators. This is an outstanding example of Gérôme's brilliant technique. The tiger is so convincingly painted that we can almost feel the texture of its fur, sense the taut muscles, and anticipate its movement. The radiant landscape is also of singular beauty. Its barren grandeur recalls the descriptions of the desert penned by Gérôme during his expeditions.

[1]It has been suggested that Gérôme identified with lions through his name. See Boime, p. 9ff.
[2]Ill. in *Eastern Encounters*, Fine Art Society, London, 1978, no. 31.
[3]Armand Dayot, *Salon de 1884*, Paris, 1884, ill. between pp. 12 and 13; and Hering, 1892, p. 244.
[4]This title was used with a color reproduction (copyright 1904 by The Library Publishing Corp.), when the painting was in the Isman collection.

36. *The Christian Martyrs' Last Prayer*, 1883

Oil on canvas, 34⅜ x 59¹/₁₆ inches (87.9 x 150.1 cm.)
Signed at the lower left on the edge of the pit:
J. L. GEROME

The Walters Art Gallery, Baltimore.

Provenance: William Walters, Baltimore, 1884.

Exhibitions: Gérôme, Dayton, 1972, no. 36; *Romans and Barbarians*, The Museum of Fine Arts, Boston, 1976-77, no. 282.

Bibliography: William Macleod, "The Public and Private Collections," *The American Art Review*, Boston, 1880, I, p. 18; *The Walters Collection*, Baltimore, 1884, no. 63; Champlin and Perkins, 1886, p. 129; *Gérôme: Reproductions of his Famous Paintings*, Gérôme Society, New York, 1889, no. 4; Alfred Mathews, "The Walters Art Collection at Baltimore," *Magazine of Western History*, New York, 1889, X, no. 1, p. 6; "Gérôme in American Collections," *The Collector*, Sept. 1, 1890, p. 150; Hering, 1892, pp. 242-243, ill. p. 8; "The Walters Collection of Art Treasures," *Magazine of American History*, April, 1892, XXVII, no. 4, p. 250; Stranahan, *History*, 1917, pp. 314, 319; Milton Reizenstein, "The Walters Art Gallery," *New England Magazine*, July 1895, pp. 554-555, ill. p. 552; *The Walters Collection*, Baltimore, 1901, p. 46, no. 63; *Cosmopolitan*, Dec. 1901; M. H. Spielman, "J.-L. Gérôme: 1824-1904 Recollections," *The Magazine of Art*, London, 28, 1904, p. 201; "The Passing of J.-L. Gérôme," *Brush and Pencil*, XIV, 1904, p. 36; J. E. Reed ed., *100 Crowded Masterpieces*, n.d.; Albert Boime, "Jean-Léon Gérôme . . . ," *Art Quarterly*, Spring 1971, pp. 13-14; Ruth K. Meyer, "Jean-Léon Gérôme, The Role of Subject Matter and the Importance of Formalized Composition," *Arts Magazine*, Feb. 1973, p. 34; W. R. Johnston, "Gérôme, an Archeologist?", *The Walters Art Gallery Bulletin*, April 1973, fig. 1, pp. 1-4; Frank Trapp, "An Aged Lion Returns," *Burlington* Magazine, May 1973, p. 345; Randall, 1979, II, pp. 563, 580.

In the Salon of 1859, Gérôme showed, in addition to the *King Candaules*, the first of his realistic reconstructions of ancient Roman arena scenes, *Ave Caesar*. It was also in 1859 that William Walters of Baltimore purchased from the artist a version of one of his most popular compositions, *Duel After the Masked Ball*, and it seems likely that the success of the *Ave Caesar* must have inclined the American collector to commission a "Roman" painting at the same time. However, this work, *The Christian Martyrs' Last Prayer*, was not ready until 1883. On May 2 of that year Mr. Walters's Paris agent, George Lucas, went to see it in the artist's studio and on July 15 Gérôme wrote the following letter of explanation to his patron:

My Dear Sir:—I send you a few notes about my picture, "The Christian Martyrs—Last Prayer," which you have bought. I regret having made you wait for it so long, but I had a difficult task, being determined not to leave it until I accomplished all of which I was capable.

This picture has been upon my easel for over twenty years. I have repainted it from the beginning three times; have rehandled and rechanged both the effect and the composition, always, however, preserving my first idea.

The scene is laid in the "Circus Maximus," which might readily be mistaken for an amphitheatre, as in the picture only the end of the circus, and not the straight sides, is visible. But you will see on the left the "Meta," which ends the "Spina," and is the goal around which the chariots made their turns in the races, as I have indicated by the tracks of the wheels in the sand.

In the time of the Caesars, Christians were cruelly persecuted, and many were sentenced to be devoured by wild beasts.

This is the subject of my picture.

As they were religious enthusiasts, to die was a joy, and they cared little for the animals, their only thought being to remain firm to the last. And rarely indeed was there found a case of apostasy.

The Roman prisons were terrible dungeons, and Christians, being often long confined before the sacrifice, when led into the circus were emaciated by disease and covered only with rags. Their hearts alone remained strong, their faith alone remained unshaken.

In the middle distance I have placed those destined to be burned alive. They were usually tied upon crosses, and smeared with pitch to feed the flames.

It was the custom to starve the wild beasts for several days beforehand, and they were admitted to the arena up inclined planes. Coming from the dark dens below, their first action was of *astonishment* upon facing the bright daylight and the great mass of people surrounding them.

They did then as does to-day the Spanish bull when turned into the arena; entering with a bound, he suddenly halts in the very middle of a stride.

This moment I have sought to represent.

I consider this picture one of my most studied works, the one for which I have given myself most trouble.

Is it a success?[1]

We can appreciate Gérôme's enthusiasm for a painting which allowed him to combine in one work two of his favorite subjects—ancient Rome and big cats. Although the Christian martyrs do look "emaciated," the large lion does not appear "starved," but is a rather healthy specimen. The other lion and tiger blinking in the passageway are so appealing that they tend to evoke a sympathetic response from the viewer. Only slowly, as we study the more lightly painted section of the victims and the circle of human torches, does the horrible nature of the subject dawn upon us. Out of the general *melee*, we suddenly pick out the red robes of the executioners who light the bundles of faggots with their long torches. Almost hidden behind the wall at the left is the chief executioner, also swathed in red. One of the most brilliant effects of the painting is Gérôme's rendering of the hazy twilight veiling the distant city, giving a softness which contrasts with the strong plasticity of the noble lion.

An unfinished large oil sketch of the same subject—showing differences in the lion, architectural details, and background—was sold at Sotheby's in 1981 and may be one of Gérôme's rejected early treatments. In 1902 Gérôme exhibited what could be described as a pendant to the Walters's painting, *La Rentrée des Felines dans la Cirque (Return of the Beasts to their Cages)*. [2]

[1]Quoted in *The Walters Collection*, Baltimore, 1884.
[2]The painting is reproduced in *Jean-Léon Gérôme Sculpteur et Peintre*, Galerie Tanagra, Paris, 1974, p. 8.

37. *Charmer de Serpents (The Snake Charmer)*
Oil on canvas, 36 x 29 inches (85 x 28 cm.)
Signed at the lower left on the basket lid: *J. L. GEROME*

New Orleans Museum of Art. Gift of Mrs. Chapman Hyams, 1915.

Provenance: Mr. and Mrs. Chapman H. Hyams, New Orleans.

Exhibitions: *Artists of the Paris Salon,* Cummer Gallery of Art, Jacksonville, Jan. 7 - Feb. 2, 1964, no. 22.

Bibliography: Robert B. Mayfield, *The Art Collection of Mr. and Mrs. Chapman H. Hyams,* New Orleans, 1915 (reprint 1964, no. 12); Ethel Hutson, "Little Journeys to the Art Museums," *The American Art Student,* May 1927, p. 18; Richard Ettinghausen, "Jean-Léon Gérôme as a Painter of Near Eastern Subjects," *Jean-Léon Gérôme,* exhibition catalogue, Dayton, 1972, p. 19.

One of the most fascinating Oriental subjects that Gérôme treated was the snake charmer. His most elaborate version is in the Sterling and Francine Clark Art Institute, Williamstown. The snake charmer or *hawee* playing his flute is seated and his boy assistant shows off the large python partly wrapped around his nude body to an audience of a turbaned warrior and his retinue seated in an elaborately tiled Turkish hall.

The painting in the New Orleans Museum presents a humbler scene. Richard Ettinghausen described it as an "Egyptian coffee house." Here, two cobras, as well as the python and the musicians, perform on a tattered carpet before a motley crowd. Composed late in the artist's career, the work uses various elements and figures from what must have been an extensive stock of drawings. Claretie specifically mentions an admirable series of snake studies,[1] and the rearing hooded cobra also occurs in Gérôme's sculpture *Bellona.* Several of the squatting figures are similar to those in the Clark picture; the old man playing the *oud* is based on a drawing now in Professor Ackerman's collection; and the seated boy playing the flute appears, without the snake, in another drawing.[2]

While the Clark painting is a horizontal composition, this one is vertical, with half of the high space given to the room. This was a format that Gérôme favored, especially for his Near Eastern scenes. It allowed him to include the effects of dappled sunlight on the walls. The free, almost impressionistic, brilliance of the light seen here and in works such as *Moorish Bath* (Museum of Fine Arts, Boston) counterbalances the carefully painted array of authentic Near Eastern *objets.*

[1]Claretie, *Peintres,* 1884, p. 68.
[2]Reproduced in J. Claretie, "J.-L. Gérôme," in *Grands Peintres françaises et étrangers,* Paris, 1884, I, p. 149.

38. *Sculpturae Vitam insufflat Pittura (Painting
Breathes Life into Sculpture)* or
Atelier de Tanagra (Tanagra Shop), ca. 1893
Oil on canvas, 25⅜ x 35⅞ inches (62 x 88 cm.)
Signed at the lower right: *JL GEROME*

Stuart Pivar Collection. Courtesy of the University of
Virginia Art Museum, Charlottesville.

Provenance: Knoedler and Co.; Schweitzer Gallery, New
York.

Exhibitions: *Reality, Fantasy and Flesh, Tradition in
Nineteenth Century Art,* University of Kentucky Art
Gallery, Lexington, Oct. - Nov., 1973, no. 42; Hofstra,
1974, no. 43.

Gérôme turned to sculpture in the 1870s, and he ex-
hibited his first major work in this medium, *The
Gladiators,* at the Exposition Universelle of 1878, win-
ning a medal of honor. It was also in the 1870s that
small brightly-painted Hellenistic terra cotta figurines
from Tanagra were first discovered and shown at the
Louvre.[1] Their lively treatment of genre subjects seemed
to justify the *Neo-Grec* aesthetic. Gérôme was fascinated
by the ancient practice of painting sculpture and embel-
lishing it with precious jewels and other materials. This
painting and another version (Art Gallery of Ontario,
Toronto)[2] provide a witty recreation of this ancient
process. Gerald Ackerman has pointed out that Gérôme
invented the Latin title, for the word *sculptura* is not
Roman but medieval.

In the atelier, we see a mixture of Gérôme's sculpture
and authentic ancient works. The small plaster piece
into which the young woman, the personification of
Pittura, is "breathing life" is *The Hoop Dancer*—
Gérôme's own version of a Tanagran figure. He pro-
duced a bronze edition of it in 1891. Another identifi-
able piece is the nude seated on the column. This is
Corinth, Gérôme's last major sculpture. As finished by
his assistant, Decorchement, the work was made of
polychromed marble, bronze, semiprecious stones, and
pâte de verre.[3]

The painting is full of bizarre inventions such as the
basket of life-like masks. One of the amusing notes is the
representation of the women shoppers in their Tanagran
hats—the very hats that appear on the authentic
figurines. This contributes to the painting's curious
interplay between reality and imitation.

[1] A series of articles on the Tanagra figures appeared in the *Gazette des
Beaux-Arts* in 1875.
[2] See *Jean-Léon Gérôme,* exhibition catalogue, Dayton, 1972, no. 41.
[3] See Gerald Ackerman in *The Romantics to Rodin,* exhibition
catalogue, Los Angeles County Museum, 1980, p. 291 and *Jean-Léon
Gérôme Sculpteur et Peintre,* Galerie Tanagra, Paris, 1974, no. 19.

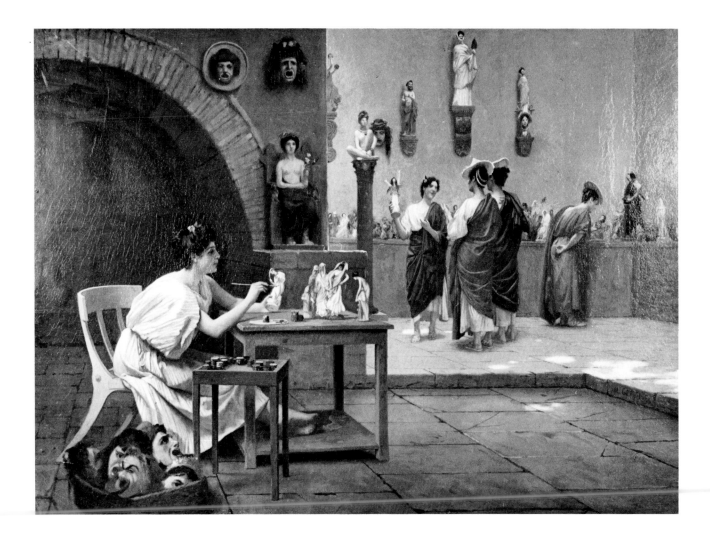

39. *Toilette japonaise,* 1873
Oil on canvas, 21¼ x 25¾ inches (54 x 65.4 cm.)
Signed and dated at the lower left: *Firmin Girard 1873*

Museo de Arte de Ponce, Puerto Rico (The Luis A. Ferré Foundation).

Provenance: August Belmont, New York.

Exhibitions: Salon, Paris, 1873, no. 637; *New York Centennial Loan Exhibition,* The Belmont Gallery (Residence of Mr. August Belmont), 109 Fifth Avenue, New York, 1876 no. 29.

Bibliography: *Catalog de Salon,* Paris, 1873, p. 99; Strahan, *Treasures,* 1881, I, p. 113, rep. opp. p. 107; Bellier and Auvry, 1882, I, p. 653; Bénézit, 1951, 4, p. 279; Held, 1965, p. 78; Ronald Pickvance, "Monet and Renoir in the mid-1870s," in *Japonisme in Art: An International Symposium,* Tokyo, 1980, pp. 157-158.

Firmin Girard came to Paris from Poncin in the mid-1850s and studied with Gleyre, perfecting a highly finished realistic style. At first, he specialized in religious and historical subjects. He began exhibiting at the Salon in 1859 with a *St. Sebastien,* but found it difficult to make a living from such subjects and turned to genre, becoming what Montrosier described as "an *anecdotier* full of humor and originality." His *After the Ball* of 1863 won a third class medal, and he continued producing scenes of everyday Parisian life; his *Flower Seller,* shown in the Salon of 1872, was one of the most successful. In that same year, the painter E. Casters exhibited a *Bazaar japonais* and this may have inspired Firmin Girard. Since the International Exposition of 1867, a taste for things Japanese had become a veritable rage in Paris.[1] This *japonisme* affected a great many diverse artists—from Manet, Renoir, and Degas to Whistler, Tissot, and Stevens (cat. no. 62).

In 1872 Firmin Girard painted a work which—when it was in the William Astor collection—was called by Strahan *Une Japonaise: Spring Time.*[2] At the time of the collection's sale it was entitled *Cherry Blossoms* and described as "a lady in Japanese costume with a sunshade reaching up to inhale the perfume of the flowery branch of a cherry tree."[3] This painting served as the basis for a porcelain plaque executed by H. Catelin in 1886.[4]

In 1873 Firmin Girard exhibited *Toilette japonaise,* which the art critic Castagnary described as "a fantasy of a Naturalist, who likes to pose problems with his brush. The result of this is one of the most successful works in the Salon. . . . It's delicious in finesse and truth."[5] In this work the artist seems to have borrowed the entire stock of one of the Parisian shops specializing in Orientalia. Strahan saw the painting in the Belmont collection and gave the following description:

> The lady of the manor, in an interior which makes us sigh for the land where the best Oriental bric-a-brac is only everyday furniture, is under the hands of her maids after the bath. While one of them arranges her hair, she touches the strings of the native mandolin. The types of visages are as carefully arranged to match the Japanese physiognomy as is convenient in Paris, where models from that distant land are not for hire in the studio. Possibly a *daimio* would not find the faces perfectly national, but to us outer barbarians they seem as Eastern as possible and besides the preoccupation of the artist was for other qualities. . . . The picture was to be a studio interior with Japanese bibelots and Japanese figures for pretext; this being the artist's motive, it was little to him whether a Japanese beauty ever climbed the stairs of his atelier in sash and socks and loops of hair to apply for employment among his train of female models.[6]

The nude is indeed more indebted to the type developed by Girard's master Gleyre than to any Japanese models, but the subject of women relaxing in an interior could easily have been inspired by authentic Japanese sources, such as the woodcuts of Sukenobu's *One Hundred Women from Different Classes,*[7] or perhaps from painted screens similar to the *Fujo Yurako (Women in Merriment).*[8] In these works women are shown engaged both in dressing their hair and playing the *samisen.*

[1]See Colta F. Ives, *The Great Wave,* exhibition catalogue, Metropolitan Museum of Art, New York, 1974; *Japonisme, Japanese Influence in French Art 1854-1910,* Cleveland Museum of Art, exhibition catalogue, 1975; and *Japonisme in Art, An International Symposium,* Tokyo, 1980.
[2]Strahan, *Treasures,* 1881, II, pp. 77, 78.
[3]Astor residence sale, catalogue, American Art Association, Inc., April 20-21, 1926, no. 369.
[4]Illustrated in *Japonisme,* Cleveland, 1975, no. 255; and *Japonisme in Art,* Tokyo, 1980, pl. V.
[5]Castagnary, 1873, quoted and translated in Pickvance, 1980, p. 157.
[6]Strahan, *Treasures,* 1881, I, p. 113.
[7]See *Japonisme,* Cleveland, 1975, fig. 10.
[8]See *Pageant of Japanese Art, Painting 2,* Tokyo, p. 89.

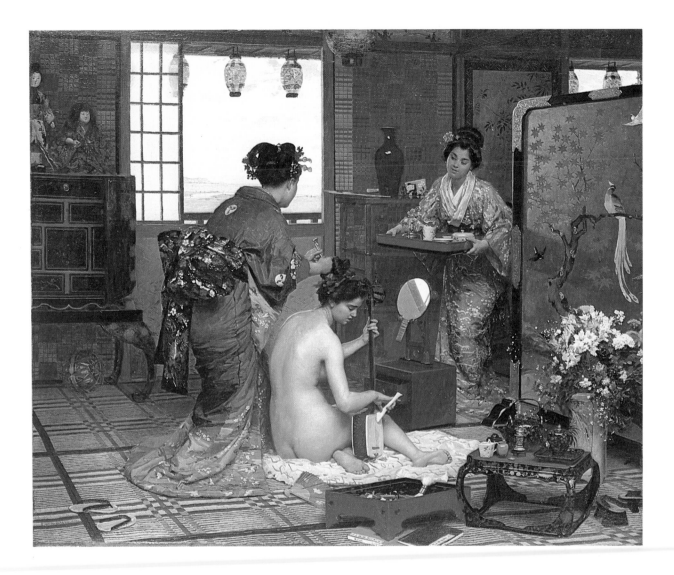

40. *Le Bain (The Bath)*, 1868
Oil on canvas, 35 x 25 inches (89 x 63.5 cm.)

The Chrysler Museum, Norfolk. Gift of Walter P. Chrysler, Jr., 1971.

Provenance: Purchased from the artist by John Taylor Johnston; Sale, Chickering Hall, New York, Dec. 19-22, 1876, no. 183; Charles Stewart Smith; Sale, American Art Association, New York, Jan. 4, 1935, no. 38; John H. McKay, New York; Sale, Parke-Bernet, New York, March 12, 1969, no. 110; Walter P. Chrysler, Jr.

Exhibitions: Hofstra, 1974, no. 52; *Second Empire*, 1978, no. VI-62; *Charles Gleyre*, Grey Art Gallery, New York University, Feb. 6 - March 22, 1980, addendum.

Bibliography: Paul Mantz, "Charles Gleyre," *GBA*, 1875, p. 411; C. Clément, *Gleyre étude biographique et critique*, Paris, 1878, p. 428, nos. 109-111, and nos. 407-412; Strahan, *Treasures*, 1881, II, p. 88, rep. opp. p. 89; Cook, 1888, I, pp. 12-13; Henry Marcel, *Le Peinture Française*, Paris, 1905, p. 140; *Charles Gleyre ou les illusions perdues*, Kunstmuseum, Winterthur, 1974-75, pp. 46, 102, 161, 186-187, 217; Shepherd Gallery, 1975, p. 147; *Apollo*, 1978, p. 24, rep. pl. VIII; Randall, 1979, II, pp. 278-82; Katharine Baetjer, ed., "Extracts from the Paris Journal of John Taylor Johnston," *Apollo*, Dec. 1981, p. 414.

Gleyre was Swiss by birth and maintained contact with his homeland throughout his life. By 1825, he had made his way to Paris via Lyon. He entered the studio of Louis Hersent, where he learned academic techniques, and he also studied watercolor with the English artist Richard Parkes Bonington. In 1828 he traveled to Rome, remaining there for four years and joining a distinguished intellectual circle that included the painter Horace Vernet (then in charge of the Villa Medici) and the composer Hector Berlioz. Vernet recommended Gleyre to John Lowell, Jr., who was traveling to the East and wished an artist to accompany him. Gleyre agreed to go, and for the next two years was in Greece, Turkey, and Egypt. After a disagreement with Lowell, the artist continued on his own to Khartoum. There he contracted an eye disease and with great difficulty made his way first to Cairo and then Beirut before arriving back in France in 1837. The works he painted the following year, which show a debt to the brilliant technique of Vernet, are filled with reminiscences of his Egyptian expedition.

Gleyre first exhibited at the Salon in 1840, but it was not until the 1843 showing of *Le Soir (Evening)*, later known as *Lost Illusions*, that he received recognition. The work's brooding melancholic character apparently reflected Gleyre's own personality. The work won a second class medal and was purchased for the Musée de Luxembourg. Also in 1843, Gleyre took over the atelier that Delaroche had had before departing for Rome. He soon established himself as one of the most popular studio masters in Paris, providing a congenial, inexpensive working place for the young artists—Bazille, Sisley, Monet, and Renoir—who were to form the core of the Impressionist movement.

In the late 1840s, Gleyre painted a series of religious works, most notably *The Parting of the Apostles*, which won a first class medal at the Salon of 1845 and was purchased by the State. That same year, the artist returned to Italy. He studied Byzantine mosaics, Giotto, and the Venetian school, with the result that his color became richer and his technique freer.

In 1849 he exhibited *Dance of the Bacchantes*, one of several classical subjects he produced during this period. It was to be his last appearance in the Salon, which he felt put too much pressure on the artist. Such independence was typical of him and, as a staunch republican, he even refused the Cross of the Legion of Honor.

Gleyre worked slowly, and there are relatively few paintings from the second half of his career. In the late 1840s he received commissions from the city of Vaud, Switzerland, on themes of Swiss patriotic history (*Le Major Duval* and *The Romans in Bondage*) and worked on them for nearly a decade. Gleyre also completed several large-scale mythological works including *Hercules and Omphale* and *Pentheus Persecuted by the Menaeds* (1863).

The last series of works by the artist—all statuesque female nudes—present more lyrical compositions of happier classical themes: *Minerva and the Graces*, *Sappho*, and *Le Bain*. According to Gleyre's friend and biographer, Clément, this last work (also called *Women at the Basin*) was inspired by a small terra cotta relief then in the Musée Campana. The work shows a mother bathing her baby, while a nude girl, probably her younger sister, looks on. Clément was of the opinion that Gleyre never did anything "more distinguished and poetic."[1] The American collector, John Taylor Johnston, for whom it was painted, agreed. After seeing it for the first time, he wrote in his diary entry for October 12, 1868, "I was delighted to find that it was really a remarkable picture of great power, sweetness & such as I am perfectly satisfied to take."[2]

One of the few works by Gleyre in America, this painting attracted great attention. Strahan, calling it *The Young Roman's Bath*, wrote: "The picture, in its blond perfection and ivory translucence, gives rather the idea of statuary than of painting. . . . It is such an achieved bit of perfection as a teacher leaves but once or twice in his career . . ."[3]

Gleyre is reported to have once criticized one of his student's works by exclaiming, "Have you never seen a woman playing with a child?"[4] Here the master shows his own keen powers of observation.

[1]See Clément, 1878, pp. 109-111.
[2]Quoted in *Apollo*, 1981, p. 414.
[3]Strahan, *Treasures*, 1881, II, p. 88.
[4]Quoted in *Charles Gleyre*, exhibition catalogue, Winterthur, 1974-75, p. 102, and translated in *Second Empire*, 1978, p. 311.

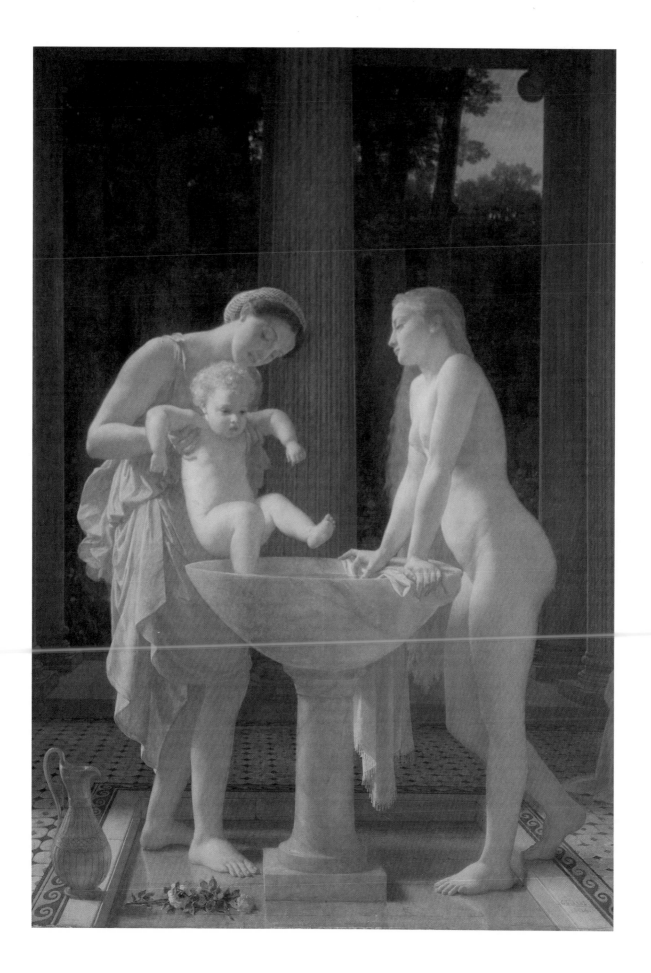

41. *Old China Shop (Pompeii),* ca. 1860
Oil on canvas, 20¼ x 17 inches (51.4 x 43.2 cm.)
Signed at lower left: *J.L. Hamon*

The Chrysler Museum, Norfolk. Gift of Walter P. Chrysler, Jr.

Provenance: John Taylor Johnston, New York, 1876; Sale, Chickering Hall, New York, Dec. 19-22, 1876, no. 175; John Wolfe, New York; Catharine Lorillard Wolfe, New York; Bequest of Miss Wolfe to The Metropolitan Museum of Art, New York, 1887; Sale, Parke-Bernet, New York, March 27-28, 1956, no. 110; Solow Galleries; Lewis Padawer Co., New York, 1960; Walter P. Chrysler, Jr..

Exhibitions: *The Controversial Century, 1850-1950, Paintings from the Collection of Walter P. Chrysler, Jr.,* Chrysler Art Museum of Provincetown and The National Gallery of Canada, Ottawa, 1962; Hofstra, 1974, no. 56.

Bibliography: *The Metropolitan Museum of Art Hand Book, No. 1, The Catharine Lorillard Wolfe Collection and Other Modern Paintings,* New York, 1894, p. 23, no. 83; *Catalogue of Paintings, The Metropolitan Museum of Art,* New York, 1905, p. 67; Bryson Burroughs, *Catalogue of Paintings, The Metropolitan Museum of Art,* New York, 1914, p. 107 and 1931, p. 152.

With a government stipend, Hamon was able to go from his birthplace in Brittany to Paris in 1840. Having already taught himself the rudiments of drawing and having supported himself by painting portraits, he went to see Ingres, who advised him to study the ancient and Renaissance art in the Louvre. Eventually he entered the studio of Delaroche, who praised his "poetic sensibility," and he remained there when Gleyre took over the studio in 1847. The same year, Hamon made his Salon debut with a *Daphnis and Chloë.* Gleyre provided moral and practical support for Hamon, suggesting, after several years without recognition, that the young artist work at the Sèvres porcelain factory. This he did from 1848-53, painting designs. According to his biographer Hoffmann,

> This period at Sèvres had the most fortunate influence on his talent; there his palette was to be surprisingly lightened, his colors took on that simplicity, limpidness, and transparency, if I may say so, that was to astonish Théophile Gautier so much, but which was also the original stamp of his very personal artistic production.[1]

Hamon scored his first great success with the painting submitted to the 1853 Salon *Ma soeur n'y est pas.* This *"petit vaudeville antique,"* as Jules Claretie called it,[2] was engraved and acquired great fame. Its depiction of a group of children in antique garb makes it an outstanding early example of what was dubbed the *Neo-Grec* or Pompeian style. Alfred de Tanouarn felt that this style grew out of Hamon's seeing designs after the frescoes

from Herculaneum and Pompeii.[3] In any case, it was a style practiced by several of Gleyre's students, including Gérôme, Picou, Toulmouche, and Aubert. As Mrs. Stranahan aptly noted, "it has been called classicism passing into genre, but was rather genre stepping back to snatch, for a while, a classic garb."[4] Hamon perservered in this *Neo-Grec* vein for most of his career. His success was indicated by his being made a Chevalier of the Legion of Honor in 1855. But by 1862 he was in serious financial difficulties and had to leave France, settling in Capri until 1871. There he continued to paint, sending his works—including an *Aurora* purchased by the Empress Eugénie—back to Paris.

The critic Jules Claretie observed of Hamon's submission to the 1873 Salon:

> M. Hamon is a Greek, or rather a Pompeian, who, out of antiquity, likes and chooses nothing but the idyls of Theocritus or the epigrams of Moschus. He prefers Anacreon to Homer, and skillfully sketches with his paintbrush a sort of *Anthology,* part Athenian and part Parisian. . . . Nothing is more coquettish and seductive at times than this particular art and although I demand of an artist things other than pastiches of antiquity, I cannot refrain from praising this special grace, this harmony, this personal gentility of the paintings of M. Hamon.
>
> The characters of his paintings are, it's true, usually rather difficult to classify, and his little girls, for example, have a certain indescribable charm capturing simultaneously both woman and child. There is a child in all the Athenians of Hamon.[5]

The women in the painting exhibited here have a distinctive childish, doll-like quality with delicate rounded limbs and pert, pretty faces. This painting had the present title when first sold in America. Later, in the Metropolitan Museum, it became known as *An Etruscan Vase Seller,* but since most of Hamon's works are set in his recreation of Pompeii, the earlier title seems more appropriate. This painting is, in fact, a variant of one of his well-known works of the later 1850s, *La Boutique à Quatre Sous (The Four Cent Counter),* in which two women examine votive statuettes.[6] In both cases there is a bearded salesman behind the counter. As with the Roman scenes of Alma-Tadema, one feels that these are nineteenth century figures simply dressed up as their classical ancestors.

[1]E. Hoffmann, *J.-L. Hamon, Peintre,* Paris, 1903, p. 63.
[2]Claretie, *Peintres,* 1884, p. 52, and "J.-L. Hamon," *L'Art et les artistes,* Sept. 1906, p. 250.
[3]Alfred de Tanouarn, "Les Neo-Grecs, Hamon," *L'Artiste,* IX, 1860, p. 9.
[4]Stranahan, *History,* 1917, p. 329.
[5]Claretie, *L'Art,* 1876, p. 84.
[6]Reproduced in a photogravure by Goupil and Co.; in Cook, 1888, p. 21; and Walter Fol, "Jean-Louis Hamon," *GBA,* I, 1875, p. 131.

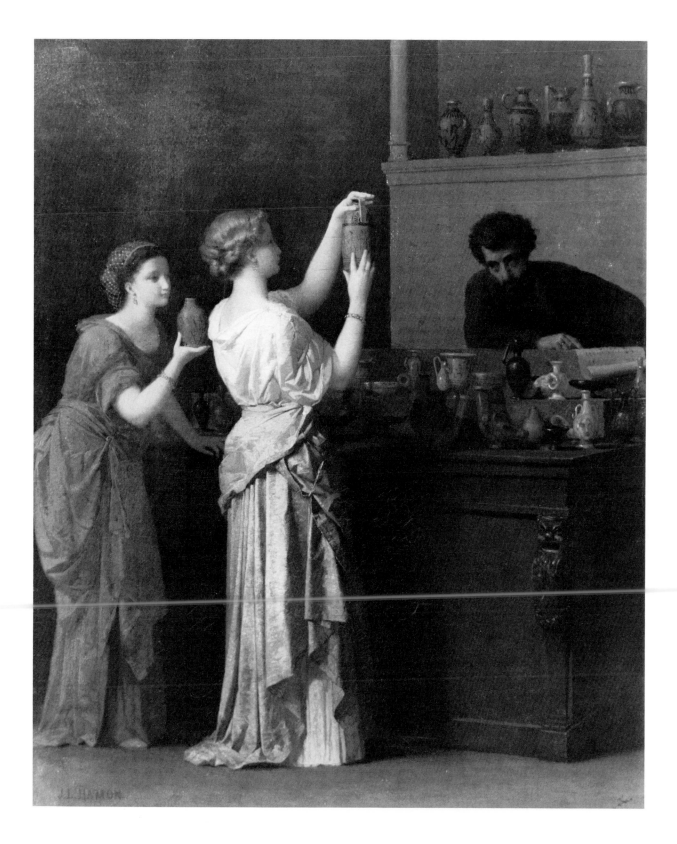

FERDINAND HEILBUTH, 1826-1889

42. *Old and Young Love,* 1869
Oil on canvas, 24½ x 30 inches (62 x 76 cm.)
Signed and dated at the lower left: *F. Heilbuth 69*

John E. Mortensen, Jr., Norfolk.

Provenance: A. E. Borie, Philadelphia; Sale, Sotheby-Parke-Bernet, New York, Jan. 25, 1980, no. 237.

Bibliography: Strahan, *Treasures,* 1881, II, pp. 22-23.

Heilbuth, the son of a rabbi, was born in Hamburg. He spent time in Munich and Rome before settling in Paris, where he entered the studio of Delaroche. He remained there after it was taken over by Gleyre, and in 1857 won a second class medal at the Salon. From about this time to the mid-1860s, he produced grandiose scenes of historical genre, often devoted to incidents from the lives of famous artists. Among these works are *Rubens Introducing Brouwer to His Wife, The Son of Titian,* and *Luca Signorelli*—made widely known through printed reproductions.

According to Yriarte, two of Heilbuth's famous works—*L'Auto-da-fé,* showing a young woman burning her love letters, and *Le Mont-de-Piété,* a realistic scene of Paris—heralded a change in his manner after he returned to Rome in 1865. There he lightened his palette and became known as "the painter of Cardinals," presenting a variety of scenes set in the Vatican City.[1]

Heilbuth periodically returned to Paris, but the Franco-Prussian War forced him to live for a time in England, where he exhibited at the Royal Academy. There he specialized in landscapes and idylls set *en plein air.* In England he developed his taste for watercolor, which was to become his chief medium in his late years. Heilbuth returned to Paris in 1874 and became a naturalized French citizen in 1878. He was made an Officer of the Legion of Honor in 1881.

This painting is similar to the one entitled *Spring* which was in the Salon of 1869.[2] Zacharie Astruc referred to Heilbuth as the "Cherubino of painters"[3] and in these works we can see why, for they are meditations on love with allegorical trappings such as the Cupid. Both in their themes and in their luxuriant brushy technique, these works pay homage to Venetian art. Strahan wrote this appreciation of the work, then in the collection of Secretary of the Navy Borie:

> Heilbuth, best known for his groups of comic, Roman cardinals, is here represented in a graver mood. *Old and Young Love* (3 x 2 fet) shows a glade in an open landscape, enbowered with graceful trees. A beautiful woman in medieval costume sits on a bank, her head relieved against the sky in an opening of the foliage; she looks as impartial as the nymph in Giorgione's "Music Party," as an old man in gorgeous velvets presses into her ear his tale of love, and into her lap his heavy purse; but Cupid is running away from them as fast as possible, and pointing to a youthful page who in the distance carves her name upon a tree. The landscape setting of this picture is particularly delicate and sensitive, seeming to melt into the dreamy temperament of the hesitating beauty.[4]

[1]Charles Yriarte, *Catalogue des Tableaux . . . de l'atelier Ferdinand Heilbuth,* Paris, 1890, p. 11.
[2]The painting *Spring* was sold at Charles Sedelmeyer sale, Paris, June 12-17, 1907, no. 59 as *Idyll dans le bois.*
[3]Zacharie Astruc, *Les 14 Stations du Salon 1859,* Paris, 1859, p. 91.
[4]Strahan, *Treasures,* 1881, II, pp. 22-23.

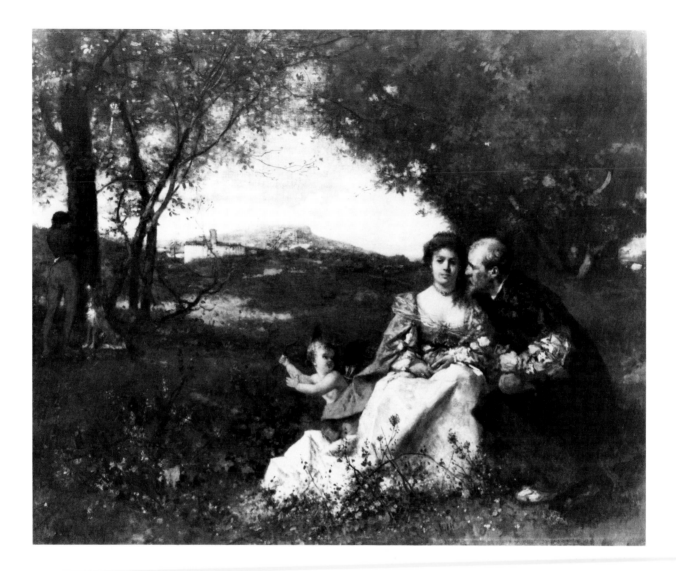

43. *Nude*

Oil on canvas, 24 x 29¾ inches (61 x 75.6 cm.)
Signed at the lower left: *J. J. Henner*

New Orleans Museum of Art. Gift of Mrs. Chapman Hyams, 1915.

Provenance: Mr. and Mrs. Chapman H. Hyams, New Orleans.

Exhibitions: *Artists of the Paris Salon,* Cummer Gallery of Art, Jacksonville, Jan. 7 - Feb. 2, 1964, no. 24; *Reality, Fantasy & Flesh, Tradition in Nineteenth Century Art,* University of Kentucky Art Gallery, Lexington, Oct. 28 - Nov. 18, 1973, no. 43.

Bibliography: Robert B. Mayfield, *The Art Collection of Mr. and Mrs. Chapman H. Hyams,* New Orleans, 1915 (reprinted 1964), no. 16; Ethel Hutson, "Little Journeys to the Art Museum," *The American Art Student,* May 1927, p. 17.

Henner was from Alsace and received a solid academic training in Strasbourg before going to Paris in 1846. There he studied with Drolling and later with Picot. He competed in several Prix de Rome competitions before winning in 1858 with his painting *Adam and Eve Discovering the Body of Abel.* He was then able to spend six years in Italy where his development was influenced by the Venetian painters Giorgione and Titian and, most particularly, the Paduan Correggio.

Henner's first Salon entry was in 1863 with *Young Bathers Asleep,* which won a third class medal. The following year, he returned to Paris and his *Le Chaste*

Suzanne won a medal, assuring his success. Although he painted some portraits, his most characteristic works were nudes in landscapes. These figures (often called nymphs) are engulfed by a Correggio-like haze that the artist achieved by blurring the edges of his forms and building up layers of glazes. The fuzzy outdoor settings evoked an idyllic twilight world. These works were immensely popular, forcing the artist to paint the same composition repeatedly with only slight variations. As a critic observed in 1880:

> New titles but always the same painting. The figure changes its pose but the nymph doesn't change, it is always the same woman. Why complain? She is langorous, amorous, voluptuous . . . shivers run up our spine when we look at her. Someone interrupts me: "I suppose you are going to repeat last year's appreciation of M. Henner's talent." O logic of logics! M. Henner can re-do the same painting every year but the poor critic is obliged to find new words with which to speak of the painter.[1]

This painting, purchased by Mr. and Mrs. Hyams of New Orleans, shows a nude in backview. Similar compositions are in the Chrysler Museum (Norfolk) and the Timken Collection in the National Gallery (Washington), and others have appeared at sales—American Art Association, January 10, 1936, no. 59 and Parke-Bernet, January 27, 1954. A photograph of Henner in his studio, published in the *Figaro illustré* of May 1898, shows a similar painting on the painter's easel.

[1]M. du Seigneur, *L'Art et les artistes au Salon de 1880,* 1881, quoted in *Equivoques,* 1973.

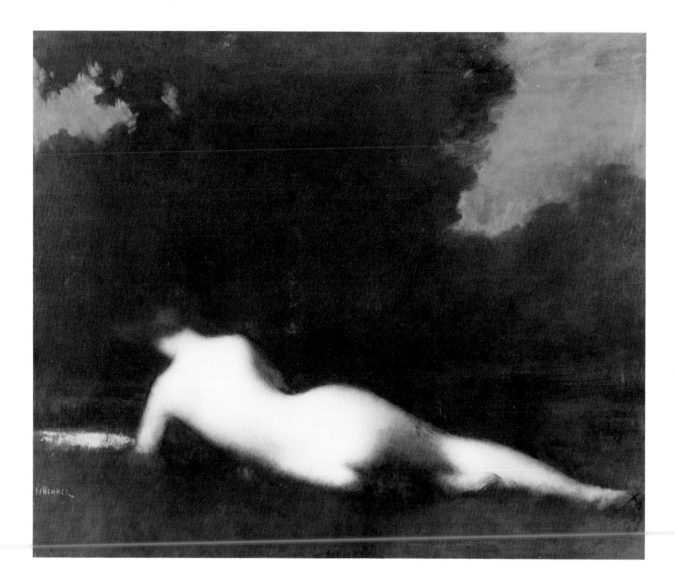

44. *The Virgin and Child with Saint John the Baptist,* ca. 1874

Oil on canvas, 31¹⁵/₁₆ x 18¼ inches (80.2 x 46.4 cm.)

The High Museum of Art, Atlanta. Purchase with funds from the Mrs. Floyd McRae Bequest, 1982.

Provenance: Paris Art Market; Shepherd Gallery, New York.

Exhibitions: *Christian Imagery in French Nineteenth Century Art 1789-1906,* Shepherd Gallery, New York, Spring 1980, no. 152.

Humbert, born in Paris, entered the Ecole des Beaux-Arts in 1861 and studied with both Picot and Cabanel. In 1865 he exhibited his first Salon entry, *Flight of Nero.* In the next two years, his entries *Oedipus and Antigone* and *An Episode from the Saracen Invasion of Spain* won medals and were purchased by the State. From 1870, when he exhibited a *Sacred Heart* painted for the Church of Saint-Eustache, the artist concentrated on religious subjects.

Humbert entered the circle of artists around the writer and painter Eugène Fromentin and became one of the master's favorites. In 1872 he sought Fromentin's advice about a painting of Judith he was planning, and the older artist replied in a letter:

> Try not to make of it a pastiche, but keep yourself at those heights of perception where all danger of modern interpretation disappears; ask yourself how an Italian of the best period would conceive ths picture . . . Beware of the modern; think of Regnault's *Salome,* that you may accomplish its reverse; invoke the antique.[1]

Unfotunately, when Humbert exhibited his large version of *The Virgin and Child with Saint John the Baptist*[2] at the Salon of 1874, the most frequent criticism of it was that it was a pastiche after a variety of Italian prototypes. Louis Janmot wrote:

> There is so much to know in the painting by Humbert that one can only consider it seriously. But . . . as Ingres said apropros of an analagous work, "It is good to absorb the old masters, but it is not necessary to get indigestion." In spite of its able execution and strong unified color, and a general aspect that attracts our attention, we find in considering the work carefully that what comes from nature isn't seen enough, what comes from the old masters is seen too much, and what comes from M. Humbert isn't seen at all.[3]

The serious nature of *The Virgin and Child with Saint John the Baptist* came as a surprise to the critics after the "indecent" *Dalila* which Humbert had shown the preceding year. Jules Claretie wrote:

> M. Humbert wanted to prove that after the ill-conceived *Dalila* which he showed last year, he was able to give to the Salon a more serious painting, with strong colors, and a composition not only chaste, but almost austere. . . . The fact is that this composition, calm and charming, with a coloration both warm and harmonious, truly denotes the temperament of a painter. But didn't we know already the competency of M. Humbert's paintbrush? Who could re-

proach him, except for his penchant for *pastiche?* But what is this Madonna, other than a *pastiche* composed after the early Florentines and Venetians? We know it from having encountered it a hundred times in all the galleries of the world.[4]

Gonse, however, approved:

> M. Humbert—who would have thought it?—exhibited a great, glorious Virgin on a throne, holding against her knees the infant Jesus and St. John the Baptist. He has taken the eternal theme of primitive masters of Milan and Venice, developed it and clothed it with a modern sensibility. He has recalled, through a happy inspiration, Cima de Conegliano, Benedetto Montagna, Giovanni Bellini, and their symmetrical arrangements, with the inevitable canopy and the background of bluish mountains. It is a *souvenir* and not a *pastiche.* . . . The Virgin, in her pensive severity, reminds one of the *Madonna* by Michelangelo at Bruges.[5]

Both Chesneau and Duvergier de Hauranne, while recognizing its Italianate sources (the former pointed to the Venetian tradition and the latter to Perugino, Donatello, and Andrea del Sarto) called it the outstanding religious work in the Salon.[6] And Montrosier summed up the situation:

> *The Virgin* by Humbert is of another era. . . . All the great religious schools of Italian art are evoked by this canvas, which recalls as much the Primitives as Cima and Bellini. This remembrance is tempered by a sensitive modern naturalism. . . . Mr. Humbert's work is one of the most accomplished in the exhibition.[7]

The painting was purchased for the State and sent to the Musée de Luxembourg. It is now in the bishop's residence at Metz.

The High Museum's *modello* for the painting renders almost exactly the composition and color of the final painting. Only a slight adjustment was made in the drapery folds around the Virgin's left arm. Even in this study, the imposing hieratic quality of the work is evident. The throne rising up against the dark landscape emphasizes this most dramatically. Humbert's careful delineation of the inlaid marble of the throne as well as the type of the Virgin, provided inspiration for Bouguereau in his painting of the same subject, shown the following year.[8]

[1]Quoted in Shepherd Gallery catalogue, 1980, p. 380.
[2]Paris Salon of 1874, no. 949. See *Le Musée du Luxembourg en 1874,* exhibition catalogue, Grand Palais, Paris, May 31 - Nov. 18, 1974, p. 104, no. 126.
[3]Louis Janmot, *Salon de 1874,* Paris, 1874, p. 16.
[4]Claretie, *L'Art,* 1876, pp. 227-228.
[5]Louis Gonse, "Salon de 1874," *GBA,* June 1874, p. 514.
[6]Ernest Chesneau, "Le Salon Sentimental," *La Revue de France,* June 30, 1874, p. 755; and Ernest Duvergier de Hauranne, "Le Salon de 1874," *Revue des deux mondes,* June 1874, p. 659.
[7]E. Montrosier, "Le Salon de 1874," *Musée des Deux Mondes,* May 15, 1874, p. 19.
[8]Now in the Tanenbaum Collection, Toronto; see *The Other Nineteenth Century,* exhibition catalogue, National Gallery of Canada, Ottawa, 1978, no. 12.

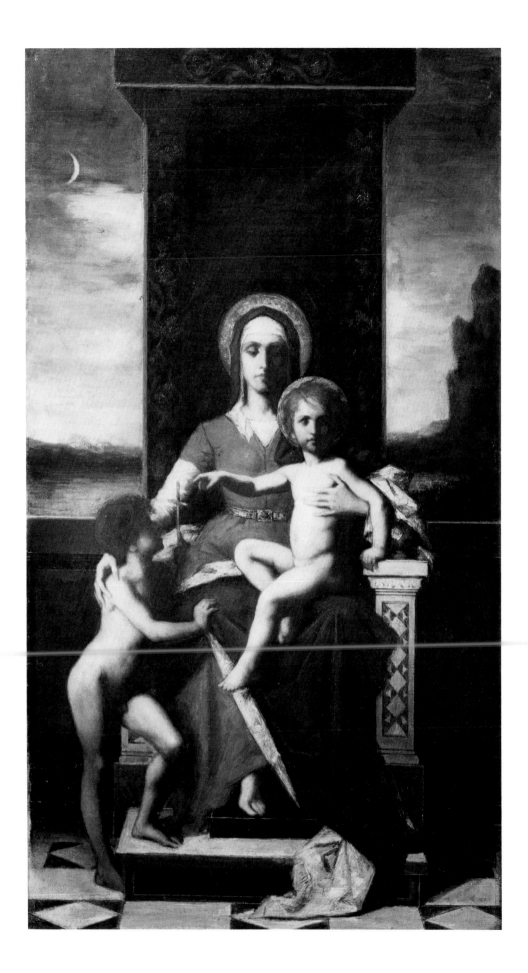

45. *A Celebration*, 1874
Oil on canvas, 25 x 21 inches (63.5 x 53.3 cm.)
Initialed and dated at the left: *E I 74*

Corcoran Gallery of Art, Washington, D.C. Purchase, 1891.

Provenance: American Art Association, New York.

Shown in Atlanta, Norfolk, and Raleigh only.

Isabey's father, Jean-Baptiste, was a famous miniature painter of the Napoleonic era and continued to work as a portraitist for the court of Charles X. The young Eugène at first had no intention of becoming an artist and his father is said to have sent him away with 400 francs exclaiming, "You will be a painter or you will be nothing." He returned after a few weeks with paintings of Le Havre which won him a first class medal for genre and marine painting at the Salon of 1834.[1] His career was launched and he continued to paint romantic windswept seascapes, drawn from his studies in Normandy and other sections of France, as well as Holland and England.

In 1843 Isabey was commissioned to paint a work commemorating Louis Phillipe's meeting with Queen Victoria upon her arrival at Tréport. Isabey sought inspiration for this work in the examples of Rubens and Guardi, enriching his palette and loosening his technique. The painting was exhibited at the Salon of 1845. Louis Phillipe also employed Isabey to assist in filling the Galleries de Versailles with scenes glorifying French history. Once again the artist turned to Rubens and produced *The Episode of the Marriage of Henry IV* which was shown at the Salon of 1850. This began a series of historical subjects which were undoubtedly intended in part to flatter the monarchy, but gradually evolved into purely imaginary "costume pieces" devoted to courtly festivities. Isabey had, of course, been exposed to court ceremonies since his youth and inherited a theatrical sensibility from his father, who had designed costumes and stage sets in addition to his other work.

In 1870, Isabey, along with many other French artists, sought refuge in England and remained there a year. It is possible that during this residency he became interested in English history. The subject of this painting, which has been called *A Wedding Festival*, is some sort of court festivity, with a stately woman accompanied at a respectful distance by a courtier. Perhaps the artist had in mind the English queen most popular with Europeans, Mary Queen of Scots, with her companion Rizzio. Isabey was obviously less concerned with depicting a specific scene than with capturing the general effect of gorgeous costumes and jewels picked out by the flickering light in the great hall. Théophile Gautier had already defined Isabey's achievement in describing a similar painting exhibited in 1855:

> M. Isabey shows us a *Ceremony of the Sixteenth Century*— what is this ceremony? We don't know; but that doesn't matter. Never has a painter staged upon the steps of a stairway a crowd of figures more smart, more stylish, more elegant; it is a waterfall of satin, of taffetas, of velvets, of brocade, on which the lacework forms a froth; the scene shimmers and glitters, sending flashes of color to the right and left, sparkling like diamonds. Coming close, one distinguishes the fine and noble heads of cavaliers atop the stiff ruffs, the charming figures of women framed with blond hair and pearls, the slender hands springing from cuffs like pistels on the calyx of flowers; the elegantly arched bustles, the bodices decorated with precious stones, cloth of gold and silver streaked with light in its folds, all the opulence of a painting which seems Venetian, but on a scale of a few centimeters.[2]

[1]This story is recounted in Shepherd, 1975, p. 113.
[2]Théophile Gautier, *Les Beaux-Arts en Europe*, Paris, 1856, p. 97.

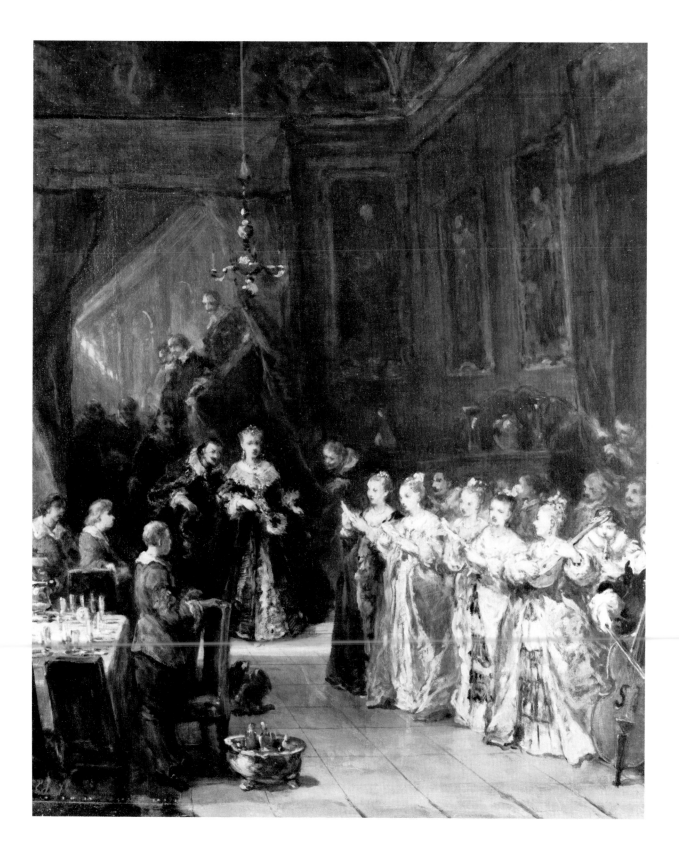

47. *Le Bas Empire: Honorius*, 1880

Oil on canvas, 60½ x 42½ inches (153.7 x 107.9 cm.)
Signed at the lower right: *J. Paul Laurens 1880*

The Chrysler Museum, Norfolk. Gift of Walter P. Chrysler, Jr., 1971.

Provenance: Darius O. Mills, New York; Sale, Parke-Bernet, Nov. 11, 1970, no. 70.

Exhibitions: Salon, Paris, 1880, no. 2150.

Bibliography: *Explication des Ouvrages de Peinture . . . exposés au Palais des Champs-Elysées*, Paris, 1880, p. 212; *Illustrated Catalogue of the Paris Salon*, London, 1880, p. 38, pl. 28; L. Baschet, ed., *L'Exposition des Beaux-Arts (Salon de 1880), comprenent planches en photogravure par Goupil et Cie*, Paris, 1880; Georges Lafenestre, *Le Livre d'Or du Salon de Peinture*, Paris, 1879-1880, p. 62; Ph. de Chennevieres, "Le Salon de 1880," *GBA*, June 1880, p. 511; also published separately as *Le Salon de Peinture en 1880*, Paris, 1880, p. 27; Emile Zola, "Le Naturalisme au Salon," *Le Voltaire*, June 18-22, 1880, (reprinted in *Emile Zola Salons*, ed. by F. W. J. Hemmings and R. J. Niess, Geneva and Paris, 1959, p. 251); Maurice du Seigneur, *L'art et les artistes au Salon de 1880*, Paris, 1880, p. 69; Th. Veron, *Dictionnaire Veron, le Salon de 1880*, Paris, 1880, p. 54; Henri Olleris, *Mémento du Salon de Peinture en 1880*, Paris, 1880, p. 18; Eugène Loudun, "Le Salon de 1880," in *Revue du Monde Catholique*, 1880, p. 455; Charles Clement, "Exposition de 1880," in *Journal des Debats*, May 22, 1880; Ph. Burty, "Le Salon de 1880," in *L'Art*, 1880, p. 154, rep. opp. p. 152; V. Champier, "Salon de 1880," *Revue de France*, June 19, 1880, p. 784; H. Cochin, "Le Salon de 1880," *Le Correspondent*, p. 740; Anon., "Le Salon de 1880," *Nouvelle Revue*, June 1, 1880, p. 660-661; W. Charles Carroll, *The Salon (Salon of 1880)*, New York, 1881, I, p. 17, rep.; Strahan, *Treasures*, 1881, II, p. 110, rep., p. 112; Bellier and Auvry, 1882-87, p. 923; J.-K. Huysmans, *L'Art Moderne*, Paris, 1883, p. 138; Ferdinand Fabre, *Jean-Paul Laurens*, in *Grands Peintres français et étrangers*, Paris, 1884, I, pp. 60 and 62; Champlin and Perkins, 1888, III, p. 35; Edwin H. Blashfield, "Jean-Paul Laurens," *Modern French Masters*, John C. van Dyck, ed., New York, 1896, p. 85; Gaston Schefer, "Jean-Paul Laurens," in *Revue illustrée*, Sept. 1903; Doucet, 1905, p. 133; Roger Peyre, "Les Artistes Toulousains: Jean-Paul Laurens," *Revue des Pyrénées*, XVIII, 1906, p. 43; F. Thiollier, *L'Oeuvre de J.-P. Laurens*, Paris, 1906, p. 22; Camille Mauclair, "Jean-Paul Laurens," *Art et Decoration*, XIX, 1906, p. 93.

The last exponent of *grande peinture*, Jean-Paul Laurens received his first formal training under Jean Blaise Villemsens at the Ecole des Beaux-Arts of Toulouse. In 1860 he won the Prix de Paris and was able to move to the capital, where he studied with Cogniet and Bida.

Laurens's Salon debut occurred in 1867 with *The Death of Cato*. In 1869, his *Jesus Curing a Possessed Man* won a third class medal and he was appointed a Professor at the Ecole de la Ville de Paris. Laurens's first great success came at the Salon of 1872 when two works, *Death of the Duke of Enghien* and *Exhumation of Pope Formosus*, attracted attention, as much for their republican sentiments as for their unusual subject matter. From then on, Laurens specialized in historical subjects of an erudite and bizarre nature. His macabre taste even extended to some of the decoration he executed in public monuments such as the Panthéon, Hôtel de Ville, and Odeon. In 1886 Laurens was appointed a Professor at the Ecole des Beaux-Arts and in 1892 was elected to the Institute.

Although he occasionally chose contemporary subjects (*The Last Moments of Maximilian*, for example), Laurens primarily painted subjects drawn from medieval history. Some works, as in the present case, took their inspiration from Byzantine and late Roman history. Honorius (born 384 AD), the son of Emperor Theodosius, divided the Roman Empire at his father's death with his brother Arcadius. Honorius thus became Emperor of the West at age eleven. Gibbon described him as "a stranger in his country, and the patient, almost the indifferent, spectator of the ruin of the Western empire, which was repeatedly attacked, and finally subverted, by the arms of the Barbarians."[1]

Laurens shows the boy-emperor at the time of his coronation. It is a simple, grand composition in vivid colors. The contrast between the boy's plebian face and his rich trappings is immediately evident, and nearly all who saw the work at the Salon of 1880 commented on how well this cretinous child embodied the spirit of the decadent late Roman Empire. Even Zola, who generally detested Laurens's violent scenes, called the painting a "fortuitous idea." Huysmans described the boy as "the sort of hooligan we have seen wandering the streets of Paris, hopping on one leg playing hopscotch, or on his knees grabbing cigar butts and pipe plugs from between the customers' legs at the cafe terraces."[2]

This painting came immediately to America. Strahan, describing the painting when in the Mills collection, provided some interesting background material about Laurens's sources:

A relic of Honorius—a full length portrait twice repeated on an ivory dyptich—was discovered in 1833 in a neglected sacristy of the Cathedral in Aosta and this treasure (which was publicly exhibited at Turin in 1880) has probably been the authority of the painter for his Honorius. . . . Working back from the epoch of this portrait—at whose period the effeminate and debilitated satrap was aged twenty-five years—our painter reconstructs the scene of the accession . . . a childish face of stupor, and small feet all unable to reach the footstool.[3]

[1] Edward Gibbon, *The History of the Decline and Fall of the Roman Empire*, London, 1897, III, pp. 238-239.
[2] J.-K. Huysmans, *L'Art Moderne*, 1883, p. 138.
[3] Strahan, *Treasures*, 1881, II, p. 110.

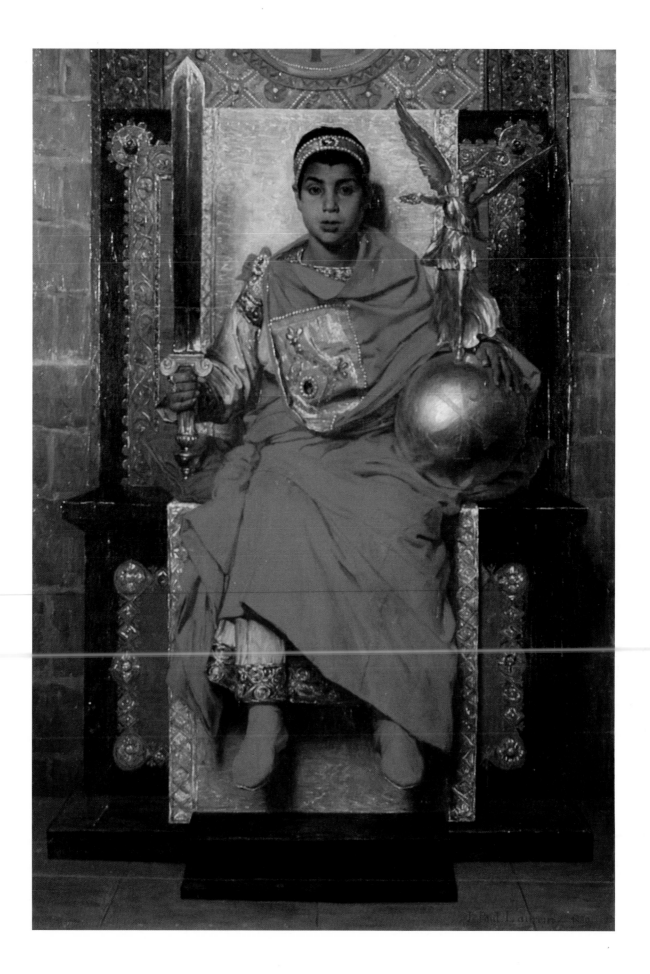

48. *Femme fellah portant son enfant, Egypte (Fellah Woman Carrying Her Child, Egypt)*, 1872
Oil on canvas, 23 x 16 inches (58.4 x 40.6 cm.)
Signed and dated at the lower right: *E. Vernet Lecomte 1872*

Stuart Pivar Collection. Courtesy of the University of Virginia Museum, Charlottesville.

Provenance: Galerie Tanagra, Paris.

Exhibitions: *The Goddess and the Slave: Women in Nineteenth Century Art*, Hammer Galleries, New York, June 7 - July 1, 1977; *Orientalism*, Memorial Art Gallery of the University of Rochester and Neuberger Museum, Purchase (N.Y.), Aug. 27 - Dec. 23, 1982, no. 56.

Bibliography: Philippe Julian, *The Orientalists*, 1977, p. 135.

The artist received his early training from the two men from whom he took his name—his father, the painter Hippolyte Lecomte, and his uncle, the famous Horace Vernet, from whom he also took an interest in Eastern subjects. Lecomte-Vernet made his Salon debut in 1845 and won a third class medal in 1846.

This painting is a replica of one exhibited at the Salon of 1864 (no. 1140). The artist's preliminary sketch for the original was reproduced in *L'Autographe au Salon* of June 1864 and has an inscription indicating it was drawn in Cairo. Comparing the painting and the sketch, it is evident that the face of the Egyptian woman was westernized by the artist for the painting. In both the sketch and the paintings, the pyramids and the desert provide a suitably exotic backdrop, for the *fellahim* were thought to be the Egyptians of noble bearing who descended from the time of the Pharaohs. The fellah women, usually draped in black and bedecked in jewels, had a sensual dignity that inspired many of the Orientalist painters of the nineteenth century. For example, a very similar work by Leon Bonnet, painted in 1870, is now in the Metropolitan Museum of Art.

Lecomte-Vernet was fond of casting his Oriental or Egyptian figures in the guise of religious characters—as, for example, his *Rebecca* of 1869.[1] The mother and child in the present work could equally well be called "Hagar and Ishmael." As in the *Rebecca*, the painter devotes great attention to the details of the woman's jewelry and provides sufficient *décolletage* for erotic appeal.

[1]Illustrated on the cover of *The Goddess and The Slave*, exhibition catalogue, Hammer Galleries, June 7 - July 1, 1971.

49. *Une Japonaise (The Language of the Fan)*, 1882
Oil on canvas, 51½ x 35½ inches (130.8 x 90.2 cm.)
Signed at the lower left: *Jules Lefebvre*

The Chrysler Museum, Norfolk. Gift of Walter P. Chrysler, Jr., 1971.

Provenance: Schauss; M. Cottier Gallery, New York; Sale, New York, May 27-28, 1892; James S. Inglis, New York; Sale, American Art Association, New York, Mendelssohn Hall, March 11-12, 1909, no. 98; Walter P. Chrysler, Jr.

Exhibitions: Hofstra, 1974, no. 64.

Bibliography: Claretie, *Peintres*, 1884, p. 359; Vento, 1888, p. 325; Haller, Paris, 1899, p. 121; Gabriel P. Weisberg, "Aspects of *Japonisme*," *The Bulletin of the Cleveland Museum of Art*, April 1975, p. 121, fig. 5.

Lefebvre grew up in Amiens. His father, a baker, encouraged his son's artistic career and sent him to Paris at age sixteen. There he studied with Cogniet and entered the Ecole des Beaux-Arts in 1852. He competed for the Prix de Rome, winning a second place in 1859 and first place in 1861 with his painting of *The Death of Priam*. While living in Rome he painted his first nude, a *Bather*, which was sent to Paris in 1863. During his stay in Italy he also painted many works with ancient subject matter, investing them with an elegant or amusing quality. When he returned to Paris, Lefebvre became disenchanted with the academic approach and sought to paint more directly from life, abandoning traditional formulas for a manner of grace and charm. The result was a series of sculptural nudes, often frankly erotic, which passed from his studio under a variety of guises—Pandora, Diana, Sappho, Ondine, Mary Magdelen—through the last part of the century.

Lefebvre made a distinguished career as a painter of women. One reviewer wrote in 1881,

it is sufficient to just mention his name in order to immediately evoke the memory and the image of the thousand adorable creatures of which he is the young father. . . . An unusually skilled draughtsman, Jules Lefebvre better than anyone else caresses, with a brush both delicate and sure, the undulating contour of the feminine form.[1]

Lefebvre won medals at the Salons of 1865, 1868, and 1870. After the last, where he exhibited his famous nude *Truth*, he was made a Chevalier of the Legion of Honor. He continued his success, winning a first class medal at the Exposition Universelle of 1878 and the grand prize in 1889. In 1891 he became a member of the Institute and in 1898 was made a Commander of the Legion of Honor.

In the early 1880s, Lefebvre produced several fancy dress paintings of women in exotic costumes, including both an *Orientale* and a *Japonaise*.[2] The taste for things *à la japonaise* had begun much earlier in the century and Tissot, Whistler, and Renoir had all painted women dressed in Japanese costume. That it had become a part of fashionable taste to don such clothes is attested to by Comerre's *Portrait of Mlle. Achille Fould*, exhibited at the Salon of 1883, in which the sitter is shown in a kimono and holding a fan.[3] Lefebvre's painting is not a specific portrait, and he invests it with a suggestive, seductive quality. It was undoubtedly this hint of coy Oriental allure that gave rise to the title of this work when sold in 1909, *The Language of the Fan*. The painting is distinguished by vivid, fresh colors and a marvelous interplay between the real flowers and the embroidered ones.

[1] L. Enault, *Paris-Salon 1881*, quoted in *Equivoques*, Paris, 1973, n.p.
[2] Claretie, *Peintres*, 1884, dates both works to 1881 while Vento, 1888, assigns them a date of 1883. Haller, 1899, lists the *Japonaise* as painted in 1882.
[3] Ph. Burry, *Salon de 1883*, Paris, 1883, ill. p. 92.

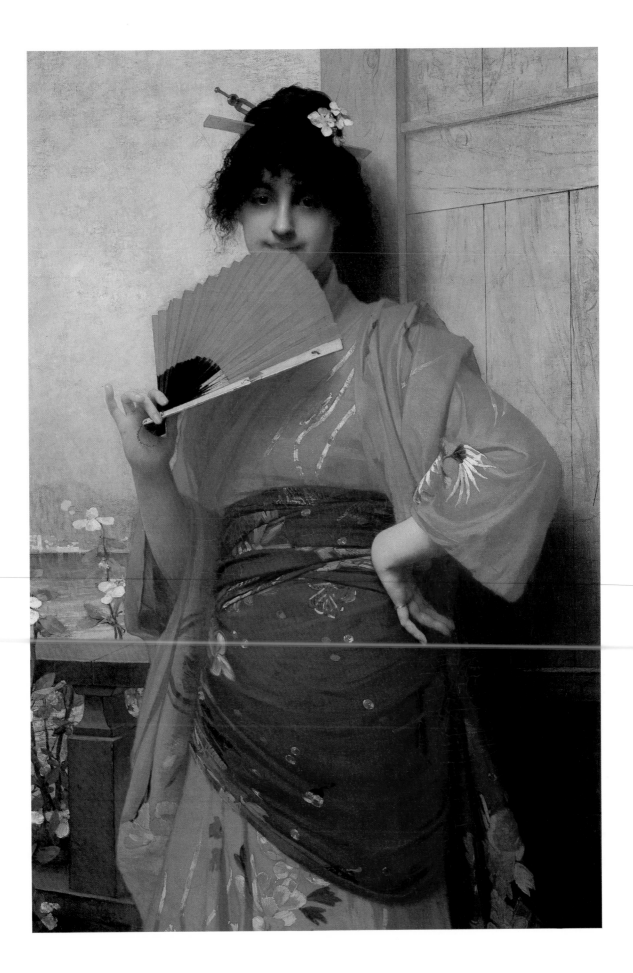

50. On Guard, 1860

Oil on canvas, 11⅞ x 9¼ inches (30.2 x 23.5 cm.)
Signed and dated at the lower right: *E Meissonier 1860*

John and Mable Ringling Museum of Art, Sarasota. Gift of Mr. and Mrs. Robert Webb, Jr., 1966.

Provenance: Mr. and Mrs. Robert Webb, Jr., Williamsburg.

Writing in 1873, René Ménard observed, "Meissonier is, perhaps, the most popular artist of our time. If he has a picture at the Salon the crowd first ascertains where it is, and the obstruction is such that it is not always easy to approach it. . . . His reputation is European and volumes could be filled with articles which the reviews and journals have consecrated to him."[1] Meissonier's eminence was attested to by the many honors heaped upon him in his lifetime—most significantly, he was the first artist to be awarded the Grand Cross of the Legion of Honor. The artist was famous for small genre and military works that were filled with such a wealth of minute detail that a magnifying glass was felt to be essential to appreciate them.

Meissonier had begun his career when, after arguments with his father, a dye manufacturer from Lyon, he was allowed to enter the studio of Julien Potien in 1832. Potien in turn entered him in the studio of Cogniet, who was then engaged in painting a scene of the Campaign in Egypt for the ceiling of the Louvre. The master could give Meissonier little time, so he remained only a few months. He learned most from studying the Dutch and Flemish painters of the seventeenth century—especially Terborch, Metzu, and Dou—and the eighteenth century French masters Greuze and Chardin. He first exhibited at the Salon of 1834; *A Visit to the Burgomaster*, a genre scene, was purchased by the *Société des amis des arts*. This type of period subject was to dominate Meissonier's production for many years, and his concern for detail was heightened by a period in the late 1830s when he produced book illustrations. Baudelaire, reviewing the artist's work in 1845, wrote: "On the whole M. Meissonier

executes his little figures admirably."[2] In 1840 Meissonier won a third class medal, then a second class in 1841, and in 1843 a first class for *A Painter in His Studio*.

In the 1848 revolution Meissonier was a captain in the National Guard and witnessed the bloody events that formed the subject of his 1850 painting *The Barricade*. It is one of several works inspired by contemporary events that Meissonier painted throughout his career. But he continued to specialize in genre scenes and it was *Une Rixe (A Brawl)*, a painting derived from scenes by the Flemish artists Teniers, Brouwer, and Van Ostade, that won him his reputation. After its exhibition at the Exposition Universelle of 1855, it was purchased by the Emperor Napoleon III and presented to Prince Albert as a memento of his visit to Paris.

On Guard of 1860 is typical of many studies by Meissonier of solitary halberdiers, swordsmen, and cavaliers of the time of Louis XIII. The Goncourts had written (apropos of another painting), "In our opinion scenes with a single character are what Meissonier does best."[3] And Théophile Gautier observed:

> Meissonier is so skillful at bringing poses to life, expression to faces, accurate mimicry to gestures! It seems as though one is listening to what these tiny figures are saying. One can guess their characters, their feelings, their interests, their weaknesses. For it is not only the finish and the preciousness of his work that distinguish Meissonier, even though this is the side of him that is most admired.[4]

In this case the haughty swagger of the guard who will let no one pass has been well captured, along with those details of period costume and accoutrements that put us in mind of Dumas's *Three Musketeers*.

[1]René Ménard, *GBA*, April 1873, quoted in Clement and Hutton, II, 1884, p. 108.
[2]C. Baudelaire, *The Salon of 1845*, translated in *Art in Paris 1845-1862*, by Jonathan Mayne, 1981, p. 23.
[3]Edmond and Jules de Goncourt, "The Salon of 1852," translated in E. G. Holt, ed., *The Art of All Nations, 1850-1873*, 1981, p. 89.
[4]Gautier, *Abécédaire du Salon de 1861*, Paris, 1861, reprinted and translated in Holt, p. 291.

51. *Les Renseignements: le general Desaix à l'armée de Rhine et Moselle (Information: General Desaix and the Peasant)*, 1867
Oil on panel, 12½ x 16 inches (32 x 40.5 cm.)
Signed and dated at the lower left: *E Meissonier 1867*

Dallas Museum of Fine Arts, Foundation for the Arts Collection. Mrs. John B. O'Hara Fund.

Provenance: Prosper Crabbe; Meyer Collection, Dresden, to 1880; William H. Vanderbilt, New York, to 1885; George W. Vanderbilt; Brigadier General Cornelius Vanderbilt; Sale, Sotheby's, London, Oct. 13, 1978, no. 219.

Exhibitions: Exposition Universelle, Paris, 1867, no. 462.

Bibliography: *Exposition Universelle de 1867 à Paris: Catalogue General*, Paris, 1867, I, p. 35; Paul Mantz, "Les Beaux-Arts à l'exposition universelle," *GBA*, 1867, p. 322; Maxime du Camp, *Les Beaux-Arts à l'exposition universelle et aux Salons de 1863-67*, Paris, 1867, p. 338; John W. Mollett, *Meissonier*, New York and London, 1882, pp. 60 and 65; Bellier and Auvry, 1882-87, II, p. 65; Strahan, *Treasures*, 1881, I, p. 107; Edward Strahan, *Mr. Vanderbilt's House and Collection*, Boston, 1883, IV, pp. 48 and 49, rep. opp. p. 50; "Mr. W. H. Vanderbilt's House," *Artistic Houses*, 1883, p. 123; *Collection of W. H. Vanderbilt*, New York, 1884, p. 28, no. 48; Claretie, *Peintres*, 1884, pp. 14-16; Eugène Montrosier, "Meissonier," *Grands Peintres français et étranger*, Paris, 1884, II, p. 302-303; Marius Chaumelin, *Portraits d'Artistes*, Paris, 1887, pp. 25-26, 51, no. 133; *The Art Annual*, special number of *The Art Journal*, part 4, London, n.d., pp. 14, 27; Gustave Larroumet and Philippe Burty, *Meissonier*, Paris, n.d., rep. p. 49; Vallery C. O. Gréard, *Meissonier: ses souvenirs—ses entretiens*, Paris, 1897, p. 400, rep. p. 47; translated by Lady Mary Loyd and Miss Florence Simmonds as *Meissonier: His Life and His Art*, New York, 1897, p. 317, and London, 1897, pp. 66-67, 95, 371; Doucet, 1905, p. 221; *Catalogue of Paintings in the Metropolitan Museum of Art*, New York, 1905, p. 206, no. 28; Bryson Burroughs, *Catalogue of the Paintings in the Metropolitan Museum*, 1914, p. 178, and 1916, p. 194; Stranahan, *History*, 1917, pp. 336, 344; *The Diaries 1871-1882 of Samuel P. Avery, Art Dealer*, ed. by Madeleine Fidell Beaufort, New York, 1979, p. xlvii.

Shown in Atlanta only.

In 1859 Meissonier accompanied Napoleon III and his troops to Italy to witness and record what was expected to be a great victory over Austria. After viewing the carnage of the Battle of Solferino, Meissonier instead chose to paint *The Emperor Reviewing His Troops*, which was exhibited at the Salon of 1861. This and a later painting, *The Emperor Surrounded by His General Staff* (Salon of 1864), were purchased for the imperial family.

Meissonier had meticulously studied each figure, including the Emperor, from life. While working on these contemporary subjects, the artist conceived the idea of painting a cycle of works to commemorate the military career of Napoleon I. Of five contemplated works only three were completed. They were on a large scale and Meissonier lavished upon them the same minute care as he gave his small cabinet pieces, even collecting Napoleonic memorabilia and re-staging battles. He became as famous as a painter of military subjects as he had been as a genre painter.

At the Exposition Universelle of 1867, Meissonier was one of the featured French artists, exhibiting thirteen works and receiving a medal of honor. Among those paintings was *Les Renseignements*, one of a number of brilliantly painted small works which depict events from the Napoleonic campaigns. This particular work is probably set in 1796 and features the young General Louis-Charles-Antoine Desaix (1768-1800), who later distinguished himself in Egypt and was killed at Marengo. According to Napoleon, Desaix's last words were: "Go tell the First Consul that I die with the regret of not having done enough to live in posterity."

During a temporary retreat by the Army of the Rhine, Desaix interrogates a peasant to determine the position of the Austrian forces. Meissonier explained that he carefully calculated the position of each figure so that "all the witnesses of the scene, even to the hussars in the glade of the background, have their eyes fixed on Desaix, who endeavors to read the looks of the hostage, and this concentrated gaze holds our own."[1]

The following appreciation of this work by Jules Claretie gives us some idea of the esteem in which Meissonier was held by his contemporaries:

> Of all the paintings which were represented then in the Champ de Mars, and which became famous, one of the best ones was "Les Renseignements." In a forest of Alsace, during the winter, a republican general has stopped: this is Desaix. Gathering his staff around the fire, he stands with his right hand in his blue *houppelande*, as he interrogates a brave peasant, who answers while fiddling with his furlined cap. An officer takes his papers and examines them. To the right, a lieutenant, adjusting his coat, warms his legs by the fire. An orderly, magnificent in his bright red uniform, his hand supporting the point of his sword, warms his wet boots in the fire. Two green *missards*, on horseback behind the peasant, swords in hand, look on, bristling in their moustaches, with the impassive regard of combat soldiers. A screen of *dragoons* in the rear guard complete the scene. The uniforms stand out brightly from the edge of the gray and foggy forest. This is really Alsace, and an accurate depiction of its damp, cold season. A thick moss, with colors brightened by the rain which soaks it, covers the upper side of the large branches and stays there like a green

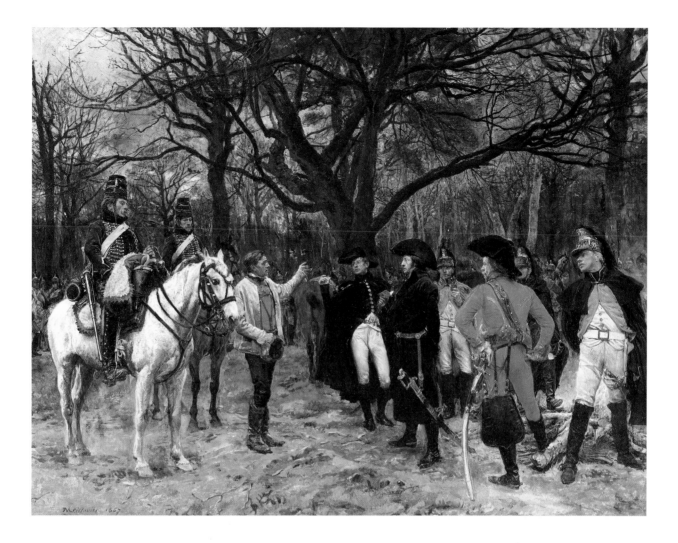

snow which never melts. With what artistry has Mr. Meissonier brought these soldiers of the past to life! These troops do not frequent the studio or the barracks; they are not the troops encountered at Poissy and sketched in passing, nor paid models; they are the soldiers of the Republic, the warriors who quickly forced the Austrians to retreat across the Rhine. . . . The costumes are perfectly accurate and carefully studied. . . .

M. Meissonier here has abandoned the figures of the 18th century for the soldiers of the First Empire, much like Gros in a small format. Truly, since Gros, no one has created a soldier of more convincing clarity or pride.[2]

William H. Vanderbilt, one of Meissonier's greatest patrons, was having his portrait painted by the artist and asked him what he considered his finest work. Meissonier replied *"Les Renseignements."* Learning that the painting belonged to the German collector Meyer, Vanderbilt had it purchased for fifty thousand dollars and delivered to Paris. He then invited the unsuspecting artist to give him his judgement on his newest acquisition. Croffut describes the scene:

> Mr Vanderbilt's attendant uncovered the picture, and behold! it was Meissonier's masterpiece. The effect was electric. The artist threw up his arms, uttered exclamations of delight, got down on his knees before the canvas, sent for his wife, and danced about as only a mad French artist can.[3]

The painting was then sent to New York, where it became one of the chief adornments of the picture gallery in Vanderbilt's palatial mansion at Fifth Avenue and Fifty-first Street.

[1]Quoted in Valery Gréard, *Meissonier*, London, 1897, pp. 66-67.
[2]Claretie, *Peintres*, 1884, pp. 15-16.
[3]W. A. Croffut, *The Vanderbilts*, Chicago and New York, 1886, pp. 168-169.

52. *Maternal Love*, 1880
 Oil on canvas, 45⅜ x 34⁷/₁₆ inches (115.3 x 87.5 cm.)
 Signed and dated at the lower left: *Hugues Merle 1880*

 The High Museum of Art, Atlanta. Gift of Mr. and Mrs.
 Crawford M. Sites in memory of Pauline McLendon Sites
 and Frank B. Sites, 1975.

 Provenance: Mr. and Mrs. Crawford M. Sites.

Merle, a student of Léon Cogniet, began exhibiting at
the Salon in 1847 but did not receive any awards until
1861 and 1863, when he won second class medals. In
1866 he was made a Chevalier in the Legion of Honor.
Merle concentrated on allegories or humble scenes, usu-
ally of mothers and children. Some of his paintings were
drawn from literary sources with a moralizing theme,
such as *The Scarlet Letter* (Walters Art Gallery). Other
works were more blatantly sentimental, such as *The Bible
Lesson.*

 Contemporaries regarded Merle's work as similar to
that of Bouguereau. Stranahan even wrote that the artist
"became a considerable rival of Bouguereau in subject
and treatment."[1] His paintings were well known and
popular in America. An earlier treatment of *Maternal
Love* was in the Vanderbilt collection, and two of his
mother-and-child paintings—one quite similar to the
High Museum's painting—are in the Sterling and Fran-
cine Clark Art Institute.

 In this *Maternal Love,* as in his other works on this
theme, Merle evokes a spiritual bond between mother
and child which recalls a *Virgin and Child* by Raphael.
The carefully-rendered small bouquet on the mother's
lap is composed of flowers which may have symbolic
connotations.

[1]Stranahan, *History,* 1917, p. 398.

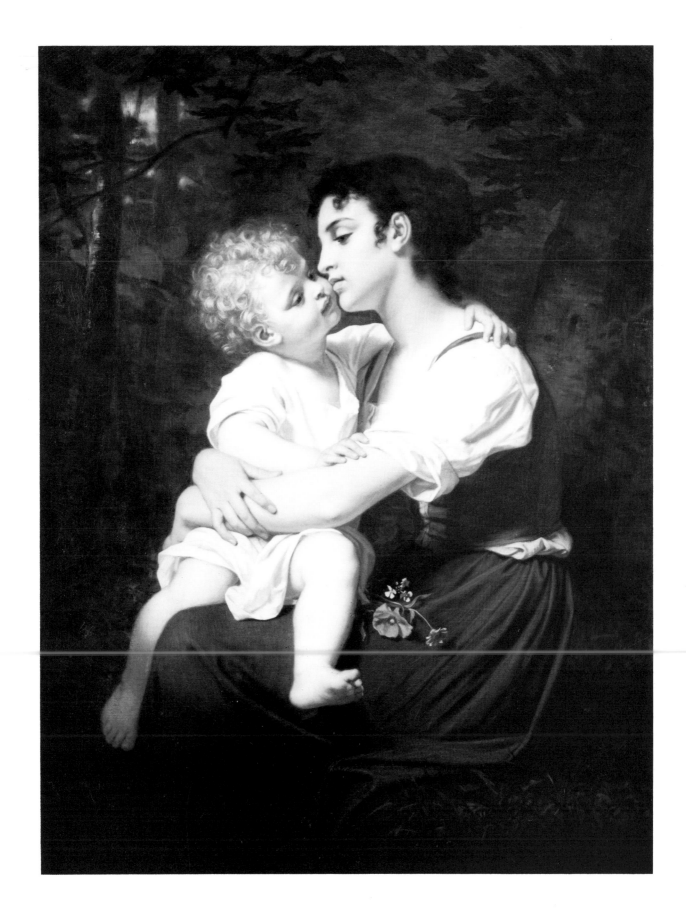

53. *"Je Vous Salue, Marie"* (*"Hail, Mary"*),
ca. 1885
Oil on canvas, 32 x 23½ inches (81.3 x 59.7 cm.)

The High Museum of Art, Atlanta. Gift of the Piedmont Driving Club, 1940.

Provenance: Purchased by the Exposition Fund, Atlanta, 1895; Piedmont Driving Club, Atlanta.

Exhibitions: Cotton States and International Exposition, Atlanta, 1895, no. 432; *Reality, Fantasy and Flesh: Tradition in Nineteenth Century Art*, University of Kentucky Art Gallery, Lexington, Oct. 13 - Nov. 18, 1973, no. 59.

Bibliography: W. A. Coffin, "Atlanta Exhibition," *Nation*, 61, Nov. 7, 1895, p. 325; *Harpers Weekly*, Dec. 14, 1895, rep. p. 1188; Gustave Larrounet, "Luc-Olivier Merson," *Revue de l'art ancien et moderne*, Dec. 1897, p. 443; Roger Peyre, *La Peinture Française*, Paris, n.d., p. 295; Raymond Bouyer, "Luc-Olivier Merson," *GBA*, July 1921, p. 41; *Luc-Olivier Merson, Exposition de l'oeuvre*, Ecole National des Beaux-Arts, Paris, May 21, p. 64, no. 522; Adolphe Giraldon, *Luc-Olivier Merson: Un noble vie d'artiste*, Paris, 1929, p. 19.

Merson's father, an artist and critic from Nantes, had written that "religious painting constitutes the highest level of the ideal,"[1] and the younger Merson wholeheartedly adopted this attitude, becoming one of the few late nineteenth century painters who produced convincing religious pictures.

Merson received his training from Lecoq de Boisbaudran and Chassevent at the Ecole des Arts Décoratifs and then from Isidore Pils at the Ecole des Beaux-Arts. Pils—himself a pupil of Picot, a winner of the Grand Prix de Rome, and a graduate of the Ecole—was able to pass on the accepted academic methods to Merson, who began exhibiting at the Salon in 1867. His first major subjects were drawn from classical mythology and history and in 1869 he obtained the Grand Prix de Rome for his *The Soldier of Marathon*. This enabled him to spend two years at the Villa Medici in Rome. In Italy Merson studied Quattrocento masters such as Fra Angelico, whose refined style and spiritual qualities would be reflected in his own work. In 1872 he sent as one of his *envois* to the Salon *St. Edmond, King of England, Martyr* (Museé de Troyes), which depicts the dead king supported by an angel. This established Merson's taste for religious and medieval subject matter.

On his return to France, Merson exhibited *The Vision*, which won him a first class medal in the 1873 Salon. His later honors included a gold medal at the Exposition Universelle of 1889, membership in the Institute in 1892, and a professorship at the Ecole des Beaux-Arts in 1894. In addition to his paintings, Merson worked on a number of large mural decorations in Parisian buildings, including the Palais de Justice, Opéra Comique, and Hôtel de Ville. He also designed stained glass windows, book illustrations, and even bank notes.

For his religious paintings, Merson chose subjects of a humble nature and imbued them with a delicate poetic character. Among his best known works were *The Wolf of Gubbio* (Salon of 1879, Musée de Lille), *St. Francis Preaching to the Fish* (Salon of 1881, Musée de Nantes) and *Le Repos en Egypt (Rest in Egypt)* (Salon of 1879, Musée de Nice). This last, representing the Virgin and Child resting in the paws of a giant Sphinx under the star-filled desert sky, was an especially popular subject that Merson repeated several times.[2] Writing of Merson's 1885 Salon piece *Arrival at Bethlehem*, A. Michel noted the purposely archaic quality combined with mysticism that characterizes Merson's art.[3] Dated by Bouyer to the same year, *"Je vous salue, Marie"* has the appearance of an enlarged page from a medieval manuscript. Larrounet saw this as a transitional work between the artist's legendary subjects and those of real life.

The painting does have a curious ambiguity about it. The peasant with his child and dog, returning home after his day in the fields, greets the Virgin and Christ Child. This is not a Virgin and Child of stone or wood, but rather the living presence of these holy personages, yet one is hard pressed to determine if this is a miraculous apparition or reality. Merson often represented the Virgin as an elongated otherworldly figure. Shown in profile, she has a remote presence, seeming to gaze into the far distance. The sense of melancholy is enhanced by the use of certain traditional iconographic details: the ax in the left foreground recalls St. Joseph's profession and the two wooden beams suggest the Cross. It is a sign of Merson's ability that the scene does not strike us as ludicrous (as does, for example, Bastin-Lepage's famous *Joan of Art*, Metropolitan Museum of Art, New York). Here the scale is more human and the vision less operatic. Merson is an artist who can contradict Courbet's famous dictum about not painting angels, because the faith he conveys through his religious personages makes them seem real.

The peasant's words which form the title are those first spoken by the Angel of the Annunciation to the Virgin Mary, and the *Ave Maria* theme was one of Merson's favorites. A version of the *Annunciation* he painted in 1908 shows the Virgin in a courtyard and the angel on the roof of a thatched cottage similar to those in the High Museum's painting.[4]

[1] Olivier Merson, *La peinture en France, Exposition de 1861*, quoted in *Equivoques*, 1973, n.p.
[2] A version is in the Museum of Fine Arts, Boston, 18.652.
[3] A. Michel, "Le Salon de 1885," in *GBA*, June 1885, p. 492.
[4] Illustrated in sale catalogue *Rêves symbolistes*, Hôtel George V, Paris, June 25, 1975, p. 105.

54. *Paysan répandant du fumier (Peasant Spreading Manure)*, 1854-55
Oil on canvas, 81 x 112 inches (205.7 x284.5 cm.)
Initialed at the lower right: *J.F.M.*

North Carolina Museum of Art, Raleigh.

Provenance: Purchased from the artist by Théodore Rousseau in 1855; Frédéric Hartman; Sale, Paris, May 7, 1881, no. 8; Francis L. Higginson, Boston; Mrs. Jacob H. Rand, Brooklyn; Robert F. Phifer.

Exhibitions: *Twenty-one Great Paintings*, Colorado Springs Fine Arts Center, 1947, no. 15; *Masterpieces of the Old and New World*, Decatur Art Center, Illinois, 1978, no. 3; *Robert F. Phifer Collection*, North Carolina Museum of Art, Raleigh, 1973; *Jean François Millet*, Grand Palais, Paris (no. 60) and Hayward Gallery, London (no. 39), Oct. 1975 - March 1976.

Bibliography: Alfred Sensier, *La vie et L'oeuvre de J. F. Millet*, Paris, 1881, p. 161; English edition, *J. F. Millet, Peasant and Painter*, trans. by Helen de Kay, Boston, 1881, pp. 95-96; Louis Soullié, *Les Grands Peintres aux Ventes Publiques*, II, *Jean-François Millet*, Paris, 1900, p. 52; Julia Cartwright, *Jean François Millet*, New York, 1910, p. 137; A. Hoeber, *The Barbizon Painters*, New York, 1915, pp. 48-49; Stranahan, *History*, 1917, p. 369; Etienne Moreau-Nélaton, *Millet raconté par lui-même*, Paris, 1921, I, p. 93; II, p. 21; III, p. 46; *Catalogue of the North Carolina Museum of Art*, Raleigh, 1956, no. 156; André Fermigier, *Jean-François Millet*, New York and Geneva, 1977, p. 56; Weisberg, *Realist Tradition*, 1980, p. 305.

Millet was from the small village of Gruchy. His parents were farmers, but they recognized his talent and allowed him to study with a portrait painter in nearby Cherbourg. The city of Cherbourg granted Millet a pension to study in Paris and in 1837 he entered the studio of Delaroche at the Ecole des Beaux-Arts. But after failing to win any medals, he left the Ecole in disgust and the city rescinded his fellowship. Millet continued painting on his own, eking out a precarious living by painting portraits. His first work to be accepted by the Salon came in 1840. During the following decade, Millet passed through a phase of "rococo" nudes and mythological subjects inspired in part by Diaz, whom he met in 1846. But by the late 1840s he had met Daumier and Charles Jacque and turned to realism. He settled on his true subject matter, the life of the French peasant, beginning with *The Winnower* of 1848. Although for some critics his somber treatment of this subject marked the artist as a radical republican, Millet's concern was less political than documentary. T. J. Clark has written:

> Millet's pictures, especially those done from 1853 onwards, are a careful record of [the peasants'] struggle for survival and its hopelessness. . . . They are, unexpectedly, a systematic description: picture by picture they indicate the key tasks and situations of this particular society.[1]

Millet's images also reveal his familiarity with the pictorial tradition of Michelangelo and Poussin.

In 1848 the State gave Millet a commission. He planned to do a *Hagar and Ishmael* but, unable to finish it, he substituted a peasant subject, *Le Repos des faneurs (The Haymakers' Rest)*. With the money from this sale, he and his large family were able to settle in Barbizon near the Forest of Fontainebleau and there he remained for the rest of his life. Despite the continuing hostility of some critics, he was gradually able to establish himself through works such as *The Gleaners* (Salon of 1857) and *The Angelus* (Salon of 1865). Reproduced in prints, these works brought him wide recognition as the most important painter of peasant subjects, which he was often said to have elevated to a "Biblical" grandeur. Through the support of the painter William Morris Hunt, Millet's work was also popularized in America, particularly in Boston.

The painting exhibited here came at a significant moment in the artist's career. He had hoped to show the work at the Exposition Universelle of 1855 but was unable to finish it in time. Nevertheless, it was purchased under a false name along with *Le Greffeur (The Treegrafter)*—which was exhibited—for a large sum by his friend, the more successful Barbizon landscape painter, Théodore Rousseau. This purchase helped secure Millet's reputation.

Millet had previously used single powerful figures as his chief subject, but, as Robert Herbert has pointed out, this painting represents the first time he isolated the figure against the spare ground of Barbizon.[2] This direct struggle of man with the land was to become a particularly powerful device in later works such as *Two Diggers* and *Man with a Hoe*. Here the bleakness of the setting, which has been described as "a cold autumnal plain,"[3] exemplifies Millet's pessimistic attitude. He said: "it is never the cheerful side of things that appears to me. I don't know where to look for it. I have never seen it."[4]

The composition had already been established in a somewhat crude study, dated by Moreau-Nélaton to 1851. In further preparatory drawings, the artist refined his design to achieve the nobility and simplicity of the final work. The stolidity, large hands, heavy shoes and obscured face of the peasant recall the figures in Courbet's famous *Stonebreakers* of 1849. But, as the critic Castagnary observed of *The Gleaners*, "[Millet's work] is not at all, like some paintings by Courbet, a political harangue or a social thesis; it is a very beautiful and very simple work of art, free of all declaiming."[5]

[1]T. J. Clark, *The Absolute Bourgeois, Arts and Politics in France, 1848-1851*, Greenwich, Conn., 1973, pp. 79-80.
[2]Robert Herbert, *Millet*, exhibition catalogue, Paris, 1975, p. 96.
[3]Moreau-Nélaton, 1921, I, p. 93.
[4]Quoted in Fermigier, 1977, p. 54.
[5]Castagnary, 1892, I, p. 17.

ADRIEN MOREAU, 1843-1906

55. Le Bac (The Ferry), 1884

Oil on canvas, 51 x 79 inches (129.5 x 200.7 cm.)
Signed and dated at the lower right: *ADRIEN MOREAU 1884*

National Museum of American Art, Smithsonian Institution, Washington, D.C. Gift of Mrs. James Lowndes, 1908.

Provenance: M. Knoedler and Co., New York; Lucius Tuckerman, Washington, D.C., 1887; Mrs. James (Laura Wolcott) Lowndes.

Exhibitions: Salon, Paris, 1884, no. 1759.

Bibliography: Armand Dayot, *Salon de 1884*, Paris, 1884, pp. 13-14; Th. Veron, *Dictionnaire Veron—Salon de 1884*, Paris, 1884, p. 261; J. Uzanne, *Figures contemporaines*, Album Mariani, Paris, 1896-1908, VIII, n.p.; *National Gallery of Art Catalogue*, Washington, D.C., 1909, p. 134; 1916, p. 165; and 1926, p. 77; *Art and Progress*, I, no. 6, April, 1910, pp. 153-154.

Moreau was born in Troyes. His father wanted him to be a lawyer, but the young man was determined to be an artist and gained his first experience as an apprentice to a glass painter. Making his way to Paris, he entered the atelier of Cogniet, and then after a year studied with Pils at the Ecole des Beaux-Arts. He exhibited for the first time at the Salon of 1868 with a religious subject and followed the next year with a neo-classical painting. During the Commune of 1871 an explosion destroyed his studio; he did not exhibit again until 1873, showing a *Concert of Amateurs*. This type of eighteenth century historical genre, often with a humorous touch, was characteristic of his work in both painting and book illustration.

In 1876 Moreau travelled through Belgium and Holland. The example of seventeenth century Dutch painters such as Metzu and Terborch influenced the popular works he exhibited that year—*Kermesse (County Fair)* and *Repose à la Ferme (Rest on the Farm)*, for which he won a second class medal at the Salon. Moreau was made a Chevalier in the Legion of Honor in 1892.

The painting exhibited here was shown at the Salon of 1884, and the artist himself provided a description in a letter of 1866 to Knoedler and Co.:

> Here is the information that you asked for regarding my painting *Le bac*. I thought of painting that subject in order to present a cross section of all the social classes of the 17th century, noblemen, soldiers, peasants, and beggars; at that time there existed few bridges, so to cross from one bank to another it was necessary to take the ferry. My study for the landscape was made on the bank of the Seine, close to the Forest of Fontainebleau.[1]

It may have been that this work was inspired by an original eighteenth century prototype such as Watteau's well-known *Departure for Cythera*. Here, although figures seem to be dressed for a nineteenth century *bal masqué*, the setting does have an almost rococo charm. Dayot rhapsodized:

> The sky with subtle gradations blends its delicate lightly veiled azur with the early morning fog of the horizon. One experiences a sort of agreeably refreshing sensation before this lovely canvas in which the air moves freely over the water, through the trees, around the figures, giving to each a masterful relief.[2]

[1] Letter in the files of the National Museum of American Art, Washington, D.C.
[2] Dayot, 1884, p. 14-15.

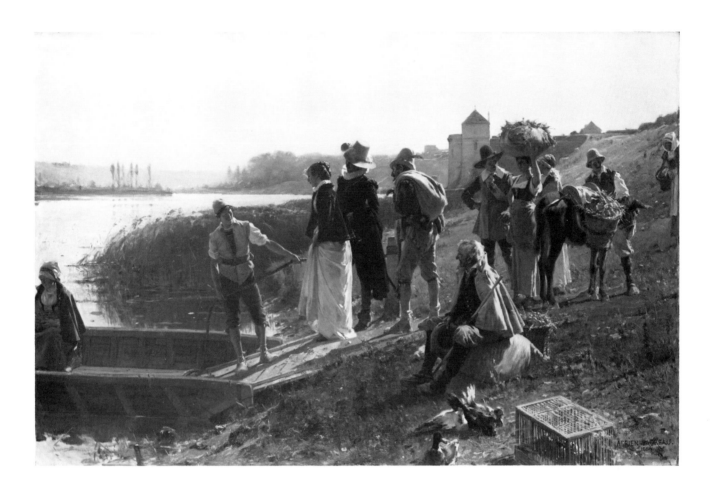

56. *The Wine Press,* ca. 1865
Oil on canvas, 18½ x 13½ inches (47 x 34.3 cm.)
Signed at the lower left: *P. Puvis de Chavannes*

The Phillips Collection, Washington, D.C.

Provenance: Durand-Ruel Gallery, Paris; Charles H. Tweed; Ferargil Gallery, New York, 1920; Duncan Phillips, 1920.

Exhibitions: *Paintings, Pastels, Decorations by Puvis de Chavannes,* Durand-Ruel Gallery, New York, 1894, no. 13; *A Survey of French Paintings,* Baltimore, 1934-35, no. 31; *A Survey of French Painting,* Pittsburgh, 1936; University of Maryland, 1966; *Puvis de Chavannes and the Modern Tradition,* Art Gallery of Ontario, Toronto, 1975, no. 4; *Puvis de Chavannes 1824-1898,* The National Gallery of Canada, Ottawa, 1977, no. 51.

Bibliography: *Arts and Decoration,* Oct. 1920, p. 302; Duncan Phillips, *A Collection in the Making,* Washington, D.C., 1926, p. 106; *The Phillips Collection Catalogue,* Washington, D.C., 1952, p. 83.

While on a recuperative trip to Italy in 1847, Puvis was inspired to become an artist by the frescoes of the Italian primitives. Although he studied briefly with both Henri Scheffer and Thomas Couture, these works along with those of Chassériau—remained his chief inspiration. He established his own Parisian studio in 1851 and, after passing through a romantic phase, settled on his personal manner of simplified monumental forms suitable for wall decoration. His detractors saw these as vague silhouettes painted in dreary monochrome but his defenders described his style as musical and majestic.

Puvis had shown a *Pietà* at the Salon of 1855, but his work was not admitted again until 1859, when a painting after one of his frescoes was selected for exhibition. In the Salon of 1861, Puvis exhibited two large paintings, *War* and *Peace.* The latter won a second class medal and was purchased by the State, so the artist donated the pendant. This marked the commencement of his official recognition. Soon Puvis was regarded as

the revitalizer of the tradition of mural painting. He was deluged with commissions—including murals for the town hall of Poitiers, the Panthéon, the Musée de Lyons, the Sorbonne, and the Boston Public Library. He was made an Officer of the Legion of Honor in 1867 and a Commander in 1889.

War and *Peace*—along with a complementary pair of 1863 paintings, *Work* and *Repose*—were installed on the staircase of the Musée Napoleon (now the Musée Picardie) in Amiens. Puvis was then commissioned to paint a large work for the south wall of the stairwell. He called the painting *Ave Picardia Nutrix (Nourishing Picardy)* and described part of it: "The center of the panel is taken up by a group making cider under the direction of a patriarchal couple."[1] This project was finished in 1865. Puvis often made smaller easel paintings based on motifs from his wall projects and the present oil and an *Allegory of Autumn* (in the Wallraf-Richartz Museum, Cologne) are taken from the autumnal section of *Ave Picardia Nutrix.* Here, however, wine is being made instead of cider and Puvis has introduced a pair of Babylonian oxen to add a note of timelessness to his arcadian scene.

When Puvis first displayed *War* and *Peace,* Théophile Gautier wrote:

Are these works—these immense canvases framed with flowers and allegorical devices like the paintings of the Farnesina—some sort of cartoons, or tapestries, or rather, frescoes borne off, in some mysterious way, from some unknown Fontainebleau? He [Puvis] seems innocent of contemporary art and springs directly from the studio of Primaticcio and Rosso![2]

Gautier's remarks were apt. The elongated proportions of these statuesque female figures, emphasized by the heavy outlining that characterized Puvis's technique at the time, create a decidedly mannerist effect.

[1] Quoted in *Puvis de Chavannes,* exhibition catalogue, The National Gallery of Canada, 1977, p. 61.
[2] Ibid., p. 59.

P. Puvis de Chavannes

57. *Seated Woman*, ca. 1865
Oil on canvas, 18 x 14½ inches (45.7 x 36.8 cm.)
Signed at the lower left: *t. Ribot*

The Corcoran Gallery of Art, Washington, D.C.
Gift of Mrs. Frank Moss.

Shown in Atlanta, Norfolk, and Raleigh only.

Having eked out an existence as a bookkeeper in Rouen, Ribot moved to Paris in 1845. There he worked at a variety of jobs while pursuing his interest in painting. His only formal training came in the atelier of Auguste-Barthelemy Glaize. Ribot's dark palette and treatment of ordinary subjects did not find immediate acceptance at the Salon. His first opportunity to exhibit publicly came in 1859, when the painter François Bonvin showed in his own studio works by Ribot and other rejected artists—Vollon, Fantin-Latour, and Whistler. Ribot's canvases fit into this "Flemish studio," as it was called, for as Gabriel Weisberg has written, "they were painted by lamplight in the evenings at his home and were drawn from his own environment."[1] Ribot's style of dark realism was derived from seventeenth century painters such as Velázquez and Hals.

In 1861, works by Ribot were finally shown at the Salon. The theme of cooks and humble kitchen scenes, which he shared with Bonvin, brought him notice. Théophile Gautier praised his work, and so did Thoré Burger, a leader of the revived interest in Dutch painting who called Ribot "petit-fils de Chardin et descendant des Hollandais."[2] In addition to his kitchen scenes Ribot painted still lifes and some portraits. In 1865 he produced a major religious work, *St. Sebastien*, which used "uncouth" types in the manner of Ribera. It won a medal at the Salon and was purchased by the State for 6,000 francs. In 1878 he was inducted into the Legion of Honor. Illness forced Ribot to curtail his activities late

in life, but at a special dinner in 1884 his fellow artists, including Fantin-Latour, Cazin, Bastien-Lepage, and Alfred Stevens, presented him with a medal inscribed *A Théodule Ribot, le peintre indépendant*.

Simple scenes such as this, of single cooks, maids, or kitchen helpers engaged in their daily activity, were Ribot's chief production in the mid-1860s. The subject matter may, in some cases, recall Chardin, but the mood and treatment are very different. The figures seem enveloped in their own isolated worlds and are decidedly wistful. Their rough features, usually derived from members of Ribot's own family, contrast to the implied sensitivity of their natures. On the occasion of an exhibit of Ribot's work in 1880, the critic Eugène Veron observed:

> His figures are modeled with a vigor which makes them resemble statues but ones made of flesh and bone. They have the true color of human skin just as they have the vigorous construction the robust movement, the complete anatomy of living bodies. . . . Those who are less struck by the merits of his execution are drawn by the moral truth of the expression. . . . Ribot also attaches to the hands an importance almost equal to that of the eyes. There is hardly a figure by Ribot of which one does not see the hands used to reinforce the effect of the expression.[3]

Here the rough heavy hands delicately cradle the book which totally absorbs the girl's attention. She is indifferent to the bareness of her surroundings or the hardness of the bench. The gloom of this interior is relieved by the broad surface of the apron with its rich texture and by the girl's pasty face, which seems illuminated from within.

[1]G. P. Weisberg, "Théodule Augustin Ribot," in *The Other Nineteenth Century*, Ottawa, 1978, p. 157.
[2]Thoré Burger, "Salon de 1863," quoted in Paul Lefort, "Th. Ribot," *GBA*, II, 1891, p. 302.
[3]Eugène Veron, "Th. Ribot," *L'Art*, 1880, pp. 160-161.

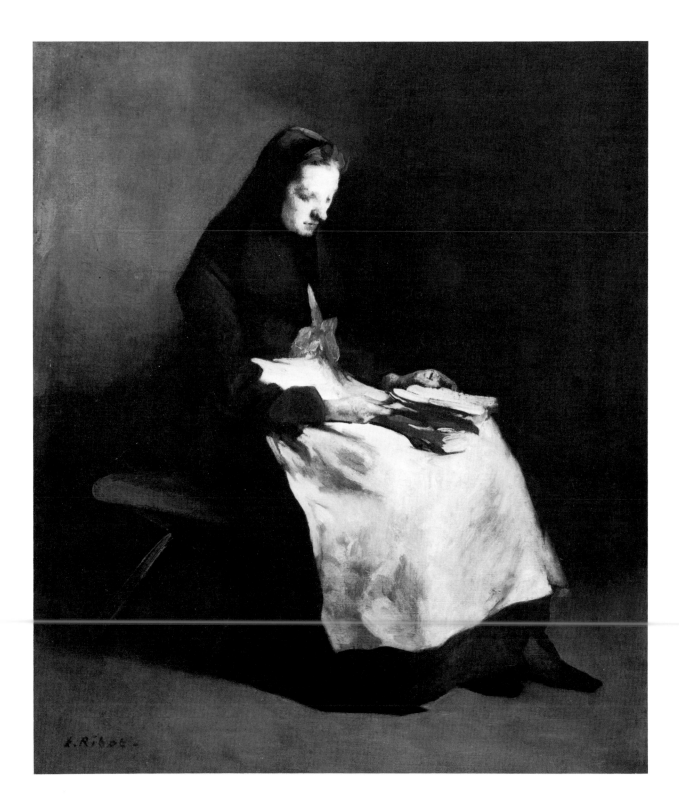

58. *Cavalier with Gloves,* ca. 1871
 Oil on canvas, 30¾ x 24½ inches (78.1 x 62.3 cm.)
 Signed at the upper right: *F. Roybet*

The Dimock Gallery, Permanent Collection, George Washington University, Washington, D.C.

Provenance: E. Fischoff; Sale, Waldorf-Astoria, New York, Feb. 22-23, 1907, no. 30.

Exhibitions: *400 Years of Art: GW Collects, Selections from the Permanent Collection,* The Dimock Gallery and The Art Department of George Washington University, Washington, D.C., Jan. 25 - Feb. 23, 1979.

59. *The Connoisseurs,* 1876
 Oil on canvas, 48 x 59 inches (121.9 x 149.9 cm.)
 Signed and dated at the lower left: *F. Roybet 1876*

John and Mable Ringling Museum of Art, Sarasota.

Provenance: William Astor, New York, by 1881; J. J. Astor, New York; Sale, Astor Residence, American Art Association, New York, April 20-21, 1926, no. 436; John Ringling, Sarasota.

Bibliography: Strahan, *Treasures,* 1881, III, p. 20; *American Art Annual,* 1926, 23, p. 389; Suida, 1949, p. 353, no. 441.

Roybet's youthful desire to study art led him from his birthplace at Uzes to the Ecole des Beaux-Arts of Lyon, where he studied drawing and printmaking with Victor-Joseph Vibert. He began painting on his own, following the example of masters such as Rubens and Titian, whose work he could see in the local museum. In 1862 he moved to Paris to pursue a career as a painter. There he met a fellow Lyonnaise artist Antoine Vollon, who introduced him to his own master Théodule Ribot, who gave Roybet moral and financial support.

In 1865 Roybet showed for the first time at the Salon, and the following year his painting *A Court Jester of Henry III* won a first class medal and was purchased by Napoleon III's cousin Princess Mathilde. This assured his success and Roybet found many willing buyers, in-cluding William H. Vanderbilt. He made an arrangement with dealers to provide them with paintings each month and stopped showing in the Salons.

During the year of the Commune (1871), Roybet travelled to Algeria and Holland, where he was particularly influenced by the works of Hals and Rembrandt. His subjects were primarily genre scenes of cavaliers, soldiers, and musicians in seventeenth century settings.

Following a period of financial difficulties, he returned to the Salon exhibition in 1892 and received acclaim and a medal of honor. Paintings from this late period, often showing the artist's friends dressed in period costumes, are more somber than his earlier works. Roybet was made a Chevalier of the Legion of Honor in 1892, becoming an Officer in 1900.

The Cavalier with Gloves reveals the full influence of Frans Hals on Roybet. The figure filling most of the space and the vigorous style of paint application recall the Haarlem master, as does the subject matter. The pose of the figure, his hat and ruff, all remind one of that most famous of Hals paintings, *The Laughing Cavalier* (Wallace Collection, London). The detail of the gloves appears in a number of Hals's male portraits (such as those now in Frankfurt and Cincinnati). While the cavalier is rendered with a Halsian bravura, he is not laughing; he presents a determined and direct gaze to the viewer. There are many similar paintings by Roybet and this particular model appears in one titled *Un mousquetaire* that was with the London dealer M. Newman in 1974.[1]

The theme of the art amateurs, as seen in the *Connoisseurs,* was frequent in French painting, and one thinks of examples by Fragonard, Daumier, and especially Meissonier, who created a taste for such picturesque scenes full of period details. Roybet devotes more attention to the rich profusion of the gentlemen's elegant attire than to the works of art they so diligently peruse.

[1]Illustrated in *Apollo,* Nov. 1974.

ADOLF SCHREYER, 1828-1899

60. *Winter Scene*
Oil on canvas, 14 x 18 inches (35.6 x 45.7 cm.)
Signed at the lower right: *Ad. Schreyer*

Sheila and David Saul, Atlanta.

Provenance: Kaye estate, Atlanta.

61. *Arabian Horsemen*
Oil on canvas, 19¼ x 12¾ inches (48.9 x 32.4 cm.)
Signed at the lower right: *Ad. Schreyer*

William M. Matthews and the Henry Morrison Flagler
Museum, Palm Beach.

Provenance: Col. Owen Hill Kenan.

Exhibitions: *Adolf Schreyer,* Paine Art Center and Ar-
boretum, Oshkosh, Wisconsin, June 8 - July 30, 1972.

Schreyer was born in Frankfurt-am-Main and received
his first training there at the Staedel Institute. His
studies were continued in Stuttgart, Munich, and Düs-
seldorf. In 1855 he joined the regiment of Prince Toxin
as field artist in the Crimea, where he found the subject
matter to feed his taste for the exotic. He was to pursue
this with travels through Russia, Wallachia (part of
present-day Romania), Syria, and North Africa.
Schreyer's chief subjects were genre scenes of colorful
peoples: on the one hand he shows the frozen wastes and
windblown peasants of the steppes, and, on the other,
Bedouin shieks in their billowing burnooses riding across
the brilliant desert.

In 1862 Schreyer established himself in Paris. Even
with his appointment as painter to the court of the Duke
of Mecklenburg-Schwerin in 1863, Schreyer kept Paris
as the center of his activities. He exhibited at the
Salon—winning medals in 1864, 1865, and 1867—and
his work was avidly sought after by collectors, particu-
larly Americans. It was also praised by the critics.
Théophile Gautier wrote to the artist concerning one of
his winter scenes, "I am egotistic enough to be a good
judge in this matter. I have been myself enveloped in the
snowy whirlwind near Kowno, and your canvas makes
me shiver; I seem to be still in Russia."[1] With regard to
Schreyer's Near Eastern subjects, of which this small
painting of Arabs on horseback is a good example, the
Courrier Artistique of 1864 observed: "His manner as well
as his talent has two natures; it recalls both Delacroix
and Fromentin. His color is a happy mingling of the
dreamy tones of one and the powerful colors of the
other."[2]

[1]Quoted in Clement and Hutton, II 1884, p. 245.
[2]Ibid.

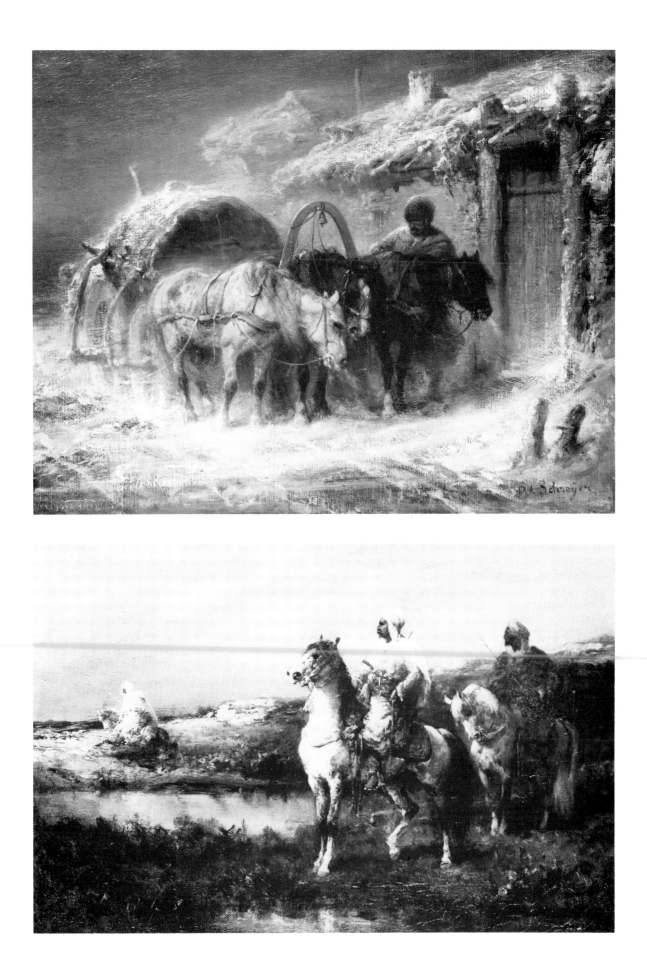

159

62. *The Porcelain Collector,* 1868
Oil on canvas, 26⅞ x 18 inches (68.3 x 45.7 cm.)
Signed and dated at the lower right: *A. Stevens/1868*

North Carolina Museum of Art. Gift of Dr. and Mrs.
Henry C. Landon III, 1981.

Provenance: Edith K. M. Wetmore, Newport, R.I.,
d. 1966; Maud A. K. Wetmore; Sale, Christie's, Dec. 1,
1970, no. 167; Schweitzer Gallery, New York; Craig and
Tarlton, Inc.

Stevens was born in Brussels. His father, an avid col-
lector, encouraged both Alfred and his brother Joseph to
be artists. Alfred studied first with a follower of David,
François-Joseph Navez. He was then taken to Paris in
1884 by a family friend, the painter Camille Roqueplan.
He spent some time studying at the Ecole des Beaux-
Arts and remained in Paris until about 1849 when he
returned to Brussels. He debuted at the Brussels Salon in
1851 and was back in Paris by the end of 1852. His early
style was rather dark and romantic, influenced by Veláz-
quez and Courbet, who painted a portrait of him.
Through his brother, who had become a successful
painter of animals, he was also acquainted with the
painters Isabey, Couture, and Rousseau.

At the Salon of 1853 Stevens showed three works;
Ash Wednesday Morning, purchased by the State, won
him a third-class medal. The Exposition Universelle of
1855, where he won a second class medal, brought Ste-
vens to general attention. One painting, *They Call it
Vagabondage,* became prominent when the Emperor ob-
jected to the practice it depicted—soldiers arresting an
indigent family. Another painting, *Chez soi,* showed an
elegant woman in an intimate boudoir setting. It was
this type of depiction of fashionable contemporary
women that made the artist's reputation. For such scenes
of *"La Parisienne"* (as she was called), he often used his
own luxurious home and studio as a setting. Stevens, as
Montesquieu has observed, was "one of the first to ap-
preciate the brilliant and bizarre charms of Far-Eastern
bibelots."[1] He collected them, lavishly furnished his
home with them, and the decors in many of his paint-
ings reflect this aspect of his wide-ranging taste.

Stevens developed an influential, wealthy clientele
ranging from King Leopold of Belgium to the Vander-
bilts of New York. Princess Mathilde lent him clothing
to use for his compositions; Sarah Bernhardt studied
painting in his popular atelier for women and was his
subject on a number of occasions. A frequenter of the
boulevards and cafés, Stevens was a friend of the Gon-
courts, Baudelaire, Manet, and Degas. In 1863 he was
made a Chevalier of the Legion of Honor. At the Ex-
position Universelle of 1867 he triumphantly showed
eighteen pictures, received a first-class medal, and was
promoted to Officer of the Legion.

In the 1880s Stevens, for reasons of health, began
going to Normandy and other coastal areas of France,
and landscapes with figures and pure impressionistic
marine subjects became frequent in his output. With the
assistance of several other artists, Stevens painted the
immense *Panorama of the Century* for display in the
Tuileries Gardens during the Exposition Universelle of
1889. This recorded the famous men and women of
France since the Revolution, many of whom he had
known. It won a grand medal of honor. In 1900, Alfred
Stevens became the first living artist to be accorded a
one-man exhibition at the Ecole des Beaux-Arts.

The connoisseur examining her treasures is a subject
Stevens treated on several occasions. Here the collector,
elegantly dressed and coiffed, is diligently researching
the mark on an Oriental cloisonné vase. The room is
furnished in an eclectic manner. In addition to the
Oriental rug, the other vases, and the Japanese fan,
there is a curious screen that juxtaposes a panel of a
flower composition with an inscription, partly decipher-
able as "Autumn day," and a panel of a figure in a
kimono. Hanging on the back wall is a large painting
that appears to be a Venetian scene by Felix Ziem. The
accumulation of rich, colorful details creates a luxurious
environment in which the charming woman is the most
conspicuous jewel.

[1]Comte Robert de Montesquiou, "Alfred Stevens," *GBA,* 23, 1900, p.
106. Stevens's fantastic *salon japonais,* is described by the Goncourts in
their *Journal* under the entry for March 13, 1875, 1956 ed. (v. II) p. 8.

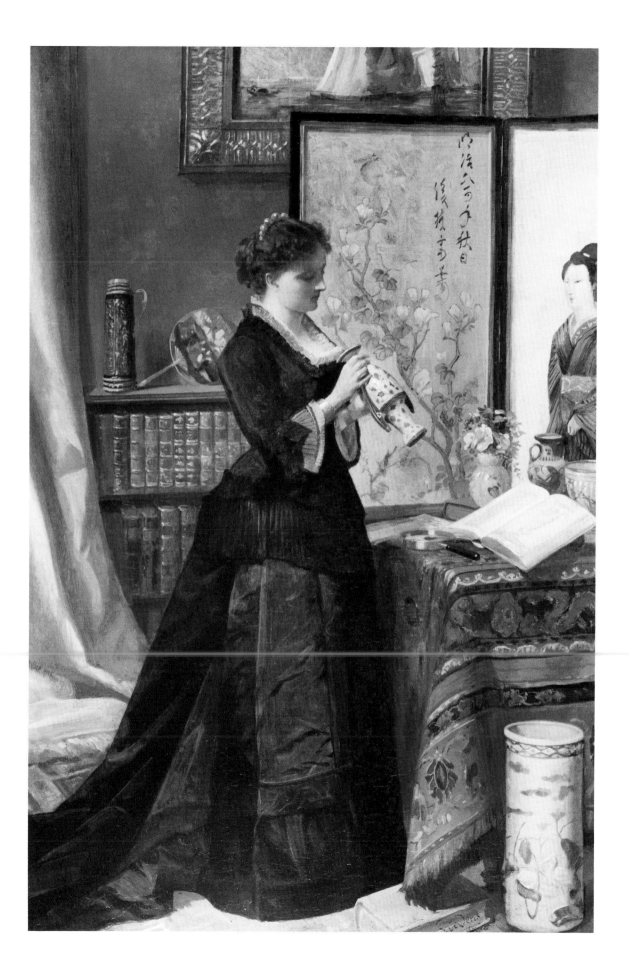

63. *Les Femmes d'Artiste (Artists and Their Wives),*
1885
Oil on canvas, 57½ x 40 inches (146.1 x 101.5 cm.)
Signed at the lower left: *J. J. Tissot*

The Chrysler Museum, Norfolk. Gift of Walter P.
Chrysler, Jr. and The Grady Fund, Landmark Communi-
cations Fund, and "An Affair to Remember," 1982.

Provenance: Sale, Christie's, London, March 30, 1889,
no. 134; Mr. Day; Charles Field Haseltine; Art Associa-
tion of The Union League of Philadelphia, 1894;
Knoedler and Co., New York, 1982.

Exhibitions: Galerie Sedelmeyer, Paris, April 19 - June
15, 1885, no. 10; Arthur Tooth and Sons, London,
1886, no. 9; *James Jacques Joseph Tissot, A Retrospective
Exhibition,* Museum of Art, Rhode Island School of De-
sign, Providence, and The Art Gallery of Ontario, To-
ronto, Feb. 28 - May 5, 1968, no. 38.

Bibliography: "Tissot's Novel Art Work," *New York
Times,* May 10, 1885, p. 4; "The Chronicle of Art," *The
Magazine of Art,* London, 1886, p. xxiv; *Catalogue of the
Works of Art in the Union League of Philadelphia,* 1908,
p. 27; James Laver, *"Vulgar Society": The Romantic
Career of James Tissot,* London, 1938, p. 74; *Catalogue of
the Collection of Paintings Belonging to the Union League of
Philadelphia,* 1940, p. 26; Maxwell Whiteman, *Paintings
and Sculpture at the Union League of Philadelphia,* Philadel-
phia, 1978, p. 98, rep. p. 90 (as *The Café Royal, Paris*);
*The Chrysler Museum: Selections from The Permanent Col-
lection,* Norfolk, 1982, cover ill.

Tissot was born in Nantes and educated at Jesuit
schools. He did not decide to become an artist until the
age of twenty. He went to Paris and studied with Louis
Lanothe; there he met Degas, who became a close friend
and painted the portrait of Tissot now in the Met-
ropolitan Museum. Tissot also studied with Flandrin,
and in 1859 went to Belgium to work with Baron Hen-
drik Leys, a painter of historical costume pictures. That
same year Tissot made his Salon debut with two por-
traits. Influenced by Leys's realistic medievalism, Tissot
began a series of paintings dealing with the Faust story.
Three of these were exhibited at the Salon of 1861 and
the State purchased *The Meeting of Faust and Marguerite.*
In 1862 he travelled in Italy and in 1864 began showing
his work in London. At this time Tissot turned from his
medieval subjects to the depiction of contemporary
genre scenes, focusing primarily on the activities of
women. In the mid-1860s, his work was also influenced
by the growing taste for *japonisme.* At the Salon of 1866
Tissot was awarded a medal.

During the Franco-Prussian War, Tissot took part in
the defense of Paris. He participated in the Commune of
1871, and after its failure he settled in London. He
worked at first as an illustrator, but soon established
himself as a painter of portraits and popular "conversa-
tion pieces," often (following the example of Whistler)

set along the banks of the Thames. By 1876 the painter
had met the Irish divorcee Kathleen Newton and gradu-
ally retired into a secluded life revolving around her.
With her fragile beauty, she became the model for his
prints and paintings over the next few years.

After her untimely death in 1882, Tissot returned to
Paris and set about re-establishing his reputation, first
with a retrospective exhibition at the Palais de l'Indus-
trie and then by painting a series of elaborate works
entitled *La Femme à Paris,* devoted to the activities and
occupations of the women of Paris. Fifteen of these were
shown at the Sedelmeyer Gallery in 1885. They were his
last genre works. A reawakening of his religious faith led
him to travel to the Middle East to prepare for his
gouache illustrations of the Bible. Tissot was made a
Chevalier of the Legion of Honor in 1894.

Artists and Their Wives is from the Woman of Paris
series. Maurice du Seigneur found the Sedelmeyer show
"a very curious exhibit" and complained of the artist's
"brittannisme." [1] When these paintings were shown the
following year at the Tooth Gallery in London, the
Magazine of Art felt they "ought to attract crowds" for
"the English love of the anecdotal is amply catered for
here." [2]

Tissot had intended to issue etchings of all fifteen
works, with accompanying texts by contemporary
writers. In the end, just five etchings were made and the
only commentary written was published in the catalogue
of the Tooth exhibition. The *Artists and Their Wives* was
described in the Tooth catalogue as follows:

> In a word, it is *le vernissage*—varnishing day—which at the
> Salon is more or less like our private view day; and the
> painters with their wives and friends have taken Le Doyen's
> restaurant by storm, and are settling down to a *dejeuner*
> which they will enjoy with true artistic spirit. . . . How gay
> everyone seems at this moment, when the great effort of the
> year is over, and when our pictures are safely hung, and are
> inviting the critics to do their worst and the buyers to do
> their best! [3]

According to a *New York Times* review of the Sedel-
meyer show, the text to accompany this subject was to
have been written by Albert Wolff, and "in this picture
nearly all the faces are celebrities." However, the only
face actually identified is the English painter John Lewis
Brown, seated "directly in front with the two ladies be-
fore him." [4] The location of the restaurant, however, is
easily identifiable as the exterior of the Palais de l'In-
dustrie, which housed the Salon and had a distinctive
caryatid portico.

[1] Maurice du Seigneur, "Les Expositions Particulières," *L'Artiste,* I,
1886, pp. 146-147.
[2] "The Chronicle of Art," *The Magazine of Art,* London, 1886, p. xxiv.
[3] Tissot exhibition catalogue, Arthur Tooth and Sons, London, 1886,
no. 9.
[4] "Tissot's Novel Art Work," *New York Times,* May 10, 1885, p. 4.

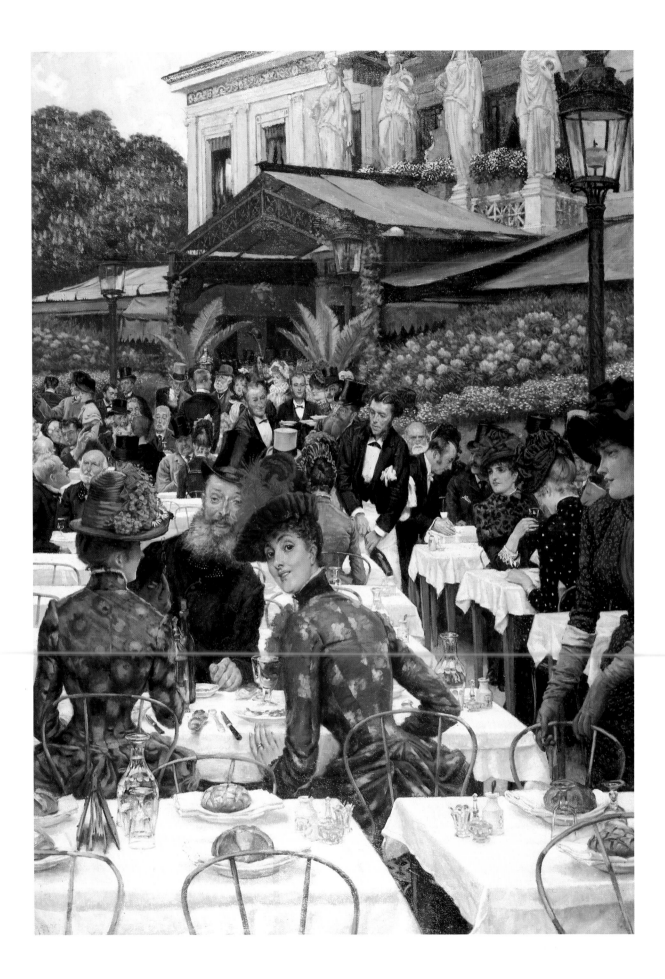

64. *Daphnis et Chloé*, 1866
Oil on canvas, 54½ x 87 inches (221 x 138.4 cm.)
Signed at the lower right: *Vibert*

The Chrysler Museum, Norfolk. Gift of Walter P. Chrysler, Jr., 1971.

Provenance: Charles A. Gould; Sale, American Art Gallery, New York, Jan. 27, 1927, no. 94 (as *Psyche and Zephyr*); E. F. Albee, New York; Hirschl & Adler Galleries, Inc., New York, 1960; Walter P. Chrysler, Jr.

Exhibitions: Salon, Paris, 1866, no. 1920; *The Controversial Century: 1850-1950*, Chrysler Art Museum, Provincetown, and the National Gallery of Canada, Ottawa, 1962.

Bibliography: Charles Beaurin, "Le Salon de 1866," *Revue du XIXe siècle*, June 1, 1866, p. 469; Edmond About, *Salon de 1866*, Paris, 1867, pp. 62-63; Montrosier, 1881, I, p. 122; Bellier and Auvray, 1882, II, p. 669; Jehan-Georges Vibert, *La Comédie en Peinture*, London, 1902, II, p. 236; Frederick W. Morton, "An Appreciation of Jehan-Georges Vibert," *Brush and Pencil*, Sept. 1902, p. 324; Shepherd, 1975, p. 349.

65. *Mystère!*, ca. 1890
Oil on panel, 29 x 23¼ inches (73.7 x 59.1 cm.)
Signed at the lower right: *J. G. Vibert*

Private Collection, Atlanta.

Provenance: Sale, Robert W. Skinner, Inc., Bolton, Mass., Nov. 19, 1981, no. 66.

Bibliography: Jehan-Georges Vibert, *La Comédie en Peinture*, London, 1902, II, pp. 124-127, rep., p. 123.

Vibert, a master of satirical realism, was one of the most popular artists of the late nineteenth century. Born in Paris, he first studied engraving with his maternal grandfather, Jean-Pierre-Marie Jazet. He entered the Ecole des Beaux-Arts at age sixteen and studied with Barrias and later with Picot. Vibert made his Salon debut in 1863 and in these early years the influence of Picot was evident in large scale mythological subjects such as *Narcissus Transformed into a Flower* (Salon of 1864) and this large painting of 1866 treating the pastoral myth of Daphnis and Chloë. Vibert may have taken the subject from earlier artists such as Gerard, whose neo-classical painting from the Salon of 1824 is in the Louvre. Other artists, including Hamon and Corot, had also treated the subject. Vibert stresses the intimacy of the scene as Daphnis teaches Chloë to play the shepherd's flute.

Montrosier called the painting an "exquisite pastoral poem,"[1] but Edmond About was distressed at what he regarded as a decline in the young artist's ability: "It is the work of a boy who has become careless, not through discouragement, but by an excess of confidence . . ." and he recommended that Vibert "return to the study of nature, take on a model, study with new freshness the human form and the solidity of living bodies, analyze the light, and recognize that the dirt staining Daphnis' feet does not resemble a shadow."[2]

In the same Salon at which the *Daphnis and Chloé* was shown, Vibert also exhibited a work painted in collaboration with the Spanish-born artist Eduardo Zamacois, *Entrance of the Torreadors* (probably the work now in the Walters Art Gallery). The critical About found this painting "new and interesting with lively bold coloring,"[3] and from this point on Vibert began to develop his career as a genre painter. He became a master of small-scale, amusing, anecdotal scenes. These had wide appeal and Proust's Duke of Guermantes, for example, says of Vibert: "The man's got wit to the tip of his fingers." The most frequent targets of Vibert's satires were the clergy, and he was often compared to the novelist Ferdinand Fabre, "for each reveal the same relish for a sly thrust at the priesthood, and the same delight in gibbeting the men of holy orders who are more worldly than spiritual."[4] Vibert liked to say that these works had helped make him rich.[5]

As Stranahan noted, "There is much 'story' in all Vibert's works,"[6] but the story is not always obvious. Fortunately, in the two-volume *La Comédie en Peinture* which he published in his last year, Vibert documented most of his works and provided explanatory narratives for works such as *Mystère!* The story can be summarized as follows: Don Bazilio, the caretaker of the *Monsigneur*, has discovered that the *Monsigneur* has been stealing two dozen roses each day. And whenever he goes out he wears his cloak, no matter how warm the weather. Puzzled, Don Bazilio follows the *Monsigneur* to the abandoned Chapel of the Madonna. The roses cannot be for the Madonna, since her statue had been transported to the large church and her shrine abandoned. In the painting, the *Monsigneur* draws the key from his pocket, places it in the lock, and looks about furtively before entering. Don Bazilio, hiding beside the chapel, is more confused than ever, but he decides that unfounded suspicion is calumny and that the mystery is best left undisturbed. For "a mystery is something which a good Christian never tries to understand, and if his mind suggests a plausible explanation, he would not even admit it."[7]

[1]Montrosier, 1882, I, p. 122.
[2]E. About, *Salon de 1866*, Paris, 1867, p. 62.
[3]Ibid, p. 64.
[4]Frederick W. Morton, "An Appreciation of Jehan-Georges Vibert," *Brush and Pencil*, Sept. 1902, p. 327.
[5]"The Painter Vibert, An Autobiographical Sketch," *Century Magazine*, 1896, p. 78.
[6]Stranahan, *History*, 1917, p. 348.
[7]Vibert, 1902, II, p. 127.

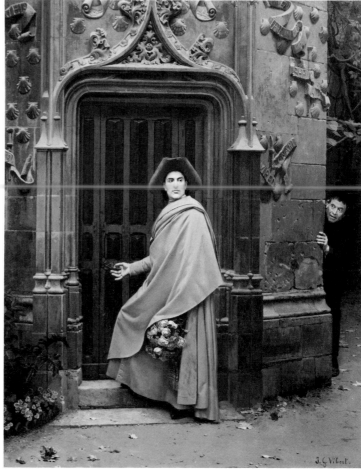

66. *Le Medecin Malade (The Sick Doctor),* 1892
Oil on panel, 32½ x 26 inches (82.6 x 66 cm.)
Signed at the lower right: *J. G. Vibert*

Mr. and Mrs. James E. Wenneker, Lexington.

Provenance: Estate of the artist; Atelier Sale, Paris, Nov. 25-26, 1902, no. 52; M. Knoedler and Co., New York, 1904; John Levy Galleries, New York; Zillia Babbitt Hyde; Sale, Parke-Bernet, New York, 1940; Dalton Sale, Parke-Bernet, New York, Oct. 16, 1941, no. 71; Sale, Parke-Bernet, New York, May 22-25, 1946, no. 780.

Exhibitions: Salon, Paris, 1892, no. 1658; Exposition Universelle, Paris, 1900, no. 1872.

Bibliography: Gustave Larroumet, *Le Salon de 1892,* Paris, 1892, p. 38; Emile Bergerat, *Le Salon de 1892,* Paris, 1892, p. 87; A. Tausseret-Radel, "La Peinture au Salon des Champs-elysées," *L'Artiste,* 1892, p. 332; C. Yriarte, *Figaro Salon,* frontispiece; J. G. Vibert, "The Sick Doctor," *The Century Magazine,* 51, 1896, pp. 944-947; Gustave Haller, *Le Salon, (Dix Ans de peintre),* Paris, 1902, I, p. 30; J.-G. Vibert, *La Comédie en Peinture,* London, 1902, I, pp. 30-40, rep.; Bénézit, 1955, p. 553.

In Vibert's autobiographical notes, published in the *Century Magazine* of April 1896, the artist's *alter ego* says to him:

> Using your pen as well as your brush, you have written songs and plays that have been applauded in the minor theatres of Paris; following the example of Molière, and having like him an extraordinary talent as an actor, you have played your own productions at the club and in artistic salons.[1]

Vibert's association with the stage was a long and active one. His wife was an actress with the Comédie Française, and his stage works included *La Tribune Mécanique* performed at the Palais Royale in 1862, and *Les Chapeaux Conference* (1874), *Le Verglas* (1876), and an operetta *Chanteuse par Amours* (1877) presented at the Variétiés.

From Molière's satire of doctors, *Le Malade imaginaire,* Vibert took the inspiration (and even the names of the characters) for his own playlet *Le Medecin malade,* which is also the subject of this 1892 painting. The one-act comedy has two characters, Argan the Hypochondriac and Thomas Daifoirus the Doctor. The setting and costumes are described in the stage directions:

> The stage represents a bourgeois salon. Gray woodwork and tapestries. The door to the left partly hidden by a leather-covered screen. At the back, a table upon which a wig already dressed is set on a wooden block. In front, a high-backed arm-chair; to the left, another arm-chair; between them, a small table with a cup and tea-pot. In the foreground, a brazier, upon which a small kettle is boiling.
>
> When the curtain rises ARGAN is asleep in the large arm-chair. He wears a flowered dressing-gown, a muslin neckerchief, fur-lined slippers, and a linen cap with yellow ribbons; his feet are resting on a high stool and his head is supported by a large pillow. In the other arm-chair DIAFOIRUS is seated. He wears the costume of his profession, a long black robe and pointed hat.[2]

In the play, the doctor after sharing a huge lobster dinner with Argan, feels queasy. He discovers that he accidentally took the powerful medicine he had prescribed for his patient. He collapses, convinced that he is dying. The painting shows Argan reviving the doctor with a splash of water. The ironic twist is that there was no draught in the tea after all, for Argan's servant routinely substituted water for all the doctor's medicines.

Exhibited in the Salon of 1892, the work attracted attention for its high price and because it was "mysteriously and stupidly" vandalized.[3] Fortunately this damage (inflicted perhaps by an outraged doctor) does not seem to have been severe, since the work was shown at the Exposition Universelle of 1900. A photograph in the catalogue of Vibert's atelier sale shows that he hung the painting in a prominent position in the grand salon of his *hôtel* at 18 rue Bellu. Today, the work still sparkles, seeming to prove Vibert's claim that the colors he developed were more beautiful and long lasting than those of other artists.[4]

[1]"The Painter Vibert, An Autobiographical Sketch," *The Century Magazine,* 1896, p. 78.
[2]Vibert, 1902, I, p. 31, translated in *Century Magazine,* 1896, p. 945.
[3]Tausseret-Radel, 1892, p. 332 and Larroumet, 1892, p. 38.
[4]*Century Magazine,* 1896, p. 79.

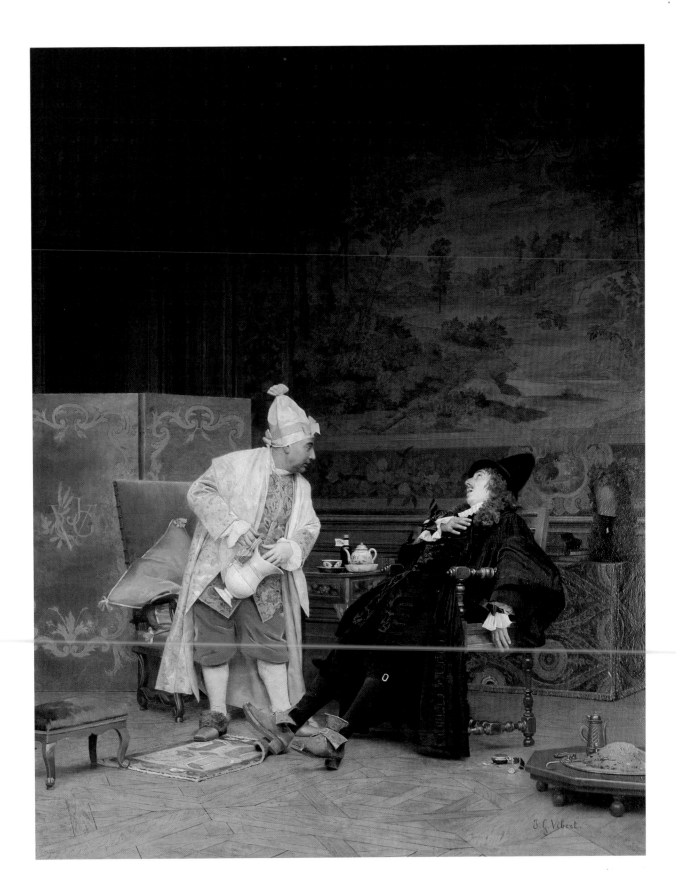

67. *Still Life with Shrimp and Oysters*
Oil on canvas, 12½ x 16 inches (32 x 40.5 cm.)
Signed at the lower right: *A. Vollon*

The Ackland Art Museum, The University of North Carolina at Chapel Hill. Purchase through the Ackland Fund, 1959.

Provenance: Vose Galleries, Boston.

Exhibitions: *Twenty-five Still Life Paintings*, Indiana University Museum, Bloomington, 1966, no. 65; *French Nineteenth Century Oil Sketches: David to Degas*, William Hayes Ackland Memorial Art Center, University of North Carolina at Chapel Hill, March 5 - April 16, 1978, no. 62.

Bibliography: *Catalogue of the Collection, The William Hayes Ackland Memorial Art Center, Paintings and Selected Sculpture*, Chapel Hill, I, 1971, p. 122, no. 75.

68. *Still Life*
Oil on panel, 7⅜ x 9⅝ inches (18.7 x 24.4 cm.)
Signed at the lower right: *A. Vollon*

Sheila and David Saul, Atlanta.

Provenance: Vose Galleries, Boston.

Vollon, one of the nineteenth century's most successful artists, was born in Lyon, where he was first trained as an engraver. His ambition was to be a painter and he studied the collection in the Museum of Lyon. He was finally able to go to Paris in 1859, and struggled to make a living by painting landscapes and portraits. Soon he was in contact with the realist painters Bonvin and Ribot. Vollon's first public notice came in 1863 when his work was included in the Salon des Refusés. The following year he was represented in the official Salon by two genre works; the State even purchased one *Kitchen Interior*. The critics recognized his debt to earlier masters and called him "the new Chardin."

In 1868 the State commissioned the large still life *Curiosities*, which included treasures from the Louvre. Official recognition continued with his election to the Salon jury, the achievement of *hors concours* status in 1869, and his designation as a Chevalier of the Legion of Honor in 1876. Vollon was made a Commander of the order in 1888 and awarded the medal of honor at the Exposition Universelle of 1900.

In 1878 Vollon went to Holland to copy a work by Frans Hals. There, he could not but appreciate the quality of Dutch seventeenth century still life painters like Claesz and Heda. Their paintings of seafood may have inspired Vollon's occasional works along these lines,[1] although his contemporaries Bonvin and Bergeret had also exploited the visual attraction of oysters and shrimp. The fresh vigorous strokes which Vollon employs here indicate an "early familiarity with the Impressionists."[2]

Vollon's depiction of kitchen utensils is more typical of his still lifes. The artist preferred to work spontaneously from the objects and had a collection of copperware, pewter, and ceramics that he would continually rearrange in his compositions. To indicate the highlights, he employed an impasto so thick that (as Claretie wrote of another example) it seems that Vollon painted with such passion that he left his brush aside to sculpt the paint with his fingers.

[1]One was sold at auction at Sotheby's, London, Feb. 11, 1970.
[2]Donna Bernens, "Vollon," *French Nineteenth Century Oil Sketches*, exhibition catalogue, The Ackland Art Museum, 1978, p. 129.

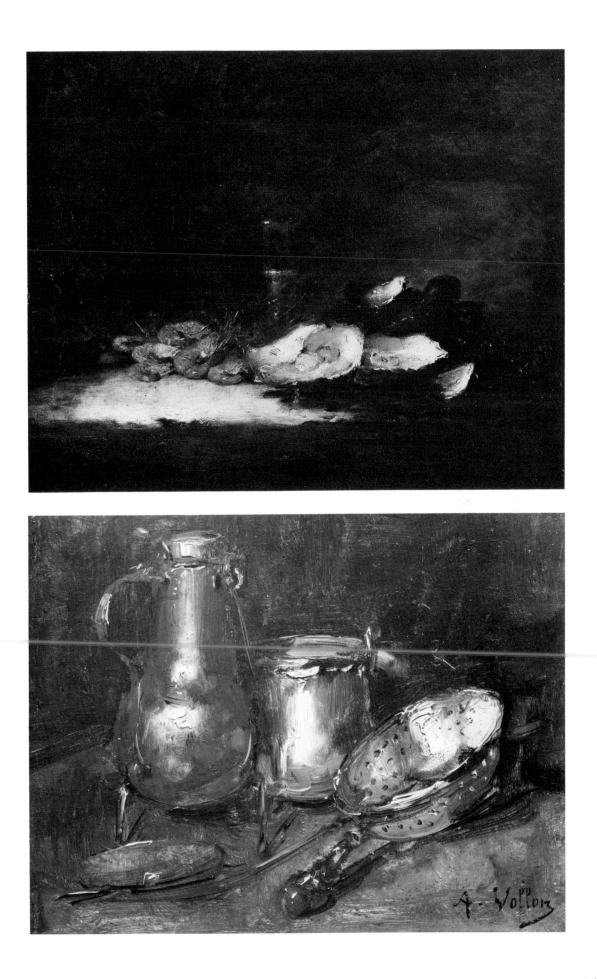

69. *Portrait of Napoleon III*, 1868

Oil on canvas, 22 x 18⅜ inches (55.9 x 46.7 cm.)
Signed and dated at the right above the epaulet:
AD YVON 1868

Walters Art Gallery, Baltimore.

Provenance: Samuel P. Avery, 1876; W. T. Walters, Baltimore.

Exhibitions: *Paris in the Belle Epoch,* Museum of Fine Arts, St. Petersburg, March 1 - April 6, 1980.

Bibliography: Strahan, *Treasures,* 1881, I, p. 94; *W. T. Walters Collection,* Baltimore, 1878, p. 4; "The Walters Collection of Art Treasures," *Magazine of American History,* April 1892, p. 251.

Yvon was one of the leading battle painters of the Second Empire. At first he followed his father in working for the Ministry of Water and Forests, but his desire to be an artist was great and he determined to study painting. He was able to enter Delaroche's atelier in the Ecole des Beaux-Arts and received encouragement from the master. Yvon made his Salon debut with a portrait in 1841. He soon turned to religious paintings, however, and established his reputation at the 1843 Salon with his *Captivity of St. Paul,* which was purchased by the State. That same year he went to Russia to prepare for painting his first major history subject, *The Battle of Kouliokovo,* an encounter of 1830 between the Muscovites and Turks. Although he exhibited drawings made in Russia at several Salons in the late 1840s, the painting was not exhibited until 1850-51. There followed another work with a Russian setting, *Marechal Ney at the Retreat from Russia* (1855). Yvon was to be decorated for this work, but his name was removed from the list. The Emperor Napoleon III, however, summoned him to the Tuileries, and the artist described this significant meeting:

Napoleon III was dressed in a fashion half-bourgeois, half-military. He wore a buttoned dress-coat over his uniform pants. His impassive face radiated the calm and well-being which were characteristic of his countenance. "They have

been prejudiced against you," the Emperor told me, "a regrettable oversight which I shall happily rectify. You are now a Knight of the Legion of Honor. Your painting of the retreat of Russia," he added, "is very fine, although it treats a sorry subject for our army." A sudden inspiration came to me. "Sire," I replied, "it rests with the Emperor to furnish the occasion of a re-engagement. Our armies are about to take Sebastopol, and I request the honor of being sent to the Crimea to gather the material for a great painting dedicated to the glory of our armies." My words were doubtless uttered with passion. The Emperor expressed his delight, "That is well said, I consent to it with all my heart. Go find M. Fould, the minister of state, I will give him my instructions."[1]

The painting of the Crimean War that resulted, *The Capture of Malakoff,* won the artist a medal of honor in 1857. The Emperor came to see it with his aides, examined it at length, shook the artist's hand, and left the Salon without looking at any of the other paintings. Yvon's heroic depiction of the army of the Second Empire served the political purposes of the Emperor (just as Baron Gros's work had served Napoleon I) and the artist received commissions not only for other Crimean battles, but also for the *Battles of Italy,* now at Versailles. One of these, the *Battle of Solferino,* painted in 1861, shows the Emperor in full military dress. The present head study was once thought to have been made in preparation for *Battle of Solferino,* but it is dated seven years later. It may, however, be a portrait from life which the artist kept in his studio for use in other official works. For example, in *Napoleon III Giving to Baron Haussmann the Decree to Annex the Suburbs of Paris* (Bibliothèque Historique, Paris), the Emperor faces in the opposite direction, but is wearing the same military uniform with the red sash of the Legion of Honor and his many other decorations. The Emperor's face in all of these works has that "impassive" (we might even say mask-like) quality which Yvon attributed to him.

[1]R. Peyre, *La Peinture Française,* Paris, n.d., p. 254.

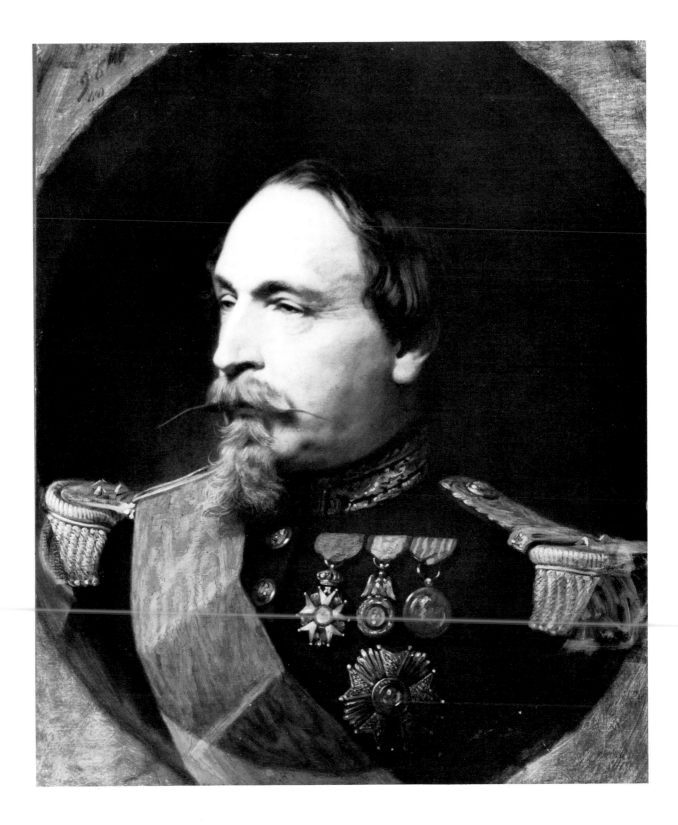

70. *Le Réfectoire des Trinitaires à Rome (Refectory of the Trinitarians)*, 1868
Oil on canvas, 29½ x 43½ inches (74.9 x 110.5 cm.)
Signed, dated, and inscribed at the lower left:
Ed. Zamacois
Roma .68

National Museum of American Art, Smithsonian Institution, Washington, D.C. Gift of Emily Tuckerman, 1924.

Provenance: Lucius Tuckerman, Washington, D.C.; Miss Emily Tuckerman, Washington, D.C.

Exhibitions: Salon, Paris, 1868, no. 2580.

Bibliography: Paul Pierre, *Un Chercheur au Salon 1868*, Paris, 1868, pp. 110-114; Edmond About, "Le Salon de 1868," in *Revue de Deux Monds*, June 1868, p. 732; Bellier and Auvray, 1882, II, p. 730; *Catalogue*, National Gallery of Art, Washington, D.C. 1909, p. 138; 1916, p. 187; 1922, p. 96; 1926, p. 102; *Opening of the National Gallery of Art*, 1910, p. 22; *National Gallery of Art Annual Report*, 1925, pp. 51,54.

Zamacois was born in Bilbao in 1847 and had his first art training with Balaca and Madrazo at the Escuela de Bellas Artes de San Fernando in Madrid. He went to Paris in 1861 and there became a pupil of Meissonier. He made his debut at the Paris Salon in 1863 with *The Enlisting of Cervantes* and *Diderot and D'Alembert*, two works of historical genre that reveal the influence of his master. The following year he exhibited *Conscripts in Spain* and in 1866 a work painted in collaboration with his friend Vibert, *The Entrance of the Torreadors*. Zamacois was soon established as a popular painter of unusual everyday scenes and fanciful historical recreations—especially popular with American collectors—such as *The Favorite of the King* (formerly Stewart Collection) and *The Two Confessors* (formerly Johnston Collection).

Writing in 1869, Eugene Benson gives us some idea of the high regard in which Zamacois's work was held by his contemporaries:

> Of the recent men in French art who have distinguished themselves by novelty of subject and elaboration of manner, Zamacois is not the least noteworthy; he, in fact, holds the attention best, and, with Vibert, excites the most lively interest among amateurs of painting. Vibert and Zamacois are to the Parisian picture-fanciers today, what Meissonier and Gérôme were yesterday—the novelty and the perfection of art. Zamacois, with a manner almost as perfect as Meissonier's, is a satirist; he is a man of wit whose means of expression is comparable to a jeweled and dazzling weapon—so much so that, to express his rich and intense color, his polished style, he has been said to embroider his coarse canvas with pearls, diamonds, and emeralds. I should suggest the form and substance of his works as a painter, by saying that he has done what Browning did as a poet when he wrote the "Soliloquy of the Spanish Cloister," what Victor Hugo has done in portraying dwarfs and hunchbacks; but with this difference, that what is *en grand* and awful in Hugo is small, elaborated, and amusing in Zamacois. Zamacois seeks his subjects in the sixteenth and seventeenth centuries, and in the life of monks and friars and priests in modern Italy.[1]

The Trinitarians was painted during a sojourn in Rome. When it was shown at the Salon of 1868, the often critical Edmond About found it "a charming and well-painted composition." Paul Pierre, who regarded it as the outstanding genre work in the Salon, felt compelled to defend the artist against the charge that he was only a caricaturist by describing at length the subject, deliniating the action of each of the twenty-two monks, and praising the superior quality of the painting. He was particularly impressed by Zamacois's depiction of the room bathed in the Italian sunlight, streaming through the window at the right and illuminating the table, so that the viewer's eye is drawn toward Heaven.[2]

[1]Eugene Benson, *Art Journal*, 1869, quoted in Clement and Hutton, II, p. 369-370.
[2]See Pierre, 1868, pp. 110-114.

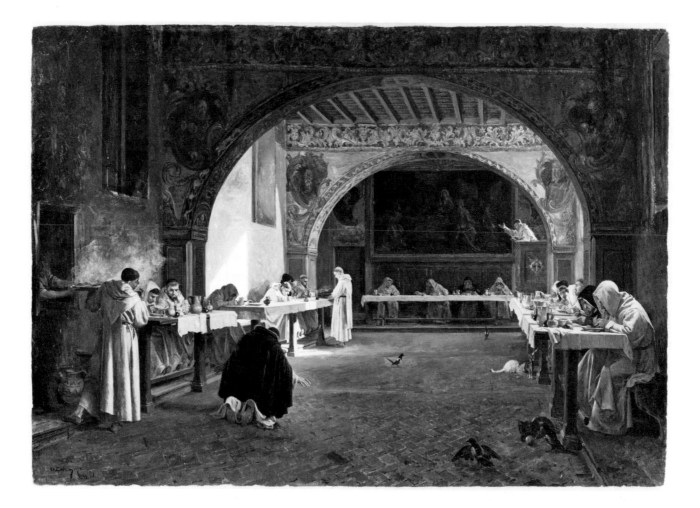